THE
FONVILLE WINANS
COOKBOOK

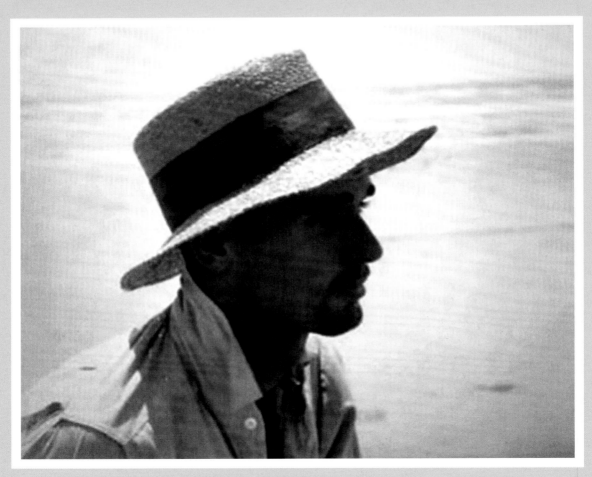

Self-Portrait, Grand Isle, Louisiana, 1934.
(Fonville Estate Collection, courtesy Robert L. Winans)

MELINDA RISCH WINANS & CYNTHIA LEJEUNE NOBLES

THE
FONVILLE WINANS
COOKBOOK

Recipes and Photographs from a Louisiana Artist

FOREWORD BY CHEF JOHN FOLSE

LOUISIANA STATE UNIVERSITY PRESS BATON ROUGE

Published by Louisiana State University Press
Copyright © 2017 by Louisiana State University Press
All rights reserved
Manufactured in Canada
First printing

Designer: Barbara Neely Bourgoyne
Typefaces: Brix Slab and Veneer Clean, display; Chaparral Pro, text
Printer and binder: Friesens Corporation

Library of Congress Cataloging-in-Publication Data

Names: Winans, Melinda Risch, 1937– author. | Nobles, Cynthia LeJeune, 1954– author.
Title: The Fonville Winans cookbook : recipes and photography from a Louisiana artist /
 Melinda Risch Winans and Cynthia LeJeune Nobles ; foreword by chef John Folse.
Description: Baton Rouge : Louisiana State University Press, 2017. | Includes
 bibliographical references and index.
Identifiers: LCCN 2017005934| ISBN 978-0-8071-6768-7 (cloth : alk. paper) |
 ISBN 978-0-8071-6769-4 (pdf) | ISBN 978-0-8071-6770-0 (epub)
Subjects: LCSH: Cooking, American—Louisiana style. | Winans, Fonville. |
 Photographers—United States—Biography. | LCGFT: Cookbooks.
Classification: LCC TX715.2.L68 W585 2017 | DDC 641.59763—dc23
LC record available at https://lccn.loc.gov/2017005934

In memory of
Fonville and Helen

Dedicated to
Bob, Meriget, and Walker

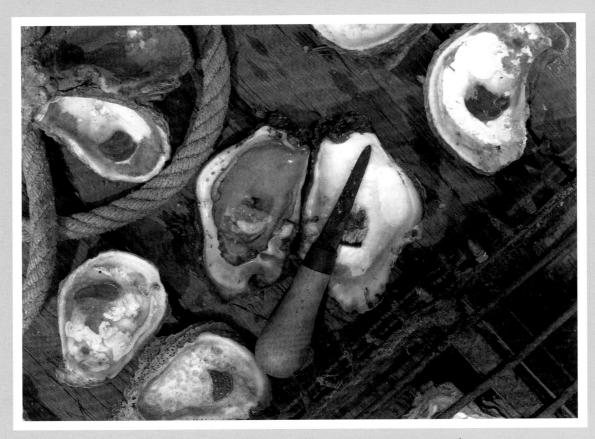

Oyster and Rake. [Fonville Estate Collection, courtesy Robert L. Winans]

Contents

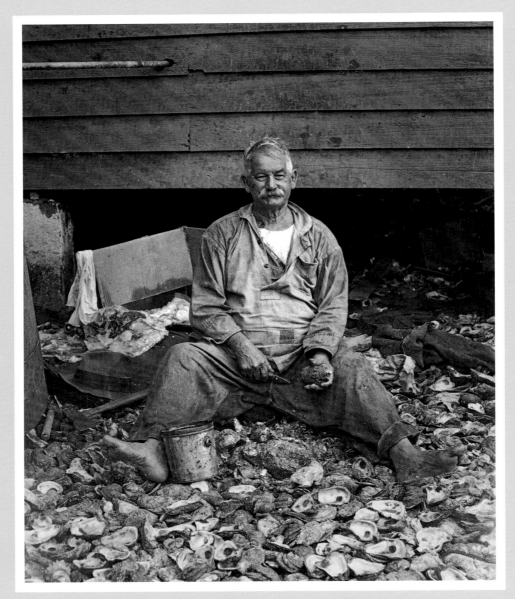

Oysterman, 1933. (Fonville Estate Collection, courtesy Robert L. Winans)

Foreword

In retrospect, it is strange to say that Fonville Winans is responsible for the success of my best-selling cookbook, *The Encyclopedia of Cajun and Creole Cuisine*. But it's true! Although I had considered reproducing historic photographs with my image replacing the original subject on all of my "big book" covers, I had no idea this particular one would create an overnight publishing sensation.

You see, "The Oysterman," Visier Boudreaux, was photographed by Fonville in 1934. It was an anniversary picture Fonville gave to Visier, and I'm sure it was framed and placed on a mantelpiece to be enjoyed only by members of the family for three-quarters of a century. I remember receiving a call from my director of communications, Michaela York, as she perused the Fonville Collection in Hill Memorial Library at Louisiana State University, and yelled, "I have our cover shot for the new book!" We went on to re-create the Folse version of *The Oysterman* with photographer David Gallent at P&J Oyster Company in New Orleans, which David says is the most famous photograph he has ever shot. The 850-page encyclopedia was released December 7, 2004, and within two weeks, the book was sold out. I attribute that success to Fonville.

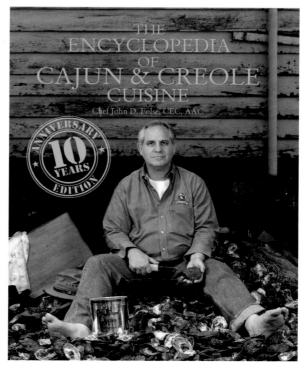

Cover of *The Encyclopedia of Cajun and Creole Cuisine.*
(Reproduced courtesy Chef John Folse and Co.)

I met Fonville as a young chef while running my first restaurant in Baton Rouge. Fonville Winans and his friend Doc Pennington would stroll in for a lunch cocktail and share stories with this young restaurateur. I had absolutely no clue that I was talking to greatness, even when Fonville suggested that he might bring a camera one day to shoot pictures of me at the stove. I just chuckled, not really appreciating the master artist standing before me, and did not follow up on the idea. To make matters worse, his son Bob, who picked up shooting personalities after Fonville's death, approached me about scheduling a portrait, and for some reason I was unavailable at the time. I missed yet another opportunity to stand before the lens of a Winans camera.

As with Fonville, my life has had many twists and turns. His came about in the bayous and swamplands of south Louisiana as he photographed his unique images that portray to the world what early Cajun life was all about. As for me, although I did not get an iconic Fonville portrait, I did come to know some of our state's great raw ingredients, farmers, and fishermen through his photographs.

Fonville was the first food photographer I ever met. His pictures of Louisiana food festivals and oyster bars set up near the docks where his boat, the *Pintail,* was moored, inspired me as a cook. No one photographed Louisiana food and brought it to the world better than Fonville in shots like *Ladies with Redfish, Louisiana Strawberries, Rice Festival, Crowley, Frog Legs,* and *Tonging*—and even our love of salt with his picture of the Avery Island salt mine.

It is interesting that many of Fonville's most recognizable photographs revolve around his interest in food and cooking. And those who knew him best knew that he loved everything about food. For example, I remember talking with political commentator James Carville, from the town of Carville in Iberville Parish, about his mother's stories of Fonville's crabbing excursions with his son Walker near Grand Isle, and the many recipes that Fonville loved to share with those with whom he came in contact. And now with the publication of *The Fonville Winans Cookbook: Recipes and Photography from a Louisiana Artist,* we can peer into Fonville's pots and experience his boiled crabs, broiled soft-shell crab, shrimp fricassee, coquina stew, and the crawfish bisque I've heard stories of.

I am so proud to say that I knew Fonville from a distance. I have been inspired over the years with the stories I have heard about his life, the photographs I have come to cherish, and the knowledge that he made my most popular cookbook famous.

—CHEF JOHN FOLSE

Preface

In 1982, in my living room in Baton Rouge, Louisiana, Walker Winans bent down on one knee and asked, "Melinda and Lara, will you marry me?" Lara was my thirteen-year-old daughter from my first marriage. I had been divorced for several years, and by then, I felt a kinship not only to my future husband, but also to his lively family, a tight-knit clan headed by Walker's father, Fonville Winans, a beret-wearing, long-distance bicycle rider who played the saxophone and flew airplanes.

Fonville also happened to be an internationally famous photographer who only took shots in black and white. Just as fascinating to me, the man who was to become my father-in-law loved to cook, and he and his wife, Helen, had raised three children who appreciated sitting down to a good meal.

Right after my seemingly quick engagement to Walker, a slightly jealous friend asked, "How in the world did you catch him?" My response: "I tied a pork chop around my neck and he followed me home." Yep, I married into the original "foodie" family.

Actually, Walker had been a family friend for over thirteen years. I had known Fonville, Helen, Walker's brother, Bob, and sister, Meriget, through my mother's membership in the Krewe of Romany, Baton Rouge's oldest Mardi Gras social group for women, which annually presented debutante daughters of its members, and where I was also a maid. From the early years of Romany, Helen was an active member, and even once served as ball captain. My grandmother was another connection to the Winans; she was a seamstress, and she had created elegant wedding dresses for many of the society brides Fonville photographed.

Back to our wedding—the original, low-key plan was to have Judge Melvin Shortess, a family friend, marry us in his downtown office. My friends, however, would not hear of something so uneventful. So longtime pals Arlene and Neil Kestner offered their spacious home on Highland Road for the service and reception. While meeting with a few other friends to decide on a menu, we immediately found ourselves under the direction of my future mother-in-law, who ended up arranging for a spectacular buffet that included many of the family's favorite recipes. One of those dishes was Sweet 'n Hot Beans, a Fonville creation and recipe that Joe DiGerolamo, owner of Joe D's Grocery, eventually wrested out of Fonville and sold in his store's delicatessen.

Fonville, of course, was our wedding photographer. As most people in the art world know, he had spent the

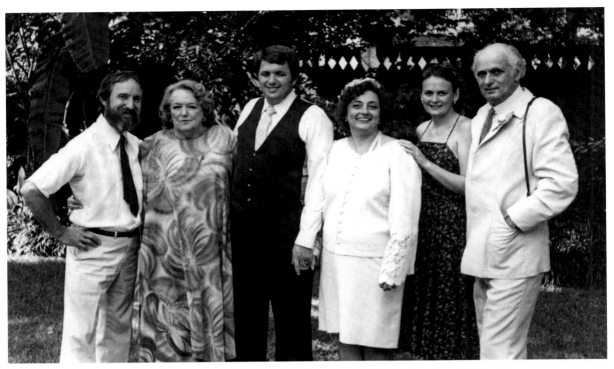

Melinda and Walker's wedding, July 23, 1983. *From left:* James Turner, Helen Winans, Walker Winans, Melinda Winans, Meriget Winans Turner, and Fonville. (Courtesy Melinda and Walker Winans)

early part of his career shooting photographs of Depression-era Cajuns in Louisiana's swamps and marshes. He later became one of the South's premier portrait photographers. By the time of my nuptials to Walker, Fonville had mostly retired. However, clients would not let him retire, even when he set an outrageous sitting fee—which was just for posing in front of the camera; actual prints cost extra. But he dusted off his camera for us and, naturally, the shots were fantastic. They are all the more special because ours was the last wedding Fonville said he wanted to photograph.

One of the first things Walker did after our marriage was legally adopt Lara, and one of the first things I did

was invite Helen and Fonville to dinner. I was so nervous. For reasons I still can't fathom, I decided to make sauerbraten from an unfamiliar recipe that required four days of preparation. To my surprise, everyone applauded the meal. Maybe Fonville's approval had something to do with the jelly glass full of brandy he downed before we sat at the table. Regardless, I certainly didn't care; I only felt relief.

The next time I invited the two to dinner, I asked Helen what she would like and, you guessed it—sauerbraten. After this second meal of what was becoming my signature dish, Fonville held out his hand and asked for my recipe. He knew he would eventually have to make

it for Helen, and I knew I had passed his cooking test. (Over the years, I've made several changes to that sauerbraten recipe, and you can find my latest version on page 104.)

My father-in-law had numerous friends, and his home on Baton Rouge's Lobdell Avenue was the gathering place for many a cocktail hour and impromptu party. Fonville usually did the cooking for these events, which gave him a good excuse to fiddle around with recipes until he felt they were perfect. Whether it was chili, gumbo, flan, or a Chinese dish, Fonville would make and remake it until he felt it could not be improved. One dish Walker and I still laugh about is his beef tamales; before he was satisfied, Fonville tweaked that single recipe at least thirty times.

Fonville suffered from a couple of strokes when he was well into his seventies, and after that he could no longer ride his beloved bike or play saxophone. On January 19, 1988, Helen died from cancer. Fonville hung on, missing her terribly, for a few more years, spending much of that time relying on a cane and a wheelchair. He died September 13, 1992, at the age of eighty-two. Baton Rouge had lost a legend, and I lost not only a dear father-in-law, but a kindred spirit obsessed with cooking.

After Fonville's funeral, the family got together and cleaned out the Winans house. At the end of that day, Walker and I were rummaging through the trash and found about fifteen cookbooks, along with two loose-leaf notebooks that contained over 250 handwritten recipes and comments by Fonville. Even though I had been in the kitchen with him often, I had no idea he kept those journals. Without discussion, Walker and I immediately rescued the cookbooks and those precious books of original recipes.

Since the day I found my father-in-law's recipes, I have wanted to turn them into a cookbook, both as a tribute to his exceptional skills in the kitchen and be-

cause I wanted a permanent record for our descendants. And while I was at it, I decided to document the many Fonville stories known only by our family and close friends. In 2015, I finally started tackling the project, which I wanted to be half cookbook and half biography. But as I dug deep into those handwritten journals, I realized I needed help putting things together. For a co-author, I turned to my good friend Cynthia LeJeune Nobles, an editor who is also a history and cookbook writer. Cynthia and I teach cooking classes as a team, too, so asking her to help produce this book was a natural fit.

So, here you have it, a book on the life of master photographer Theodore Fonville Winans as seen through the eyes of his daughter-in-law, his three children, and his close friends. We have included a selection of his photographs, many of which have never appeared in print, and over one hundred of his favorite recipes—outstanding food that nourished us all for so many years. Unless otherwise noted, Fonville wrote all the recipes in this cookbook. Cynthia and I have tested each one, and we have kept the recipe titles as close to the originals as possible (Leg-in-a-Cast Flan—how can you top that?). We also edited Fonville's recipes to a uniform format, but kept some of his inconsistencies, such as variations in the spelling of "ketchup" and "catsup." As with many home cooks, Fonville would often just jot down notes and ingredient lists. Had we included recipes exactly as he wrote them, most would not have been understandable or usable. Since this is a cookbook we hope you'll use, we rearranged his ingredients in order of use and we polished his cooking instructions.

Fonville's recipes are snapshots of mid-twentieth-century cooking, so we did not substitute out the convenience ingredients, such as cans of soup and bouillon, which he seldom calls for anyway. In keeping with that time period, he occasionally adds a touch of MSG, which

you can certainly include or leave out with excellent results. When a recipe called for cooking onions, Fonville used yellow onions. He used red in salads.

One ingredient change we did make is for amounts of pepper; sometimes Fonville made his food blistering hot, so we have altered several of his recommendations for black pepper and cayenne pepper. Other than cutting down on the heat, we have left all the ingredients and techniques as Fonville recorded them. The recipes we chose are dishes he frequently prepared, and are some of his best. These include an array of cocktail recipes, including the best Old Fashioned we've ever had.

A few books featuring Fonville's work have been published. But hopefully these pages will give you a deeper understanding of why his photography is so renowned and what made this creative genius tick. What you are about to read will also shed light on the many reasons why he was loved by so many, and why cooking was one of the major ways he showed his love.

—MELINDA RISCH WINANS

Acknowledgments

Thanks to Chef John Folse, Glenna Uhler, Anne Arbour, Camille Thibodeaux, Ernestine Bridgforth, Ursula Bogan Carmena, Donna Britt, C. J. Fiorella, Leo Honeycutt, Doc Hopkins, Louis Golden, Diane Saye, and Jerry Thompson. To Marjo Easley for testing several recipes. To Lara Phillips for her review and comments. Thanks go also to the Winans family: to Meriget and James Turner, for their editing and stories; to Rena and Bob Winans, for their generosity with the Fonville photos and for answering many questions about each; and to Walker Winans, for his computer expertise and testing and tasting many recipes—you all made this possible.

Fishing off Fort Livingston. [Fonville Estate Collection, courtesy Robert L. Winans]

THE
FONVILLE WINANS
COOKBOOK

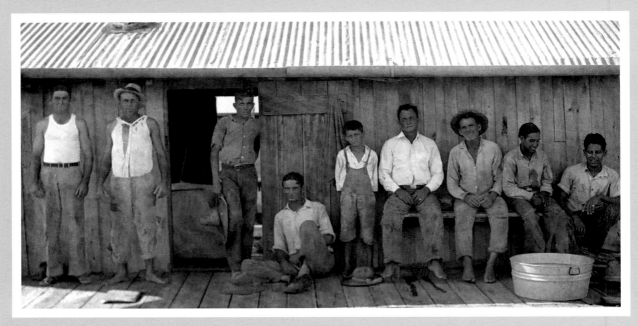

Men in Front of Building, Grand Isle. [Fonville Estate Collection, courtesy Robert L. Winans]

Make-Do Gumbo

I never planned anything in my life and everything came my way by chance. I've been like a leaf that drifted off a tree—for some reason I always drifted in an interesting direction.

—Fonville Winans, at age seventy-nine, to Kristine McKenna of the *Los Angeles Times* (December 2, 1990)

Around 1992, at the end of Theodore Fonville Winans's life, his oldest son, Bob, asked the still-spry photographic genius what he would have done had he not devoted his career to the camera. Without hesitation, Fonville, as everyone had come to call him, declared he would have been a chef. That answer is not surprising. Throughout his eighty-two years, whatever the tall, exotically handsome photographer came in contact with became another possible tool for expressing creativity. To him, food was a particularly exciting artistic medium. The classic and experimental dishes he obsessed over also served another important purpose, which was to bring together his large collection of friends. So he cooked often. In spite of his talent at the stove, however, Fonville never did head up a commercial kitchen. Instead, it was his mastery of photography that made him a legend.

Fonville Winans spent his adult life taking portraits in Baton Rouge, where, aside from making debutantes and brides look good, he was the go-to photographer for Louisiana politicians and corporate executives. Before that, he created his most acclaimed works, the photographs of Louisiana's Depression-era Cajuns, the hardscrabble descendants of the French Acadians banished from Nova Scotia in the 1700s. Through the thousands of photographs he took over the course of his career—of wrinkled, sun-baked faces, of smiling socialites, and of slick-suited CEOs and lawmakers—Fonville ended up chronicling life in midcentury Louisiana. And he did it all in black and white.

Long before he turned professional, Fonville instinctively knew how to paint with light. That talent grew with time, and at the height of his career, and for reasons he never seemed to understand, his work was

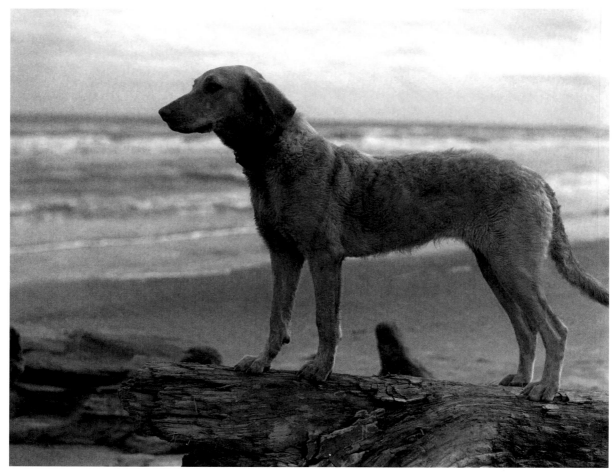

Dog on a Log, Grand Isle, 1930s. (Fonville Estate Collection, courtesy Robert L. Winans)

praised as some of the nation's best. His brilliance won him accolades from nationally recognized peers, as well as recognition from professional organizations such as the Cameracraftsmen of America and the Southwest Professional Photographers Association. From the 1940s to the 1990s, he received approximately fifty merit awards from the prestigious Professional Pho-

tographers of America trade association. Because of his talent and high profile, he was sought out to teach and to give lectures, and he constantly attracted the attention of like-minded artists.

When not behind a camera, Fonville was often in his darkroom or in his workshop inventing gadgets, which were mostly things that made darkroom work

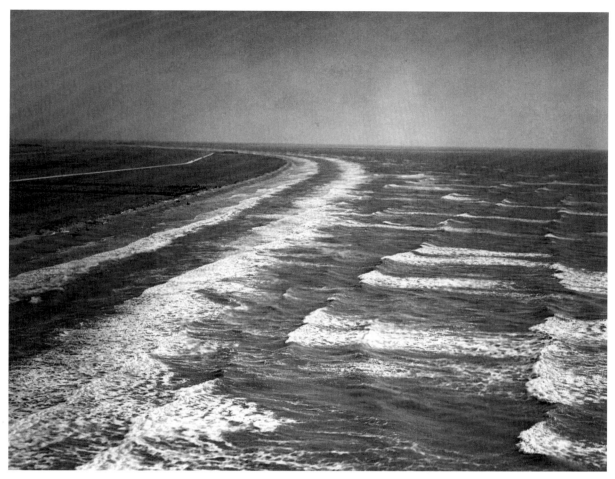

Aerial View of Louisiana's Gulf Coast. [Fonville Estate Collection, courtesy Robert L. Winans]

more efficient. He was an avid bicycle rider. He raised a family, and he often fed them with food he had foraged. Throughout it all, Fonville's path was paved with tenacity and boundless energy. With confidence, and often a wink, those who knew him personally described him as a maverick, an eccentric, a prankster, an entertainer, a ladies' man, a relentless optimist, and, above all, an extraordinary Will Rogers–style genius. He would ignore any recognition, positive or not, with an easygoing shrug. According to him, he had no control over his reputation, skills, and talent; that all came from serendipity.

Hailing from a relatively refined and educated family, Fonville was born August 22, 1911, about 110 miles

northwest of St. Louis in the small city of Mexico, Missouri. His father was Lawrence Lewis Winans, a civil engineer with Dutch ancestry, and a bona fide great-great-great-nephew of President George Washington. His mother, Ruth Fonville, was of French heritage, and she was a homemaker and an accomplished musician who gave her maiden name to her brown-eyed son. Fonville had three sisters: Lelia, Ruth (Ladie Ruth), and Dorothy (Dot).

> *After Sunday school I bought some cubeb** *cigarettes and smoked them. I went to the park and roasted some potatoes and apples.*
>
> —Diary entry by Fonville Winans at age twelve, February 24, 1924
>
> (*The cubeb vine grows in southeast Asia, and its berrylike fruit can be dried and used in cigarettes.)

While Fonville was in eighth grade, the family moved to Fort Worth, Texas, and it was there that he honed his initial interest, playing the saxophone, a skill nurtured by his musically talented mother. In 1902, Ruth was the first and only female graduate of the Missouri Military Academy, a boarding and college preparatory school, where her father, Col. William D. Fonville, was school superintendent from 1901 to 1911. Ruth played the bugle at the academy. Later, she was a music teacher and played trumpet and piano in the Fort Worth Symphony. She also ran the orchestra at the Travis Avenue Baptist Church. At home, she would call her children to dinner by blowing assembly. She also cooked by sound, and could put an ingredient in a glass cup and know the quantity by the reverberation. There is no doubt that "Mama Ruth," as Fonville's children called their grandmother, had a fantastic ear for music.

By the time he enrolled in Fort Worth's Central High School, Fonville was skilled at playing both the saxophone and the clarinet. One day he entered a saxophone-playing contest and beat a schoolmate by the name of Tex Beneke. The "loser" was the same Beneke who went on to play with the Glenn Miller Orchestra, and who eventually achieved international fame as a big-band blues singer.

Music, however, was not Fonville's only competitive interest. During his time in high school, he also participated in pole vaulting. This was the era when vaulters jumped with bamboo poles and landed in sand pits. Using this relatively crude equipment, Fonville would regularly beat his teammate Earle Meadows, who later became co-holder of the world record.

Fonville's engineer father owned a construction company. He was also a tinkerer whose main hobby was weaving fabrics and textiles. Over the years, Lawrence built several looms. As an only son, Fonville was particularly close to his father, and at an early age he exhibited a similar knack for building things.

Fonville's winding road to photographic stardom began in 1930 with the purchase of a watch. After graduating from high school, he earned money by playing music with a dance band at Fort Worth's Wintergarden Ballroom. He quickly saved up thirty dollars, which he plunked down at a jewelry store to buy a wristwatch. On his way home from making the purchase, he spied a 3-A folding Kodak camera in the window of a downtown store. Intrigued, then impassioned, Fonville retraced his steps, returned the watch, and bought the camera. Now broke, the golden-tongued teen convinced the store owner to let him open a charge account for three rolls of film.

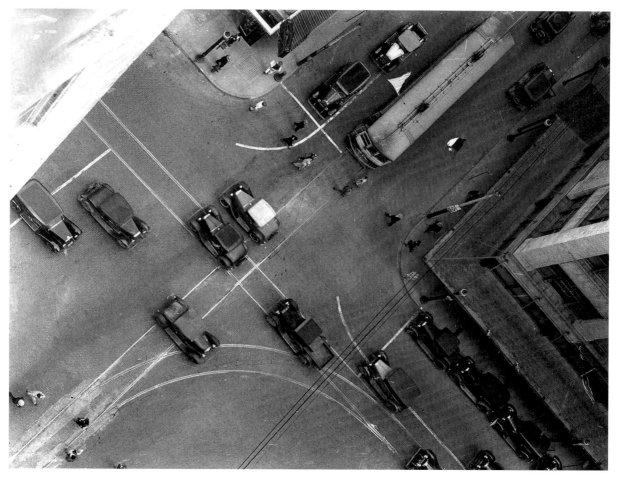

Street Scene, 1930—the photo that won Fonville a prize and launched his career in photography.
(Fonville Estate Collection, courtesy Robert L. Winans)

A few days after his purchase, Fonville took a photo of the intersection of Fort Worth's 7th and Main Streets and entered a contest advertised in the *Fort Worth Star-Telegram.* The competition was sponsored by the Palace Theater, which was publicizing an upcoming movie, *Street Scene,* starring Sylvia Sidney, the spunky Depression-era actress who became famous for appearing in gangster movies. Shocking Fonville and everyone who knew him, he won first place with his photo, also titled *Street Scene.* His prize was fifteen dollars and two movie tickets. From then on, photography became his passion.

*After high school and in between his early trips to Grand Isle,
in addition to playing music, Fonville held jobs as an aerial photographer
for the Texas Flying Service, a tester for the Texas Electric Service
Company, a photographer for the Civil Works Administration,
and a photographer for the* Fort Worth Star-Telegram.

Also after high school, Fonville found time to give in to an adventurous streak, and he and his friend Clyde Carmichael drove a Model T Ford to California. The excursion took almost six months. Along the way, Fonville took photographs and wrote daily letters to his mother.

Fonville's connection with Louisiana started at the beginning of the Great Depression, when his father was building a bridge over a creek in Marble Falls, Texas. A flash flood wiped out the almost-finished project and destroyed all his company's equipment. Lawrence used reserve capital to complete the job, but that left little money for essential family expenses, and virtually nothing for Fonville to attend college. With no construction clients on the horizon and desperate for any kind of work, at one point both Lawrence and Fonville resorted to handing out advertising pamphlets door-to-door.

Lawrence worked hard to build his business back up. The family's fortunes changed for the better in 1931, when he won a contract to build a bridge in the undeveloped swamps of south Louisiana. Twenty-year-old Fonville followed along, and it was there, with his swelling ambition but meager finances, that the young adventurer laid the template for the rest of his life.

No matter how large his bank account ever grew, Fonville never forgot those hard Depression years, and he always pinched his money like it was the year 1930. This frugal mindset followed him into the kitchen, where, regardless of who he was serving, economy dictated the menu.

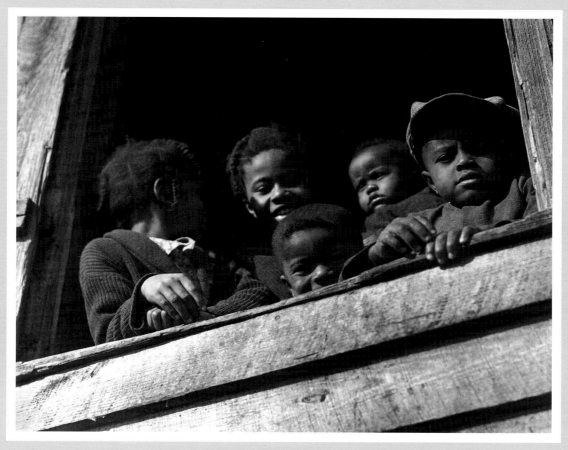

Children in Window, St. Francisville, 1939. (Fonville Estate Collection, courtesy Robert L. Winans)

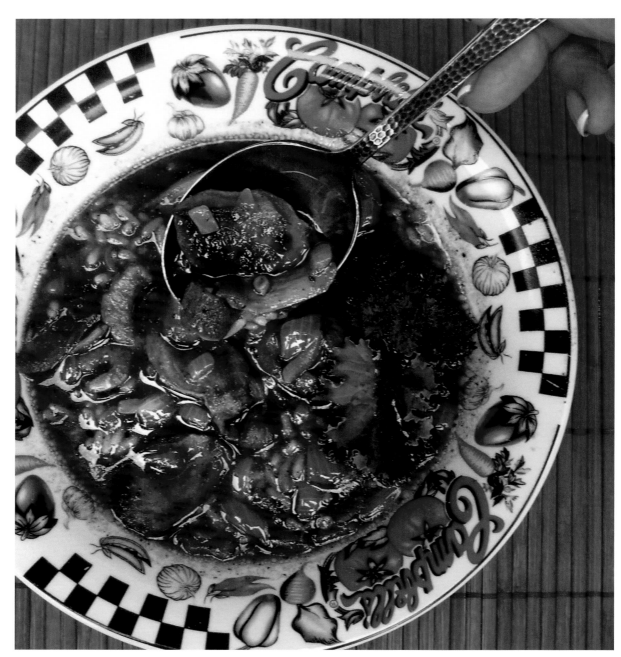

Make-Do Gumbo. (Photo by Cynthia LeJeune Nobles)

MAKE-DO GUMBO
(Chicken, Sausage, Okra, and Filé Gumbo)

Makes 8 servings

Fonville sometimes added a layer of flavor to his roux-based dishes by first blending crushed dry crab boil into the hot roux. Dried crab boil is available all over south Louisiana; however, elsewhere it may be difficult to find. For gumbo, he would "clear," or sauté, the recipe's vegetables in the roux, which sometimes resulted in okra seeds exploding out of the pot and all over the kitchen. He also routinely broke the golden rule of gumbo making, which is to never thicken the dish with both okra and filé.

1. Place chicken in a large pot and cover with water by 1 inch. Bring to a boil and simmer 1 hour. Remove chicken from pot and reserve broth. When chicken is cool enough to handle, remove skin and bones and discard. Chop chicken into 1-inch chunks and set aside.

2. In a large, heavy-bottomed pot set over medium heat, make a roux by stirring together flour and oil and cooking, stirring constantly, until dark brown. Add the crab boil and stir 30 seconds. Add the onion and okra and stir constantly until the onion is translucent, about 2 minutes. Add the sausage and brown lightly.

3. Add enough water to reserved broth to make 2 quarts of liquid. Carefully add to roux mixture and bring to a boil. Stir in dried shrimp, salt, black pepper, celery seed, garlic powder, and cayenne pepper. Simmer on low heat 1 hour.

4. Stir in reserved chopped chicken and filé powder and simmer 10 minutes. Serve in gumbo bowls over rice, with hush puppies and cantaloupe on the side.

2 whole chicken legs (thighs and drumsticks)

Water

½ cup all-purpose flour

⅓ cup vegetable oil

1 tablespoon dry crab boil (found in specialty stores or online), crushed in a mortar and pestle or spice grinder

1 cup chopped onion

1 cup sliced fresh or frozen okra

1 link (8 ounces) hot hickory-smoked pork sausage, cut into ¼-inch slices

1 ounce dried shrimp

1 teaspoon salt

½ teaspoon ground black pepper

½ teaspoon celery seed

½ teaspoon garlic powder

¼ teaspoon cayenne pepper

2 teaspoons filé powder

Hot cooked rice, Hush Puppies (recipe page 13), and chunks of cold cantaloupe for serving

BLACK BEAN SOUP

Makes 4 servings

When Fonville chopped food in a blender, he would say he was "blenderizing" the ingredients.

1. "Blenderize" the black beans and liquid, along with 2 cups of chicken broth.

2. In a 2½-quart pot, cook bacon over medium heat until crisp and brown. Add onion and sauté until tender, about 5 minutes.

3. Stir in bean mixture, bay leaves, half of lime slices, lime juice, garlic powder, cumin, black pepper, cayenne pepper, and salt. Add remaining 2 cups broth and wine. Bring to a boil and lower to a simmer. Cook, uncovered, 20 minutes, stirring occasionally. Soup should be slightly thick. Remove bay leaves and serve hot in individual bowls. Top each with a slice of lime. The cooked lime slices can be left in the dish or removed.

1 (26.5-ounce) can black beans, with liquid

4 cups chicken broth, divided

4 slices bacon, diced

1 medium onion, chopped

3 bay leaves

2 limes, 1 sliced, divided, and 1 juiced

1 teaspoon garlic powder

¼ teaspoon cumin

¼ teaspoon ground black pepper

¼ teaspoon cayenne pepper

⅛ teaspoon salt

¼ cup sauterne wine

JUICY BAKED CHICKEN

Makes 4–6 servings

Fonville often made notes about the size of the chickens he purchased, typically between one and two pounds, the size of a modern Cornish hen. Today, the smallest grocery-store chickens usually weigh at least four pounds. Regardless of your chicken's heft, this recipe makes an incredibly moist bird.

1. Preheat oven to 375°F. Split chicken in half down the breastbone and backbone. Place on a broiling rack, skin side down, and set aside.

2. Make a basting sauce by thoroughly mixing together melted butter, bacon grease, vinegar, mustard, Worcestershire sauce, cayenne pepper, salt, and black pepper.

3. Place chicken on the middle rack of the oven and bake, basting frequently, until the first side is well browned and beginning to turn tender. Turn chicken over and continue baking and basting until brown and fork tender, when the internal temperature of thighs is 165°F, for a total cooking time of about 1 hour. Remove from oven and let sit at least 5 minutes. Serve warm.

1 young broiling chicken

½ cup (1 stick) butter, melted

½ cup bacon grease or vegetable oil

½ cup white vinegar

1 tablespoon dry mustard

1 tablespoon Worcestershire sauce

¼ teaspoon cayenne pepper

Salt and ground black pepper to taste

CHICKEN and SAUSAGE JAMBALAYA

Makes 6–8 servings

1. In a Dutch oven set over medium-high heat, sauté sausage until brown. Add onion, bell pepper, green onions, garlic, and parsley. Lower heat to medium and cook 10 minutes, stirring often.

2. Add water, chicken, tomato paste, salt, black pepper, and cayenne pepper. Simmer, uncovered, 10 minutes.

3. Add rice and bring to a boil. Lower heat to a bare simmer, cover pot, and cook until rice is tender, 20 minutes. Remove from heat and let sit, covered, 5 minutes. Fluff with a fork and serve hot.

1 pound smoked pork sausage, cut in ½-inch slices

1 large onion, chopped

1 green bell pepper, chopped

1 bunch green onions, bottoms and tops, finely chopped

2 cloves garlic, minced

¼ bunch fresh parsley, minced

3 cups water

½ pound cooked chicken, cut in ½-inch dice

3 tablespoons tomato paste

Salt and ground black pepper to taste

Dash of cayenne pepper

2 cups raw long-grain rice

SPARE RIBS and KRAUT

Makes 4 servings

1. Slice pork into individual ribs. Season with salt and pepper. Carefully pour boiling water into the base of a steamer pot until bottom of the insert sits just above water.

2. Place ribs in the top of the steamer. Cover with the sauerkraut. Bring water back to a boil. Reduce to a simmer, cover pot tightly, and steam 2½ hours.

3. Transfer sauerkraut and ribs to separate bowls. Cover sauerkraut and keep warm. Let ribs cool to room temperature. To serve, place room-temperature ribs on a bed of warm sauerkraut and sprinkle lightly with paprika.

1 rack Kansas City–style pork ribs

Salt and ground black pepper

Boiling water for a steamer pot

1 (32-ounce) jar sauerkraut

A sprinkle of paprika

STUFFED EGGPLANT

Makes 4 servings

1. Preheat oven to 375°F. Set a skillet over medium heat and fry half of bacon until crisp. Remove bacon, crumble it, and set aside. Leave grease in skillet.

2. Slice eggplants in half lengthwise and scoop out pulp, leaving a ½-inch margin of pulp on the shells. Coarsely chop the pulp and reserve. Put shells aside, too.

3. To the grease in skillet, add shallots and cook over medium heat 1 minute. Add reserved eggplant pulp, water, garlic, parsley, salt, pepper, and basil and cook, stirring occasionally, until the eggplant flesh is soft, about 5 minutes.

4. Remove mixture from heat and transfer to a bowl. Stir in bread cubes, egg, and reserved cooked bacon. Stuff eggplant shells with mixture. Dust tops with bread crumbs and sprinkle with remaining raw bacon. Bake in a shallow pan until top is brown and bacon is crisp, 25–30 minutes. Serve warm.

4 slices bacon, in ½-inch dice, divided
2 (1-pound) eggplants
4 whole shallots, chopped fine
1 cup water
2 cloves garlic, minced
2 tablespoons minced parsley
1 teaspoon salt
1 teaspoon crushed red pepper, or to taste
1 teaspoon dried basil
6 slices stale bread, cubed
1 large egg, slightly beaten
½ cup bread crumbs

Stuffed Eggplant. [Photo by Cynthia LeJeune Nobles]

SPINACH GREEK STYLE

Makes 6–8 servings

1. Heat oven to 350°F. Butter a 1-quart glass baking dish. Drain spinach in a colander by pressing out the water with the back of a wooden spoon.

2. In a large bowl, beat eggs until frothy. Stir in spinach, feta cheese, green onions, parsley, and dill. Season with salt, black pepper, and cayenne pepper. Pour into prepared dish.

3. Bake until top is brown and bubbly, about 20–25 minutes. Cool 5 minutes before serving.

Butter for greasing the baking dish

2 (10-ounce) packages frozen chopped spinach, thawed

3 large eggs

4 ounces feta cheese, cut into small pieces

½ cup chopped green onions, bottoms and tops

3 tablespoons chopped parsley

⅛ teaspoon dried dill

Salt, ground black pepper, and cayenne pepper to taste

HUSH PUPPIES

Makes 12

1. In a deep fryer or pot, heat 2 inches oil to 350°F. While oil is heating, mix together cornmeal, flour, baking powder, sugar, baking soda, and salt in a bowl. Add remaining ingredients and stir until everything is combined to form a soft dough.

2. Drop by tablespoonsful into hot oil and fry until deep brown, about 2–3 minutes per side. Drain hush puppies on paper towels and serve hot.

Vegetable oil for frying

1½ cups yellow cornmeal

½ cup all-purpose flour

2 teaspoons baking powder

2 teaspoons sugar

1 teaspoon baking soda

1 teaspoon salt

1 cup buttermilk

½ cup minced onion

1 large egg

1 tablespoon butter, melted

1 tablespoon minced parsley

2 teaspoons minced jalapeño pepper

½ teaspoon cayenne pepper

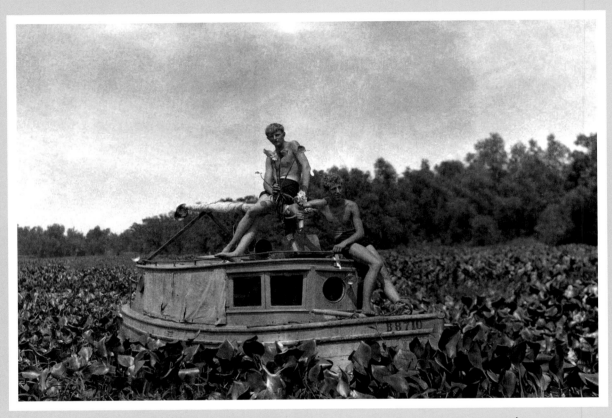

Pintail *among Water Hyacinths*, 1930s. (Fonville Estate Collection, courtesy Robert L. Winans)

Cruising on the *Pintail*

The whole of the country is a jumble of low marshy islands surrounded by shallow lakes and cut to pieces with twining bayous. To the south spreads the gulf in its blue expanse, and to the north stretches Grande Lake, or Barataria Bay. At the base of the lighthouse is a thicket of fruit bearing fig trees.

—Fonville Winans, journal entry describing Grand Terre, Louisiana, June 26, 1932

It's not at all unusual to walk into south Louisiana office buildings and restaurants and find walls decorated with black-and-white prints of Fonville Winans's most important body of work, the "art" photographs he took in the early 1930s on Grand Terre and Grand Isle. The two tiny barrier islands are some eighty miles south of New Orleans on Louisiana's Gulf coast, and at the time Fonville lived there they were a major tourist destination.

The 1931 contract Fonville's penniless father, Lawrence, won in south Louisiana was for building a bridge across Bayou Ramos near Morgan City, some hundred miles west-northwest of Grand Isle. The young Fonville hired on as a carpenter's helper to build forms for the concrete bridge, and he thought the marshy surroundings of Morgan City were fascinating.

Fonville was always looking for new adventures and eventually found his way to the unspoiled beaches and swamps of Grand Isle. When he arrived, Highway 1, which connects Grand Isle to the rest of the state, had not yet been built. The mucky region was dotted with weathered thatched houses, wooden wagons, stubby palmetto palms, bearded cypress trees, and mountains of oyster shells. Wild horses still roamed. Snowy egrets flew and alligators crawled around at will. Fonville saw locals tong for oysters and seine for fish in the Gulf of Mexico, while children combed the beach for crabs. In the marshes, workers gathered moss and trapped muskrat, mink, otter, and raccoon for their pelts. For entertainment, there was two-stepping in rundown bars, or drinking beer, playing cards, and smoking hand-rolled cigarettes.

This was the isolated universe of the Gulf Coast fishermen and trappers, many of them Cajuns without any formal education. Some were descended from Jean

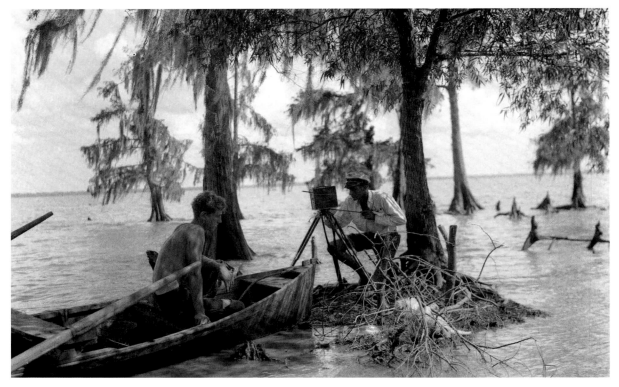

Fonville in Cypress Swamp with Movie Camera, 1930s. [Fonville Estate Collection, courtesy Robert L. Winans]

Lafitte's privateers and pirates, a fact most locals ignored or strongly denied. That had to have frustrated Fonville, whose head had been filled with swashbuckling fantasy after an earlier visit to New Orleans, where he had read Lyle Saxon's popular biography *Lafitte the Pirate.*

Even so, Fonville was immediately captivated by this time-warped world, especially by the island's human population, which survived without electricity, telephones, cars, roads, and many other luxuries. And they spoke almost nothing but French, to boot. To Fonville, this sparse, unadulterated lifestyle was high adventure. He wrote in his journal that it was "my Africa, my South

America," and exploring it was a siren call he could not ignore.

One day, while visiting Morgan City, he stumbled upon the *Pintail,* a tiny, leaky boat with no clutch and no reverse. Preparing to return for a short while to Texas, he vowed to make the vessel his. On his next trip back to Louisiana, later in 1931, he bought the boat from a J. B. Hebert for twenty-five dollars.

Back in Texas, he recruited a crew, fellow entrepreneurs Bob Owen (first mate) and Don Horridge (second mate). Intent on making a blockbuster movie about Grand Isle, they all gave up working regular jobs, and Owen

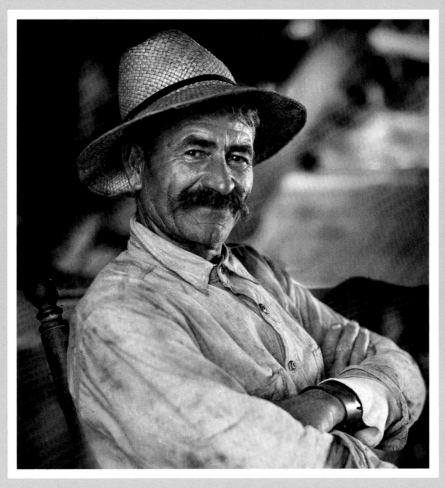

Tony Kristicevich, 1938. Kristicevich was one of Fonville's favorite photo subjects on Grand Isle. (Fonville Estate Collection, courtesy Robert L. Winans)

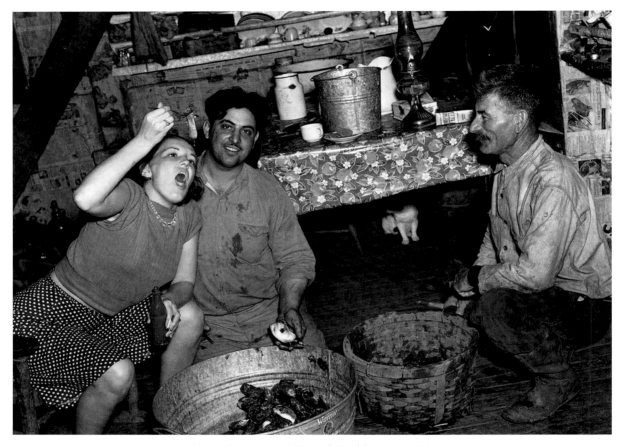

Helen Eating Oysters at Tony Kristicevich's Camp, 1930s.
(T. Fonville Winans Collection, Louisiana State Museum Historical Center)

and Horridge each chipped in fifty dollars to help pay living expenses. The trio equipped themselves with still cameras and a hand-cranked 16mm movie camera, captain's hats, and shirts embroidered with the word "Pintail." In June 1932, they drove Fonville's creaky Model T Ford to Morgan City, where they scraped and painted the *Pintail*'s hull and fitted it with the battery from his Ford. When that battery died, they bought a Star engine from a wrecked automobile, for which they paid ten dollars.

The crew of the *Pintail* immediately snaked their way through the state's "enchanting" marshes, the whole while documenting the "fascinating" waterways, as well as the habits of isolated pockets of Cajuns. Throughout it all, Fonville kept detailed diaries. A journal he wrote during the summers of 1932 and 1934 was eventually published as the book *Cruise of the Pintail* (LSU Press, 2011). In this volume, the then-amateur photographer's words and photos paint the picture of a fortune seeker

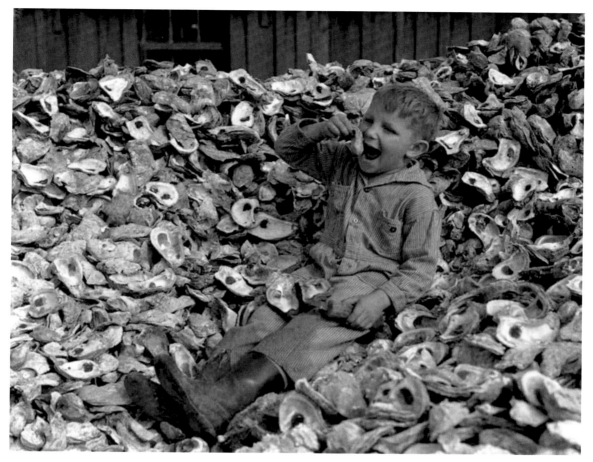

Oyster Boy, Grand Isle, 1930s. (Fonville Estate Collection, courtesy Robert L. Winans)

who weathers a multitude of challenging storms. Bayou routes were often blocked by water hyacinth. The *Pintail* constantly leaked. He was especially obsessed with the nuisance of "blood-thirsty" mosquitoes. (During his childhood, Fonville contracted malaria and had been treated homeopathically at the home of his grandfather, Theodore Winans.)

On the social front, Fonville's natural charm helped him fit in nicely with what he called the "natives." In spite of his obvious status as an outsider, he was invited to dances, played cards, dated young ladies, and drank with anyone who offered a beer. He was also a guest at weddings and in private homes. By the end of his few years on the Gulf Coast, he had made lasting friendships with both "rip-roaring pleasure seek[ing]" tourists and the "ever quiet and watchful" fishermen, such as Tony Kristicevich and Warren Chighizola, both of whom were subjects of some of Fonville's most famous photos.

Chighizola's Shack, Grand Isle, 1933. [Fonville Estate Collection, courtesy Robert L. Winans]

GETTING BY

Perhaps Fonville's most famous photograph of this era is of an oyster shucker named Joseph Visier Boudreaux, who is perched on top of a mountain of oyster shells. Titled *The Oysterman,* the image was captured the morning of August 23, 1934, the day after Boudreaux and his wife, Geolina Chighizola, celebrated their fiftieth wedding anniversary. At the time, Fonville was at Grand Isle camp-sitting for Alfred Danziger, private attorney and "wingman" to none other than Governor Huey Long.

When he became a professional portrait photographer, Fonville took spectacular photographs with only one shot. He credited that skill to his younger days on Grand Isle, where film was hard to come by.

Danziger, who lived in New Orleans, owned a large chunk of the island and was determined to make it a tourist destination. He also owned a vacation house on Grand Isle that he named "The Place," and it was there that Governor Long would hide out and cut loose.

The broke but ambitious Fonville had naturally made a point to meet Danziger, and the two quickly formed a strong friendship. Danziger became such a close buddy that the attorney let Fonville use his basement for a darkroom. (This was a big step up from the makeshift darkrooms Fonville had previously constructed in the cabin of the *Pintail* and in the basement of Grand Isle's Oleander Hotel.) In time, Danziger was so taken with the young photographer's skill that he even sent several of his photos to the *New York Times,* which published a few.

Fonville submitted several Grand Isle stories and photos to his old employer, the *Fort Worth Star-Telegram,* which gave him some professional notoriety but little pay. Often, he made postcards of whomever he ran into and sold them to his subject. And although he also caught and sold a fair amount of seafood, money was extremely tight, and sometimes nonexistent.

This lack of funds made things interesting at the table. Coffee was often drunk without sugar or cream. Sometimes dinner was only bread and water or pancakes, which might be made without eggs. At least once, hunger forced the threesome to raid a fisherman's oyster bed.

In spite of his often bare pantry on Grand Isle, Fonville's diaries show that he had a strong appreciation for good food. Cooking was done by campfire or on a generator-run gasoline stove in the cabin of his tiny boat. When he could scrape together the money, he bought steaks and sausage, or "fried a heap of pork chops and made a skillet full of brown gravy." Seafood, of course, was often on the menu, and the three explorers would feast on meals of fried oysters, fried speckled trout, boiled crabs, crab gumbo, and crab gravy, along with an array of shrimp dishes.

MOVIE TIME

During the summer of 1932, Fonville and his companions went back home to Texas, where he cobbled together a film he titled *The Cruise of the Pintail.* The choppy black-and-white reel showed the friends banging through Louisiana marshes in their ramshackle boat and visiting coastal villages.

In Fort Worth and Dallas, Fonville worked out a deal with the school system to charge ten cents per student to view his twenty-six-minute movie, with the schools receiving half the profits. As a bonus, the children were also able to watch Fonville handle four live baby alligators.

While in Louisiana, he had lured the reptiles in by bellowing out his version of an alligator mating call. When not showing them off to Texas schoolchildren, he housed the alligators at the local zoo.

The movie and the alligators were extremely popular, but Fonville's enterprise was short-lived. Apparently, children were spending lunch money on the offhand entertainment, and angry parents soon put an end to the venture.

DEEP IMPRESSIONS

Fonville went back to Louisiana in 1933. He went again in 1934, the year he abandoned the battered *Pintail*. Afterwards, returning to Fort Worth, he put together another film, *Pintail Adventure*.

In the end, neither of the two films made him a fortune. But the time Fonville Winans spent on his excursions helped crystallize his future vocation, which would be to photograph honest facial expressions. And for the rest of his life he also took pleasure cruising on boats, wading through swamp muck to find the perfect cypress tree, watching fishermen tong for oysters, and belting out the alligator mating call.

It was also during this era of wonder and challenge that Fonville was introduced to what he labeled his "favorite cuisine," Cajun. In Gulf waters, he had learned how to catch the seafood important to so many Cajun dishes. Onshore, the Cajuns he befriended taught him how to make roux and how to season with a relatively heavy hand. Over the years he ended up creating a multitude of signature gumbos and jambalayas, as well as crab and oyster dishes. And although he certainly explored other cuisines from time to time, this man from Texas always thought of home cooking as something that was Cajun, the style of preparing food he adopted while he was on Grand Isle.

Catch of Redfish, Grand Isle, 1930s. (Fonville Estate Collection, courtesy Robert L. Winans)

Pintail Crab Stew. (Photo by Cynthia LeJeune Nobles)

PINTAIL CRAB STEW

Makes 6 servings

According to a note Fonville wrote on this recipe in 1969, he created Pintail Crab Stew while docked at Grand Isle's Coast Guard landing during the days he was cruising with his buddies on the Pintail. Apparently, he and his crew had this stew so often it was dubbed the "specialty of the house." He also commented: "I think a dash of MSG is in order. We had no such thing on the boat." This is what he wrote about the dish in his diary on June 22, 1933: "This morning we arose early and caught a mess of sea crabs, which I prepared for breakfast. My method of cooking them is very acceptable to our palates: first, the crabs are boiled alive, and the delicate, sweet meat is picked out. Then I prepare a brown gravy with onions, a dash of salt, pepper, hot sauce, and catsup. Into this I pour and mix the crabmeat and allow to simmer for a few moments. And this dish is really good."

½ cup all-purpose flour

¼ cup bacon grease or vegetable oil

1 cup minced onion

3 cups water

¼ cup catsup

1½ teaspoons salt

½ teaspoon dried red pepper flakes

Sprinkle of garlic powder

Sprinkle of ground black pepper

1 pound crabmeat

Hot cooked brown rice and Louisiana hot sauce for serving

1. To make a roux, set a large, heavy saucepan over a medium flame and add flour and grease. Stir constantly until the roux is medium brown, about 5 minutes.

2. Add the onion and cook 2 minutes, stirring constantly. Add water, catsup, salt, red pepper flakes, garlic powder, and black pepper. Lower heat to a simmer and cook 3 minutes. Carefully stir in crabmeat and cook until it's heated through, about 2 minutes.

3. Serve hot over rice and topped with a couple dashes of hot sauce.

Original Pintail Crab Stew recipe.
[Courtesy Walker Winans]

CRAWFISH ÉTOUFFÉE

Makes 6–8 servings

Like so many southern cooks of his time, Fonville kept a metal container near the stove to store bacon grease, which he used in just about any savory recipe that called for oil.

1. Heat bacon grease and butter in a large skillet set over medium-high heat. Sauté celery, onion, bell pepper, and green onions until onion is golden, about 7 minutes.

2. Add crawfish and fat. Lower heat to medium and cook, stirring occasionally, 10 minutes.

3. Add crab boil and bring to a boil. Cook 1 minute. Stir broth and cornstarch together in a cup and stir into crawfish mixture to thicken. Lower heat and simmer 2 minutes.

4. Serve étouffée hot over rice and garnish with parsley and green onions.

1 teaspoon bacon grease or vegetable oil

1 teaspoon butter

2 ribs celery, chopped

1 small onion, chopped

1 bell pepper, chopped

½ bunch green onions, bottoms and tops, chopped, plus additional for garnish

1 pound Louisiana crawfish tails and fat

1 teaspoon dry crab boil (found in specialty stores or online), crushed in a mortar and pestle or spice grinder

½ cup chicken broth

2 tablespoons cornstarch

Hot cooked long-grain rice for serving

Chopped parsley for garnish

Crawfish Étouffée. (Photo by Cynthia LeJeune Nobles)

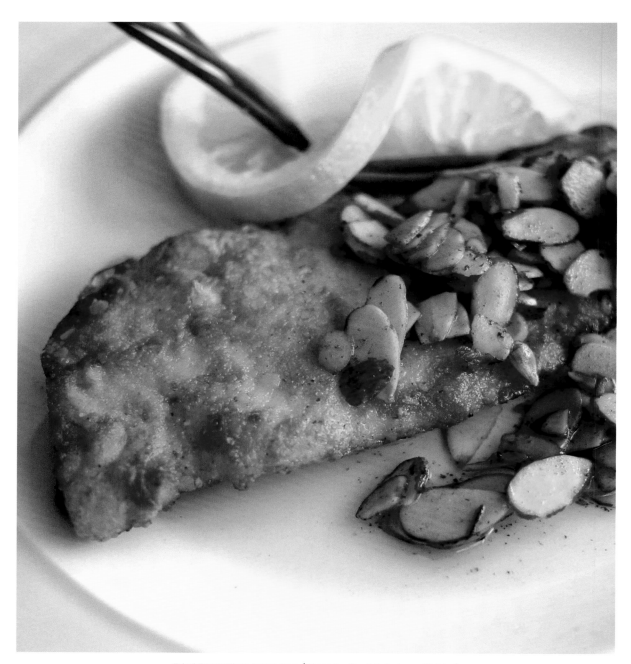

Fried Trout Filets Amandine. (Photo by Cynthia LeJeune Nobles)

FRIED TROUT FILETS AMANDINE

Makes 4 servings

Fonville recorded this recipe in the 1970s, but his writings reveal that he had dined on trout many times in his younger days on Grand Isle:

So it was fried trout for supper. We had finally moved back inland to fish, where the trout had just begun to strike, and loaded our sack. Fish! Fish! Fish! I fear I ate so much that I'll suffer a twinge of conscience next time I look one in the face.
 —Fonville diary entry, Friday, August 24, 1934

1. In a shallow bowl, beat the eggs and milk with a fork until well combined. In another shallow bowl, combine cracker meal, flour, ¼ teaspoon salt, and ¼ teaspoon black pepper.

2. Lightly sprinkle the trout with salt and black pepper. Dip into the milk mixture and then into the flour mixture. Set aside.

3. In a large skillet, heat ¼ inch oil over medium-high heat. When oil is hot, add the filets and fry on each side until brown, about 6 minutes total. Remove to a plate and keep warm.

4. Remove the oil from the skillet and add the butter. Melt over medium heat until butter just starts to turn brown. Add the almond slivers and cook 1 minute. Stir in the lemon juice, bring to a fast boil, and remove from heat.

5. Serve the almond sauce over the fish and garnish with chives.

2 large eggs

¼ cup milk

1 cup cracker meal

½ cup all-purpose flour

Salt and ground black pepper

4 (6-ounce) speckled trout fillets

Vegetable oil for cooking

½ cup (1 stick) butter

½ cup almond slivers

2 tablespoons freshly squeezed lemon juice

Fresh chives for garnish

DRY SHRIMP GUMBO

Makes 4–6 servings

Dried shrimp are intensely salty, yet sweet. Gumbo made with them is a Cajun favorite, and Fonville made an excellent version. Filé is ground sassafras root and is commonly added to south Louisiana gumbos. (Note from Fonville: "Onion tops better than parsley.")

1. In a 3-quart, heavy-bottomed saucepan set over medium heat, make a roux by combining flour and oil and cooking, stirring constantly, until medium brown, the color of a pecan, about 7–8 minutes.

2. Add onion, shrimp, and garlic and stir constantly with a long-handled wooden spoon until onion is softened, about 3 minutes.

3. Add water and chicken broth and stir until mixture is smooth. Add crab boil, salt, black pepper, cayenne pepper, and bitters. Simmer 20 minutes.

4. Right before serving, stir filé into gumbo to thicken. Simmer only 1 minute. Serve in individual bowls over rice and garnish with green onion tops.

¼ cup all-purpose flour

¼ cup vegetable oil

½ cup finely diced yellow onion

⅓ cup dried shrimp

½ teaspoon finely minced garlic

2 cups water

1 (14.5-ounce) can low-sodium chicken broth

1 tablespoon dry crab boil, or to taste (found in specialty stores or online), crushed in a mortar and pestle or spice grinder

½ teaspoon salt

¼ teaspoon ground black pepper

Cayenne pepper to taste

Dash of bitters (Fonville used Angostura brand)

Filé powder (found in specialty stores or online)

Hot cooked rice for serving

Finely chopped green onion tops for garnish

SHRIMP FRICASSEE

Makes 4 servings

1. In a large saucepan, bring the water, lemons, and crab boil to a boil. Reduce heat and simmer 15 minutes. Add shrimp and bring to a boil. Reduce heat and simmer 3 minutes. Drain and save ⅔ cup stock and lemon slices. Peel shrimp and discard shells.

2. In an iron skillet set over medium heat, make a roux by combining flour and oil and cooking, stirring constantly, until mixture turns dark brown, about 7 minutes. Add onion, garlic, salt, black pepper, sugar, thyme, and cayenne pepper to the roux and cook slowly, stirring frequently, until the onions are very soft, about 7 minutes.

3. Stir in reserved stock with lemon slices and simmer 10 minutes. Add shrimp and bring back to a simmer. Cook 2 minutes. Spoon over a bed of rice. Mix parsley and chives together and sprinkle on top. Serve hot.

2 cups water

2 lemons, sliced thin

1 teaspoon dry crab boil, or to taste (found in specialty stores or online), crushed in a mortar and pestle or spice grinder

20 ounces frozen unpeeled shrimp or 1½ pounds headless unpeeled fresh shrimp

½ cup all-purpose flour

⅓ cup vegetable oil

1 cup diced yellow onion

3 cloves garlic, minced

1 teaspoon salt

½ teaspoon ground black pepper

¼ teaspoon sugar

⅛ teaspoon dried thyme, or ¼ teaspoon fresh

Pinch of cayenne pepper

⅔ cup shrimp or seafood stock (reserved from boiling shrimp)

Hot cooked rice for serving

Minced parsley and chives for garnish

TONY KRISTICEVICH'S
OYSTER SPAGHETTI

Makes 4 servings

Fonville never forgot the friends he made on Grand Isle. Even after he became a sought-after portrait photographer in Baton Rouge, he would take time to drive his wife, Helen, down to the coast for visits. The couple was often the dinner guests of Tony Kristicevich, who liked to serve his special creation of oysters in red sauce over spaghetti. This recipe is adapted from Kristicevich's original recipe and is reproduced here courtesy of his son-in-law, New Orleans restaurateur C. J. Fiorella.

2 tablespoons bacon grease or vegetable oil

1 large onion, chopped

3 cloves garlic, minced

½ pound pickled pork, cut into ½-inch pieces*

1 (6-ounce) can tomato paste

1 (8-ounce) can tomato sauce

Ground black pepper to taste

2 dozen freshly shucked oysters, drained well, reserving their liquid

1 (1-pound) package cooked no. 4 spaghetti, for serving

1. Heat bacon grease in a large saucepan set over a medium flame. Add onion and sauté until brown, about 7 minutes. Add garlic and sauté 30 seconds. Set heat to medium-low and add pickled pork. Cook, stirring occasionally, until meat is tender, about 15–20 minutes.

2. Add tomato paste (save the can) and cook until browned slightly or absorbed into the onions. Add tomato sauce and black pepper and continue to cook until the sauce changes to a darker shade of red, about 10 minutes.

3. Fill the tomato paste can twice with the reserved oyster water, rinsing out whatever paste is left in the can and pouring into the sauce. Cook until the sauce has reduced and thickened, about 30 minutes. Add any remaining oyster water and let it reduce until very thick. (Remember, when the oysters are added they will release a lot of water.)

4. Add the oysters and cook until they have reduced in size and become slightly firm, about 3 minutes. Don't overcook; they cook fast. Pour the sauce over cooked pasta and serve immediately.

*Pickled pork, also known as "pickle meat," is salted, spiced pork butt or rib ends. Before the days of refrigeration, it was a staple in south Louisiana kitchens.

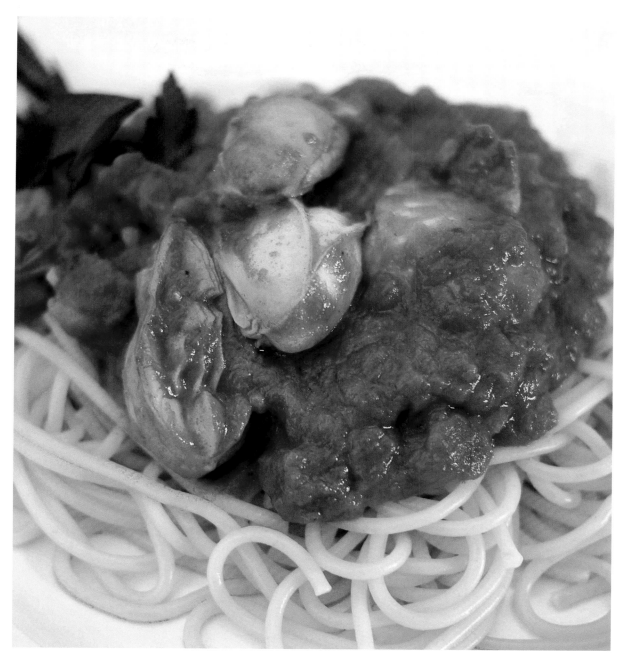

Tony Kristicevich's Oyster Spaghetti. (Photo by Cynthia LeJeune Nobles)

PANCAKES À LA FONVILLE

Makes 6–8 (4-inch) cakes

Fonville's Grand Isle–era diaries reveal that plain pancakes were often all he and his crew had for a day's breakfast, lunch, and dinner. It wasn't until 1974, however, that he created this unusual recipe, which is a cross between a pancake and a corn muffin.

1. In a medium bowl, mix together grits, cornmeal, flour, and baking powder. In a separate bowl, whisk together milk, egg, 1 tablespoon bacon grease, and sugar.

2. Heat a griddle or skillet over medium-high heat and add remaining tablespoon bacon grease.

3. Add wet ingredients to dry ingredients and stir just until combined. For each pancake, pour ¼ cup batter onto the hot skillet and cook until the surface is full of bubbles. Flip pancakes over and cook 1 more minute. Remove to plate and keep warm. Serve hot with butter and syrup.

⅓ cup regular grits

⅓ cup white cornmeal

⅓ cup all-purpose flour

2 teaspoons baking powder

1¼ cups whole milk

1 large egg

2 tablespoons bacon grease or melted butter, divided

1 tablespoon sugar

Butter and syrup for serving

Today being the 22nd, outside of being my birthday, is the 50th anniversary of the old Boudreaux couple. Golden wedding! Tonight the ceremonies were to be at the church and, as a sequel to the occasion, their granddaughter was getting married. Being one of the most powerful and oldest families on the island, all of the natives were ramping about in festive spirit. Liquor flowed freely everywhere. To refuse was to insult. So we, too, celebrated and insulted no one.

—Fonville diary entry, Grand Isle, August 22, 1934

BOURBON ON THE ROCKS

Makes 1 drink

Twist of lemon peel

Crushed ice

1 jigger Tom Moore bourbon

Dash of water

Rub rim of an old fashioned glass with lemon peel. To the glass, add lemon peel and enough crushed ice to fill halfway. Pour in bourbon and water. Stir well and serve.

Honing Skills at Louisiana State University

Wednesday, September 12: . . . Arrived in Baton Rouge at 10:30 a.m. and boarded a streetcar for the university. Arrive there in a daze, a total stranger in a strange place.

—Fonville Winans diary entry, 1934

At the age of twenty-five and with no foreseeable job opportunities, Fonville Winans decided to take on the adventure of moving to Baton Rouge and enrolling at Louisiana State University, a place more foreign to him than any alligator-infested swamp.

The idea to go to LSU came from Duyane (Buck) Norman, an LSU student who had done advertising on Grand Isle for attorney Alfred Danziger. Norman had spent most of one summer with Fonville at Danziger's camp. During that time, he convinced Fonville to enroll by stressing that Governor Long had established generous educational scholarships. He also emphasized that LSU was particularly interested in bolstering its music programs, which played right into Fonville's saxophone and clarinet talents.

With only ten dollars in his pocket, the potential student first had to apply for a working scholarship. After that, Fonville hopped a bus to New Orleans to finagle a letter of recommendation to LSU president James M. Smith from Danziger. The busy attorney directed Fonville to write his own letter, and Danziger agreed to sign it. Fonville happily obliged and wrote a glowing reference. Three days later, he met with Smith, who gave him a job doing photography for the 1934–35 school year. The work paid twenty dollars a month, the maximum for a freshman.

The enthusiastic student took classes in English, Spanish, and speech, and he majored in journalism. Music was his main extracurricular activity. Borrowing a school saxophone, he signed on with the marching

LSU Pentagon Barracks. (Fonville Estate Collection, courtesy Robert L. Winans)

band and received a twenty-dollar-a-year scholarship. The grant also provided a band uniform and a room in the Pentagon Barracks, the complex of buildings near the State Capitol, and the original site of Louisiana State University.

As a student, Fonville ended up living many places. One was at a Mrs. Gianelloni's boardinghouse on Chimes Street, where he paid for room and board by waiting tables, doing yard work, and hauling hay. He also lived in the west wing of the LSU football stadium, in the LSU military barracks by the Greek Theater, and on both

Penalvert and Royal Streets in the downtown district known as Beauregard Town.

Early on, Fonville grew disenchanted with the band's long, hot hours of marching drills, and he was not at all looking forward to taking the group's required military course. One day he ran into A. M. Culpepper, director of LSU's brass choir, and the two discussed other possibilities. Soon after, Fonville resigned from the marching band and signed up with the brass choir to play tenor horn. This opportunity gave him a $100 scholarship. He also opted to play in the cafeteria orchestra, which

Fonville, *seated far right,* in the LSU Orchestra, 1935.
(T. Fonville Winans Collection, Louisiana State Museum Historical Center)

earned him free meals. To make even more money, Fonville joined Culpepper's Louisiana Kings dance band, and he played both sax and clarinet, mostly at private parties at Baton Rouge's Westdale Country Club.

At the LSU portrait studio in Foster Hall, Fonville took photos for the *Reveille* school newspaper and the *Gumbo* yearbook. His darkroom was housed in the basement of the Music and Dramatic Arts building. Ever the polished talker, Fonville had convinced Alfred Danziger to donate a projector. Also, President Smith gave him $200 to buy a 16mm camera to start what he called the "Campus News Reel," a film chronicle of daily life at LSU.

Fonville was assigned to take photographs of the university's budding opera stars and the marching band. His photos and films of everyday LSU life included foot-age on lab animals, tennis matches, and a rain-soaked football game against Georgia in Athens. Importantly, he took film clips of Governor Huey Long. Long, who was determined to modernize the campus with a $9 million expansion budget, was spending a lot of time at LSU overseeing projects, and he was highly visible. Each month, Fonville showed his filmography to students in the theater of the Music and Dramatic Arts building.

Campus life took a sharp turn when a tall, blue-eyed brunette Fonville had casually known at his high school came up one day and asked if he was from Fort Worth. Helen Collins, of Irish and English ancestry, was the daughter of Ralph "Bob" Collins, a water meter salesman who was also a concert pianist and had performed in vaudeville. Her mother, Edna "Noni" Walker Collins, had actually married Bob during a vaudeville performance.

"The Educated Vegetable Man," Porter (Eddie) Bryant, outside LSU Stadium.
(Fonville Estate Collection, courtesy Robert L. Winans)

Fonville and Helen Collins were married in May,
when sweet peas were in bloom. For every anniversary,
Fonville gave his bride a bouquet of sweet peas.

Helen's striking beauty captivated the young Fonville, and a year after they reconnected, on May 5, 1936, the two were married in Fort Worth.

Even with scholarships, the newlyweds could not afford to stay enrolled at LSU. The same year they married, they dropped out of college, returned to Fort Worth, and moved into the Winans house, where Fonville set up a

Girls on Fence. [Fonville Estate Collection, courtesy Robert L. Winans]

studio and unsuccessfully tried his hand at commercial portrait photography. With little money coming in, the couple moved to Kansas City. There, Fonville took a job with a chicken hatchery catalog edited by his uncle. Fonville's duty was to take photos of the flocks. His biggest challenge was convincing the chickens to quit pecking for corn and raise their heads on cue. He solved that problem by first setting up his camera and then firing a cap gun. The curious heads would shoot up and Fonville would quickly snap the picture.

Working with chickens, however, proved uninteresting, and Fonville soon longed to go back to photographing humans. After two years of marriage and little promise of significant work in Texas, he and Helen moved back to Baton Rouge, where they had made lasting friendships at LSU.

Fonville and Helen courting on the Mississippi River levee near LSU, 1935.
(Fonville Estate Collection, courtesy Robert L. Winans)

FONVILLE'S CORN CHOWDER

Makes 6–8 servings

This recipe has no potatoes or seafood, so it is probably not considered a true chowder. Yet, it's an easy, tasty dish that revolves around canned soup and canned corn, ingredients commonly used in Fonville's day.

1. Melt butter in a large saucepan set over medium heat. Add onion and cook until lightly brown, about 5 minutes.

2. Stir in milk, corn, mushroom soup, salt, and pepper. Bring to a boil and lower heat to a simmer. Cook, stirring occasionally, 10 minutes. Serve hot garnished with bacon.

1½ tablespoons butter

½ cup chopped onion

4 cups milk

1 (15-ounce) can cream-style corn

1 (10¾-ounce) can cream of mushroom soup

Salt and pepper to taste

3 slices bacon, crisped and crumbled, for garnish

PICKLED OKRA

Makes 1 pint

Note from Fonville: "Fat okra not good for pickling."

1. Bring 2 quarts of water to a boil. Add okra and boil 2 minutes. Drain and arrange okra in a sterilized pint jar, with tapered tips up. Add garlic, hot pepper, salt, sugar, peppercorns, and alum. Set aside.

2. In a saucepan, bring one cup water and crab boil to a boil. Add vinegar and bring to a boil again.

3. Pour hot liquid over okra, making sure it is completely covered. Screw on cap and cool completely at room temperature. Okra can be served immediately or stored in the refrigerator up to 2 weeks.

Water

8 or more small okra (enough to fill a pint jar)

1 whole clove garlic, peeled

1 Mexican hot pepper, such as jalapeño

1 scant teaspoon salt

½ teaspoon sugar

¼ teaspoon black peppercorns

Small lump alum

1 teaspoon dry crab boil (found in specialty stores or online)

1 cup white vinegar

HELEN'S SUPER SALAD

Makes 6–8 servings

Fonville referred to Helen as a "super salad maker."

Combine all salad ingredients and top with Helen's Italian Salad Dressing. Serve chilled.

6-cup mix of endive and butter crunch lettuce

¼ medium head iceberg lettuce, chopped

4 radishes, thinly sliced

2 large tomatoes, peeled and chopped

1 large cucumber, unpeeled and cut into thin slices

1 large green onion, chopped

1 cup whole, pitted black olives

1 (6.5-ounce) jar artichoke hearts, drained and chopped

¼ cup crumbled bacon

¼ cup grated Parmesan cheese

Helen's Italian Salad Dressing (*recipe follows*)

HELEN'S ITALIAN SALAD DRESSING

Makes 2¾ cups

1. Combine all ingredients in a quart jar with a tight-fitting lid and shake vigorously. Refrigerate at least 2 hours.

2. Strain the dressing to remove the onion and garlic. Return strained dressing to jar. Shake well before serving. Can be made 1 day ahead and refrigerated.

1 cup salad (vegetable) oil

1 cup red wine vinegar

1 cup ketchup

½ cup finely chopped onion

¼ cup sugar

1 clove garlic, finely minced

2 teaspoons salt

1 teaspoon dry mustard

1 teaspoon paprika

1 teaspoon dried oregano, finely chopped

SAUSAGE and RICE À LA HELEN

Makes 4 entrée servings

1. Brown sausage in a large skillet set over medium-high heat. Remove sausage and drain off all but 1 tablespoon fat.

2. Set the same skillet over a low flame and cook onion, celery, bell pepper, and parsley until vegetables are wilted but not brown, about 3 minutes. Remove skillet from fire.

3. Add browned sausage, along with rice, water, green onions, butter, salt, black pepper, and cayenne pepper. Spoon mixture into top of a stovetop rice cooker. (You can also use an electric rice cooker with an additional ¼ cup water, or use a tightly covered saucepan with an additional ½ cup water and cook over low heat.) Bring to a boil and cook until rice is tender, about 40 minutes. Toss with a fork and serve hot.

½ pound smoked pork sausage, cut into ¼-inch slices

1 small yellow onion, chopped

1 stalk celery, chopped

½ red or green bell pepper, chopped

2 tablespoons dried parsley, or ¼ cup chopped fresh

1 cup raw long-grain rice

1 cup water

¼ cup minced green onions, bottoms and tops

1 tablespoon butter

1 teaspoon salt

¼ teaspoon ground black pepper

Pinch of cayenne pepper

Sausage and Rice à la Helen.
[Photo by Walker Winans]

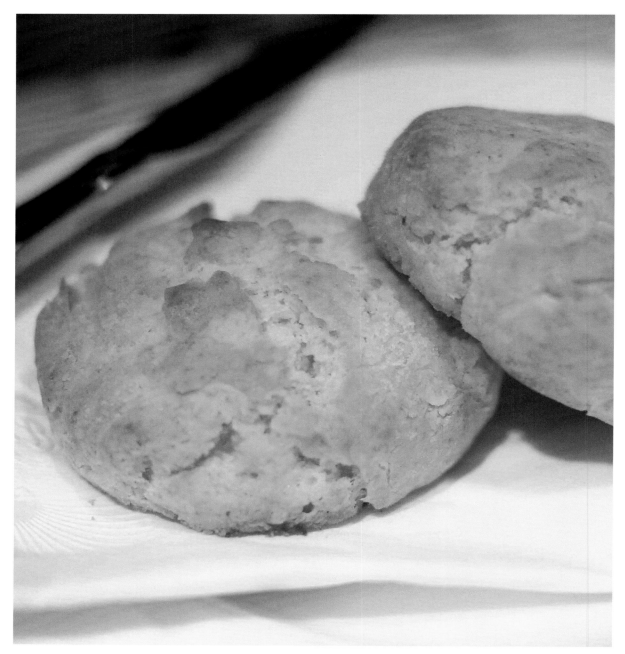

Drop Biscuits for Two. (Photo by Cynthia LeJeune Nobles)

DROP BISCUITS for Two

Makes 2 large biscuits

Note from Fonville: "This morning I put blueberry pie filling between 2 layers of the dough—M-m-m-m good (with strong drip Sanka)!"

⅓ cup all-purpose flour, unsifted
½ teaspoon baking powder
¼ teaspoon salt
1 tablespoon lard or cold butter
2–3 tablespoons whole milk

1. Preheat oven to 400°F. In a bowl, combine flour, baking powder, and salt. Add lard and combine with your fingers until mixture resembles coarse meal.
2. Stir in enough milk to make a stiff dough. Divide into two pieces and use a spoon to spread each piece onto greased foil to form two 2-inch biscuits.
3. Bake until tops are golden brown, about 12–14 minutes. Serve hot.

BOURBON TODDY

Makes 1 drink

Dissolve the sugar in the water in an old fashioned glass. Add bourbon, ice, and nutmeg. Serve with a teaspoon in the glass (in case the drink needs more stirring). For a hot toddy, leave out the ice and add 2 tablespoons hot water.

1 cube sugar
3 teaspoons water
1 jigger bourbon
1 cube ice
Dash nutmeg

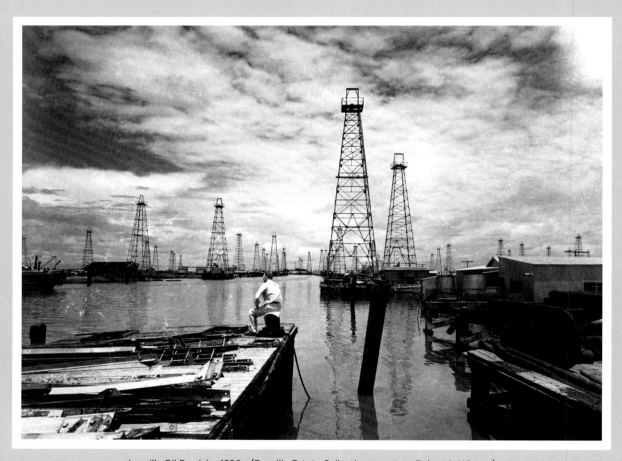

Leeville Oil Derricks, 1930s. (Fonville Estate Collection, courtesy Robert L. Winans)

CHAPTER 4
Airplanes, Big Shots, and a Studio

Make it snappy, kid!

—Huey Long to Fonville Winans, who was taking a photograph of the governor and LSU president James Smith
on the steps of the State Capitol in 1934 (as told by political historian Leo Honeycutt)

It was 1938, and the photos of south Louisiana's swamp life Fonville had taken in the early 1930s were stashed away and not expected to ever amount to much. The budding photographer hadn't finished college, and the national unemployment rate was at 19 percent. To pay the bills, he and Helen moved to Baton Rouge, where, as a student at LSU, he had made valuable political connections.

One of his Louisiana contacts was someone who had lent him a hand many times, attorney Alfred Danziger. And it was through Danziger that Fonville secured a job as a photographer for the Louisiana Highway Commission. This position led to Governor Richard W. Leche appointing him as Louisiana's state photographer.

Fonville's official duties included taking photos of roads and bridges, along with hospitals and other buildings. He was directed to document Louisiana's commerce, which included photographing oil derricks, paper mills, moss companies, and the sugarcane, rice, and salt industries, as well as commercial shrimping, oystering, fishing, and any other farming. He also took highly publicized photographs of prisoners and their guards at the Louisiana State Penitentiary at Angola.

The same year Fonville was hired, he personally bought a 36-horsepower Aeronca C-3 airplane and earned a pilot's license, which allowed him to do aerial photography for the Highway Department. He affectionately nicknamed his plane the *Duck*. The two-seater was started by manually turning the propeller, and it was so squat that, before takeoff, he could reach out the cockpit and touch the ground with his hands.

During World War II, he flew the *Duck* for the Civil Air Patrol, the civilian branch of what he called the U.S. Army Air Corps (the name changed to the U.S. Army

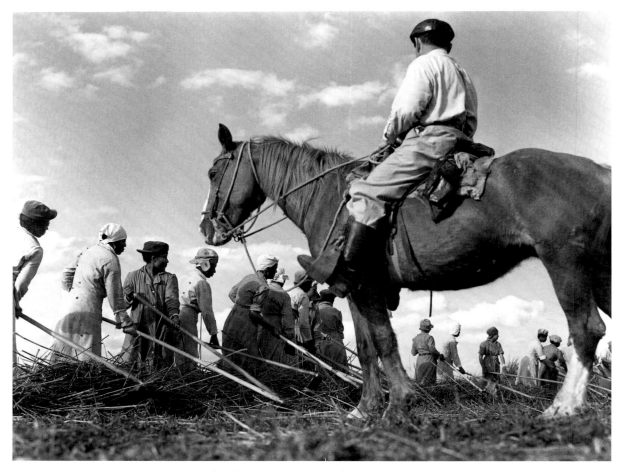

Angola Prison Trustee on Horse with Female Prisoners.
(Fonville Estate Collection, courtesy Robert L. Winans)

Air Force in 1941). His assignment was to do search and rescue in Louisiana, and to survey the mouth of the Mississippi River for German U-boats. After the war, the Aeronca was destroyed in a hangar fire in Shreveport. Soon after, he bought a four-seater Stinson Model 108 Voyager, which he kept at Baton Rouge's Harding Field

and, over the years, flew for both business and pleasure across the United States.

Between the months of February and June, 1947, Fonville flew his airplane above Baton Rouge's most developed streets and took at least thirteen rolls of 35mm photographs. The prints were intended for sale

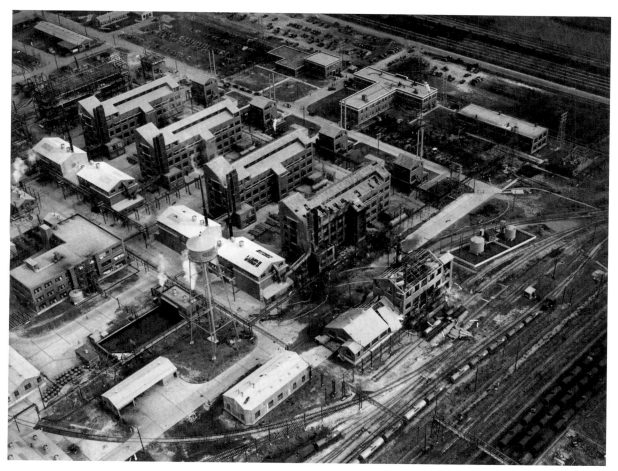

One of many aerial views of Baton Rouge Fonville took as state photographer.
[T. Fonville Winans Collection, Louisiana State Museum Historical Center]

to businesses documented in the images. Fonville kept a shot log of this project, which includes notes on which photos sold and which did not. Today, these negatives give an astonishing insight into a city that, at the time, was experiencing a postwar growth explosion, but which was still confined to a relatively small geographic area.

One of Fonville's most celebrated aerial photos is that of a rare snow blanketing the grounds of the State Capitol. For that stunt, he and his co-pilot took a door off of the plane and he hung out in midair and snapped the shot.

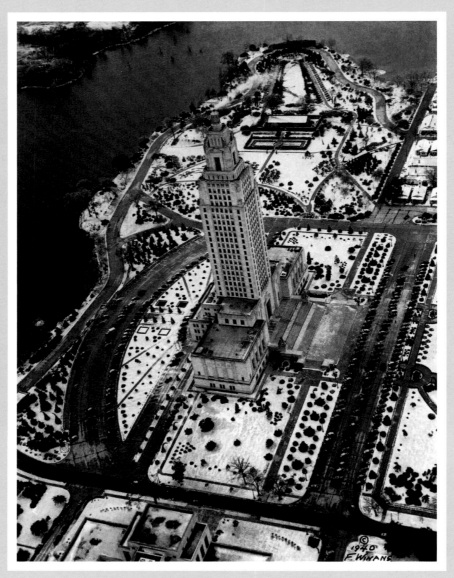

Snow around the Louisiana State Capitol Building, 1940.
(Fonville Estate Collection, courtesy Robert L. Winans)

Governor Jimmie Davis. (Fonville Winans Photograph Collection, Mss. 4605, Louisiana and Lower Mississippi Valley Collections, LSU Libraries, Baton Rouge, LA)

GETTING TO KNOW LOUISIANA'S "BIG SHOTS"
Working for the state introduced Fonville to a group of individuals he had always found fascinating, Louisiana's colorful politicians. In time, Fonville developed relationships with most officeholders worth knowing, and he became the photographer they trusted to make them look their best. For many, getting "Fonvillized" was a natural part of the political campaign process.

Most of the politicians Fonville photographed had good standing with the public. But others had dubious reputations, such as Richard Leche, who would become the first Louisiana governor sentenced to prison. The

Governor Earl K. Long. (Fonville Estate Collection, courtesy Robert L. Winans)

suave governor Edwin Edwards was eventually incarcerated for racketeering and extortion, among other charges. Jessel Ourso, the powerful sheriff of Iberville Parish, fought criminal charges and federal allegations of extortion, and A. O. Rappelet, who was both senator and representative from Lafourche and Terrebonne Parishes, pleaded guilty to charges of malfeasance.

Among the more important political portraits Fonville took are those of the members of the Long dynasty. Fonville started his professional career during the era of the Longs, the populist family of elected officials headed by Huey, the "Kingfish," who was governor from 1928 to 1932 and a U.S. senator from 1932 until his assassination in 1935, a month after announcing he would run for president. Huey Long was the first governor Fonville photographed, and Fonville never tired of telling the story of the first time he laid eyes on the imposing man. At the time, Fonville was a student at LSU and the band director introduced the governor as "a very important person." When Long took the stage, he bellowed, "Important, hell. I own this place!" During the next few years, Fonville took several photographs of Huey Long, including an iconic picture of him standing on the State Capitol steps with LSU president James Smith.

Among the many Long family members who served in political office and sat for Fonville were Huey's brother Earl, "Uncle Earl," who was Louisiana governor for three nonconsecutive terms from 1939 to 1960; and Huey's son, Russell, who was elected to the U.S. Senate in 1948.

A STUDIO FOR LOUISIANA'S FIRST MASTER PHOTOGRAPHER

In a 1980 interview with *Gris Gris* magazine, Fonville relays that, for political reasons, he was asked to resign from his state photography position when Governor Sam Jones took office in 1940. That's when Fonville decided to go out on his own as a photographer. At the

> *Fonville's darkroom is another trip back in time, a setting straight out of Rube Goldberg, with chemicals decanted in whiskey bottles, antiquated clothespins tacked to a shelf to hold drying negatives, 40-year-old instruction sheets pinned above the enlarger. Amid a welter of yellowed Kodak boxes, machine parts and general bric-a-brac, the chemical trays are spotless, and the care he lavishes on a print is evident.*
>
> —Ruth Laney, "Fonville's LSU," *LSU Magazine*, September 1987

time, he and Helen were renting a house on Walnut Street in North Baton Rouge, and their cottage was so small he was forced to use the bathroom and a side porch for darkrooms. In 1941, he leased a two-story stucco structure in downtown Baton Rouge at 667 Laurel Street, at the corner of North Seventh Street. Around 1960, he bought the building, and he took portraits there for the rest of his working life. For many of those early years, his studio telephone number was Dickens 45-368.

Until the day he died, in 1992, the inside of Fonville's studio was decorated with whatever happened to be lying around. The upstairs held assorted junk. Downstairs, where the work was done, walls were covered with black-and-white prints of Cajuns, cypress trees, pirogues, sugarcane, and New Orleans street scenes, as well as glamorous women and beguiling men. The hallway served as a file room, and on its floor were boxes stacked to the ceiling. A room in the back held a narrow day bed and a desk, which doubled as a dining table. Fonville used this area for after-hours entertaining.

Fonville (*front center*) in Professional Photographers Association. (T. Fonville Winans Collection, Louisiana State Museum Historical Center)

A twenty-four-roll film processing machine, which he patented in the 1940s, was the main piece of equipment in the darkroom. In his sitting room, there was a plain white backdrop, along with one made of wrinkled paper, and another fabric backdrop made to look like a bookcase. Here and there were props for children and a few chairs of differing heights. Subjects were illuminated with two fluorescent lights and one backlight. In the middle of the room stood an antique Kodak No. 10A Century Studio Camera mounted on a Kodak No. 1A Semi-Centennial Stand, both manufactured by the Folmer & Schwing Department of Eastman Kodak Company in the mid-1920s.

In the back of the studio room was a machine shop, complete with a refrigerator and a stove. That's where Fonville spent hours creating things with his metal lathe, band saw, table saw, drill press, and joiner/planer.

Fonville never hung a sign on his building. He didn't have to. The quality of his work was evident, and his reputation built up fast. Soon, just about any "big shot" who needed to put their best face to the public was making an appointment with Fonville. The result of these sittings was a political portfolio that includes portraits of virtually every Louisiana governor who held office from 1932 through the 1980s.

Fonville's business was bolstered in 1945, when he earned the title of master of photography. The coveted honor is awarded for superior photographic skills and is bestowed by the Professional Photographers of America (PPA). Fonville was the first master photographer in the state of Louisiana. He was also a member of the Camera-craftsmen of America, which elected only one member per state based on their ability. Neither of these honors was given freely.

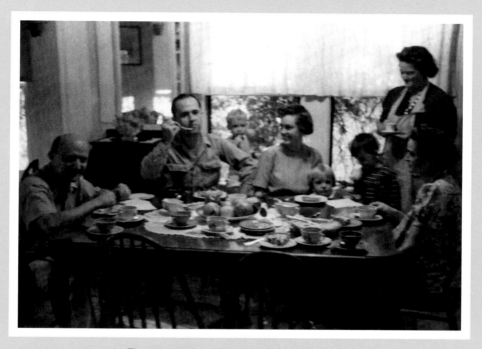

Three generations of the Winans family at dinner.
(T. Fonville Winans Collection, Louisiana State Museum Historical Center)

Fonville became friends with coal baron Stuyvesant "Jack" Peabody when the two met at a photography conference in Chicago. Peabody, an outstanding amateur photographer, took these photos at the Winans home in Baton Rouge.

"Sweet Cookie." Helen in the kitchen, 1944. [Photo by Stuyvesant "Jack" Peabody, reproduced courtesy Stuyvesant Peabody III]

"Cookie's Delight." Fonville, 1944. (Photo by Stuyvesant "Jack" Peabody,
reproduced courtesy Stuyvesant Peabody III)

. . . it is also here [at his studio] that he entertains his friends, and putters, invents, experiments with carpentry, makes rice wine, refines his derailleur bicycle, and generally enjoys himself.

—Excerpt from an unattributed manuscript owned by Melinda and Walker Winans

Donna Britt, long-time news anchor for Channel 9, the CBS television affiliate in Baton Rouge, visited with Fonville often, and she likes to say he "collected celebrities." She, however, thinks Fonville was the star.

Britt's husband is Mark Ballard, an editor for the local *Advocate* newspaper, and throughout the 1980s, the couple would stop in at Fonville's downtown studio for an afternoon chat. This was late in Fonville's life, a time he wanted to be retired but wasn't. So instead of courting paying customers, he spent his days in his studio holding court with his vast medley of friends, which included members of the local art community and political and business leaders.

Fonville's style of entertaining was anything but pretentious. Britt remembers walls lined with photographs of judges, politicians, beauty queens, babies, and even a few nudes. The kitchen might vaguely hide bottles of whiskey. When Britt and Ballard were the only guests, Fonville would make sandwiches and the three would swap stories that mainly focused on photography. Britt says she rarely saw him work, although he did take time to do a portrait of her daughter, Annie.

Fonville was always gregarious and he made everyone feel like a long-lost friend. He came across as sensitive and intuitive, asked follow-up questions, and told fantastic jokes. Britt and Ballard were also taken in by Fonville's eternal optimism and his sunny view of the world that reflected in his work.

Britt notes that Fonville exhibited childlike wonder, that he had a pure sense of joy and he thought anything was possible. This boundless enthusiasm and lack of cynicism shines through brilliantly in his early pictures of Cajuns, in which they smile for Fonville's camera as they go about their simple daily lives. Britt also cites his Avery Island salt dome picture. She thinks it's amazing that he had not thought twice about climbing down into a salt mine with his clunky camera and tripod. Surrounded by a vast white emptiness, he locked his shutter open and lit selected areas of the chamber to create one of his most celebrated photographs, an eerie underexposure of himself shooting the scene.

And, yes, Fonville was good at name dropping. Of course, he never let an opportunity fly past, and he was extremely charming. But it wasn't the connections or charisma that attracted Britt and Ballard. The couple was drawn to Fonville's keen understanding of art. No matter the medium, he could dissect, critique, and teach. His insight seemed to come naturally, and it was this inherent talent that, in Britt's eyes, made him more interesting than almost any dignitary.

MARGARITAS *Makes 4 drinks*

Note from Fonville: "March 31, 1990: Donna Britt and Mark Ballard here [at Fonville's home] to watch raccoons . . . The use of Cointreau or triple sec is avoided. Masks the exotic flavor of the tequila. We learned this little trick at a restaurant in Progreso, Mexico. Also ran into it in a bar in Tucson."

Salt and a lime for rims of glasses	¼ cup lime juice
	¼ cup sugar
¾ cup (6 ounces) Jose Cuervo tequila	8 regular ice cubes (or 16 "automatic ice cubes")

Rub a cut lime around the rims of four coupe champagne glasses and dip them in salt. Pulverize remaining ingredients in a blender and pour into salted glasses.

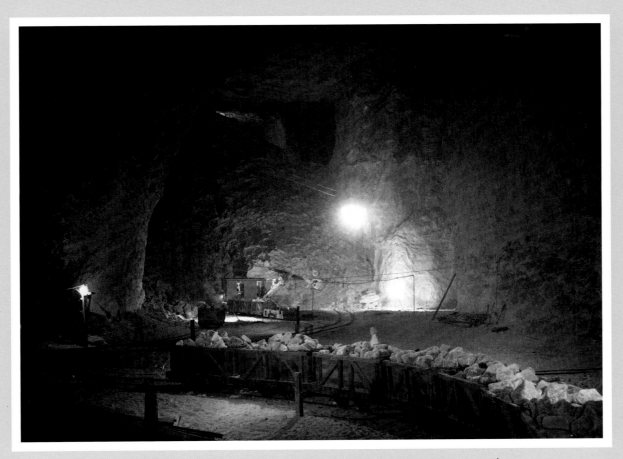

Avery Island Salt Mine, 1939. (Fonville Estate Collection, courtesy Robert L. Winans)

FONVILLE'S MASTERY OF RICE COOKING

Fonville liked to cook rice, which was a cheap way to feed a crowd, and it was the basis for many of his Cajun-style dishes. For most of the following recipes, he used a stovetop Blue Rose rice cooker. This stainless steel double pot is named after the Blue Rose variety of rice developed in the early 1900s in Crowley, Louisiana, some seventy-five miles west of Baton Rouge. This area is the heart of the Louisiana rice industry and the location of the International Rice Festival, an event Fonville photographed extensively in the late 1930s.

This particular rice cooker is unique in that the steam holes are near the top of the insert that contains the rice and seasonings. You can still buy a Blue Rose rice cooker from Crystal Rice Plantation in Crowley or from Konriko in New Iberia. Most of the following recipes call for a rice steamer, but if you don't have one, you can use an electric rice cooker or a tightly covered pot, adding more water as described in the recipe. The results won't be exactly the same as in the Blue Rose pot, but the dish will still taste good.

I WOULD SERVE THIS TO COMPANY RICE

Makes 6 servings

Fonville noted that *"ladies love this one!"*

1. Combine all ingredients, except bread crumbs, in the top of a stovetop rice steamer set over moderately boiling water and cook, covered, until rice is just tender, 30–40 minutes. (You can also use an electric rice cooker and add ¼ cup water, or use a tightly covered saucepan with an additional ½ cup water and cook over low heat.)

2. Preheat oven to 350°F. Scoop cooked mixture into a shallow 2-quart baking dish and sprinkle with bread crumbs. Bake until hot and bubbly, about 30–35 minutes. (If you cook this dish beforehand, this last step can be done just before serving.)

6 large, cooked artichoke hearts, halved, or 12 small canned artichoke hearts

1 pound shrimp, peeled and deveined

1 (10¾-ounce) can condensed Cheddar cheese soup

1 cup raw rice

6 tablespoons evaporated milk

¼ cup shredded Cheddar cheese

1 tablespoon butter, melted

½ teaspoon salt

¼ teaspoon ground white pepper

¼ teaspoon cayenne pepper

¼ cup bread crumbs

TROPICAL RICE

Makes 4–6 servings

Sometimes Fonville served this dish in the festive style of the day, inside a scooped-out pineapple that was halved lengthwise.

1. Heat oil in a skillet over a medium flame and sauté shrimp 1 minute. Add ham and sauté 2 more minutes.

2. Add celery and water chestnuts and sauté until celery is just tender, about 3 minutes. Season with salt, black pepper, and cayenne pepper. Add pineapple and stir.

3. Spoon mixture into the top of a stovetop rice steamer set over moderately boiling water. (You can also use an electric rice cooker with an additional ¼ cup water, or use a tightly covered saucepan with an additional ½ cup water and cook over low heat.) Add water, rice, and butter. Cook, covered, until rice is just tender, 30–40 minutes. Fluff rice with a fork before serving.

1 tablespoon vegetable oil

4 ounces raw shrimp, peeled and deveined

6 ounces smoked ham cubes

¼ cup diced celery

¼ cup diced water chestnuts

½ teaspoon salt

¼ teaspoon ground black pepper

Dash of cayenne pepper

4 ounces canned diced pineapple, drained, or ½ cup fresh

1½ cups water

1 cup raw long-grain rice, washed 3 times

2 tablespoons butter

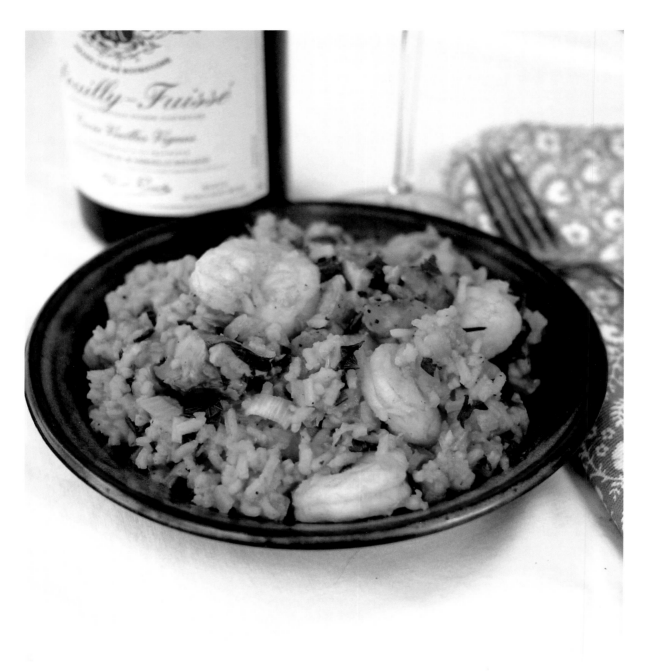

French Paella. (Photo by Cynthia LeJeune Nobles)

FRENCH PAELLA

1. Remove skin and bones from chicken and discard. Chop chicken into pieces. Sprinkle meat with salt and pepper.

2. Add chicken, hot water, and bouillon cubes to the top pan of a stovetop rice steamer set over moderately boiling water. (You can also use an electric rice cooker with an additional ⅓ cup water, or use a tightly covered saucepan with an additional ¾ cup water and cook over low heat.)

3. Add shrimp, rice, tomatoes, onion, garlic, 1 teaspoon salt, ¼ teaspoon black pepper, cayenne pepper, and saffron. Mix well and cover. Cook using medium heat until rice is extremely tender, about 40 minutes. Add parsley and green onions and toss with a fork. Serve warm.

1 baked chicken from the grocery store

Salt and ground black pepper

1½ cups hot water

4 chicken bouillon cubes

1 pound raw shrimp, peeled and deveined

1½ cups raw rice

3 large ripe tomatoes, peeled and diced

1 onion, chopped

1 clove garlic, minced

¼ teaspoon cayenne pepper

1 pinch saffron

2 tablespoons minced parsley

2 tablespoons minced green onions

BROCCOLI RICE

Makes 6–8 servings

1. Put water and cream of tartar in the bottom of a stovetop rice steamer; bring to a moderate boil.

2. Combine all other ingredients in the top of the steamer, except the cheese. (You can also use an electric rice cooker with an additional ½ cup broth, or use a tightly covered saucepan with an additional 1 cup broth and cook over low heat. If doing either, eliminate step 1.) Cover and cook until rice is tender, about 35 minutes. Some of the seasonings will float to the top, but do not stir.

3. After rice is done, fluff with a fork. Add the cheese, cover again, and steam until the cheese melts. Fluff rice again. Serve hot.

8 cups water

½ teaspoon cream of tartar

2 cups raw long-grain rice

2 cups chicken broth

1 cup finely chopped green onions, bottoms and tops

⅔ cup chopped green bell pepper

½ cup chopped broccoli florets

⅓ cup minced parsley

¼ cup vegetable oil

1½ teaspoons salt

½ teaspoon Worcestershire sauce

¼ teaspoon cayenne pepper

½ cup shredded sharp Cheddar cheese

HIGH SOCIETY RICE

Makes 8 servings

Fonville wrote a note that the secret to this recipe's success is to not add salt and to finely chop all the vegetables.

1. In the top of a stovetop rice steamer set over moderately boiling water, stir together rice, chicken bouillon, and butter. (You can also use an electric rice cooker with an additional ½ cup water, or use a tightly covered saucepan with an additional 1 cup water and cook over low heat.) Cover and steam 35 minutes, maintaining medium heat. Do not stir while rice is cooking.

2. When rice is done, stir in raw vegetables. Serve hot.

2 cups raw rice

6 chicken bouillon cubes dissolved in 2 cups water

4 tablespoons (½ stick) butter, melted

¾ cup finely chopped carrots

¾ cup finely chopped celery

¾ cup minced parsley

¾ cup minced green onions, bottoms and tops

1 (5-ounce) can water chestnuts, drained and thinly sliced

GREEN RICE

1. Put water and cream of tartar in the bottom of a stovetop rice steamer; bring to a moderate boil.

2. Combine all other ingredients in the top of the steamer. (You can also use an electric rice cooker with an additional ½ cup broth, or use a tightly covered saucepan with an additional 1 cup broth and cook over low heat. If doing either, eliminate step 1.) Cover and cook until rice is tender, about 35 minutes. Toss with a fork and serve.

Note: Green seasonings will float to the top, but do not stir until dish is finished cooking.

8 cups water

½ teaspoon cream of tartar

2 cups raw rice

2 cups beef or chicken broth (can be made from 6 bouillon cubes dissolved in hot water)

5 broccoli florets, finely chopped

1 cup chopped green onions, bottoms and tops

1 fresh poblano pepper, finely chopped

⅔ cup chopped green bell pepper

⅓ cup minced parsley

¼ cup corn oil

1½ tablespoons Worcestershire sauce

1 teaspoon salt

¼ teaspoon cayenne pepper

CREAM of RICE CUSTARD

Makes 4 (½-cup) servings

1. Prepare a double boiler so that water does not touch bottom of the top pan. Bring water to a boil. While water is coming to a boil, whisk egg in a small bowl and set aside. In a saucepan, combine milk, cream of rice, sugar, cornstarch, and salt. Over medium heat, bring milk mixture to a boil, whisking constantly. Transfer mixture to the top of the double boiler.

2. Lower water in bottom of boiler to a simmer and whisk egg into milk mixture. Cook over simmering water, whisking constantly, until thick, about 5 minutes. Remove from heat and stir in vanilla and almond extracts.

3. Divide among 4 dessert ramekins and sprinkle with cinnamon. Chill thoroughly. Serve cold.

1 large egg

2¾ cups whole milk

5 tablespoons uncooked cream of rice hot cereal, or cream of buckwheat or cream of wheat

⅓ cup sugar

1 teaspoon cornstarch

¼ teaspoon salt

1 teaspoon vanilla extract

2 drops almond extract

Cinnamon for sprinkling

Cream of Rice Custard. (Photo by Cynthia LeJeune Nobles)

Mrs. Royce Hatchett (Frances Dougherty), January 1941—the photo that launched Fonville's portrait career. (Fonville Winans Photograph Collection, Mss. 4605, Louisiana and Lower Mississippi Valley Collections, LSU Libraries, Baton Rouge, LA)

CHAPTER 5

Beauties and Brides

My friends and I only considered Fonville for portraits. And going to his studio was fun!

—Baton Rouge resident Ernestine Bridgforth

The bulk of Fonville's commercial business centered on photographing brides, debutantes, and young ladies interested in making it big in Hollywood or in modeling. This category of clients was drawn not only to his talent, but also to his personality. Just ask anyone who knew him—women were magnetized to Fonville, and he never met a woman he couldn't turn into an instant friend.

Fonville's cosmopolitan good looks (some say he reminded them of Ernest Hemingway or Rock Hudson) and his ability to schmooze made his charm effortless. Not surprisingly, that flattery sometimes led to innocent flirtation. He had an affinity for dazzling the opposite sex, which enhanced his reputation as a portrait artist.

Probably his greatest skill in dealing with clients, however, was his ability to listen. Fonville was truly interested in his subjects, and he would take the time to let them explain what type of photograph they wanted or whatever was on their mind. He also believed that

there was something beautiful in every woman he photographed, and a small part of him fell in love with each one.

CAPTURING HIGH SOCIETY

Fonville's career as a society portrait photographer took off in 1941. His big break came the day he stopped by Stroube's Drugstore in downtown Baton Rouge and chanced upon a "popular member of younger society," Mrs. Royce Hatchett, the former Frances Dougherty, who had grown up just north of the city on Linwood Plantation. The sophisticated brunette was returning to her home in Thibodaux after a family visit, and Fonville persuaded her to let him take a head shot. He then enticed the *Baton Rouge State-Times* society editor, Mary Champagne, to run the photo in the newspaper. The captivating picture appeared in the "Society and Clubs" section on January 6, 1941. The credit line merely read

Fonville's signature.
(Photo by Walker Winans)

"Photograph by Fonville Winans." With this one glamorous photograph his phone started ringing and it didn't stop. All of a sudden, he "had a business." This was also the time he began signing his works with what became the familiar, flourishing "Fonville."

As the go-to photographer for flattering society portraits, Fonville aimed to capture the true face of a client, not what the client thought she wanted to be. To achieve this unaffected end, Fonville insisted that no woman have her hair professionally styled the day of a sitting. A studio session usually started with the client, whether age six months or sixty years, wearing white against her face. If any other color was worn on top, a changing room with stock white blouses was available.

No matter how much any bride or debutante begged, Fonville worked strictly with black-and-white photography. Part of his rationale was that colored prints did not last. Also, he wanted total control in the darkroom, which he felt was not possible when using color film. He therefore usually referred someone insisting on color to another photographer.

To put a client at ease, he would praise her looks and tell jokes. Those two tricks rarely failed to work. If a subject was still too frozen, he would take those old enough to imbibe to the back room and give her the choice of a cocktail or a snort of his favorite libation, Tom Moore bourbon.

Remarkably, Fonville had a rule that he only take one camera shot for one pose. His camera, which remained set to his specifications, would focus on a spot slightly lower than between the eyes. Click. That would be it; there would not be another try.

Many clients were outstanding beauties and were naturals in front of the camera. Those who went on to stardom include actresses Joanne Woodward, Donna Douglas (Elly May on the television show *Beverly Hillbillies*), and Margaret Landry, a Baton Rouge native and *Look* magazine's "Sweater Girl of 1941," who appeared in *The Leopard Man* (1943) and *The Adventures of a Rookie* (1943). LSU student Ilean Girlinghouse went on to become a Powers model in New York.

> *Some time ago we learned of a national contest to select America's "Sweater Girl of 1941." Helen called a friend of ours and persuaded her to enter. We made her "entrance photos." It's a long story but to make it short, the girl, Margaret Landry, won the contest. Winners were announced in the December 30th issue of* Look *magazine. Margaret's is a full page photo, one by yours truly.*
>
> —Fonville in a letter to his parents, December 15, 1941

Joanne Woodward. (Fonville Winans Photograph Collection, Mss. 4605,
Louisiana and Lower Mississippi Valley Collections, LSU Libraries, Baton Rouge, LA)

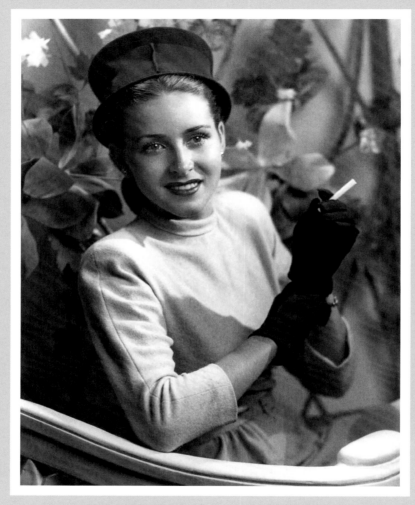

Ilean Girlinghouse, 1940s. (T. Fonville Winans Collection,
Louisiana State Museum Historical Center)

ELIZABETH COLE Age 18
(ASHLEY)

Hair----Br Bust----34 t---22½
Eyes---Hzl Waist---23 Gloves---7
Height-5'5½ Hips----34 H)se----9
Weight-108 Dress---9-11 S\0es-6½B

Elizabeth (Cole) Ashley. (Fonville Winans Photograph Collection, Mss. 4605,
Louisiana and Lower Mississippi Valley Collections, LSU Libraries, Baton Rouge, LA)

Baton Rouge resident Liz Cole, later called Elizabeth Ashley, sought Fonville out to take modeling photos at the Old Arsenal, a powder magazine built in 1838 and located on the grounds of the New State Capitol. That portfolio landed her a television commercial for Coca-Cola, which led to fame in movies, on Broadway, and on television. Ashley later credited Fonville's talent for her break into show business, but he took the humble road and praised her ambition.

HERE COME THE BRIDES

Fonville's reputation among brides-to-be became such that wedding dates were set according to his schedule, not that of the caterer or the church. When it came time to get married, Baton Rouge native Ernestine Bridgforth was one of the many who changed her original wedding date so she could hire Fonville. In this case, it could not have been any other way; she felt she owed Fonville a debt for connecting her with her husband.

A few years before her marriage, Ernestine was maid of honor in a friend's wedding, and Austin Bridgforth, a man she had never met, was a groomsman. While Ernestine was posing for photographs with the bridesmaids, the hoop under her skirt kicked up. Fonville, true to style, didn't think twice about stooping behind her and fixing things. The photographer's lack of constraint caused her to turn beet red with embarrassment, which made her future husband laugh hysterically, and also made him find her irresistible.

Fonville's photographs of the Bridgforth wedding on June 28, 1957, also brought him a bit of luck. That summer, he was the featured speaker at a wedding photography convention in Canada, and he showcased what he came to call "the photo," a shot of the newly married Bridgforth couple in profile, with light playing on the angles of their faces, making them look almost ethereal. The photo had been taken with one of his favorite wedding cameras, a 35mm Leica, which was silent in buildings, along with a hand-held light meter. (Other cameras he used for weddings were two different models of Nikon 35mm Rangefinders.) As with so many of his famous photographs, this much-acclaimed shot was taken by accident; it wasn't posed and the lighting was theoretically wrong. It was also the one wedding shot Fonville felt gave him bragging rights.

> *Many families today hang Fonville Winans portraits as artwork. At some funerals, only portraits taken by Fonville are allowed for display.*

Fonville would not take a photo of a bride in her wedding gown before the wedding. He felt that the excitement of the day reflected in a bride's face, and he wanted to capture that spontaneous joy in her formal picture.

At every wedding, Fonville threw himself into the action, and was usually considered part of a wedding party. He often found himself choreographing attendants, and he would authoritatively stop automobile traffic outside churches. To help calm nerves, he always carried a flask of Tom Moore and was known to give more than one father of the bride a long sip.

He typically took a montage of photos that told the story of the entire wedding day, from a bride putting on makeup through driving off for the honeymoon. Locals remember Fonville as one of the first photographers in the area to offer these ordered collections. His trademark shot was of the garter on the bride's leg, with Fonville appearing in a mirror behind, snapping the photo. To get that shot and those of the bride dressing, he would click away in the bride's bedroom.

After the wedding, brides were not allowed to pick their favorite photos for the official album—Fonville performed that task. Very few complained; his clients trusted his artistic judgment.

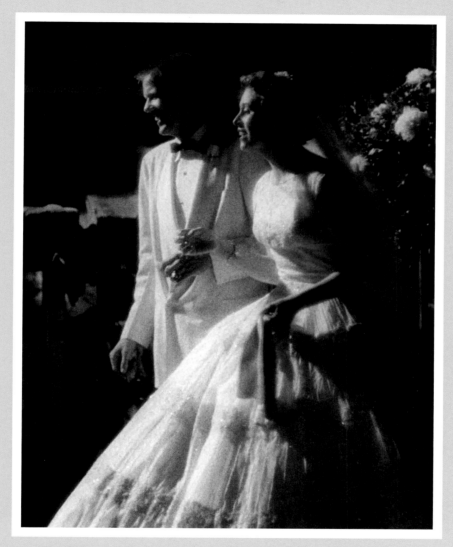

"The Photo," Austin and Ernestine Bridgforth on their wedding day, June 28, 1957.
(Reproduced courtesy Austin and Ernestine Bridgforth)

Dressing for a Wedding (with Fonville reflected in the mirror).
(T. Fonville Winans Collection, Louisiana State Museum Historical Center)

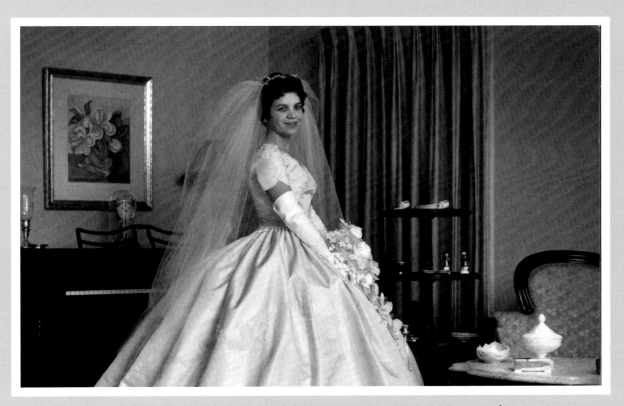

Ursula Bogan Carmena, July 23, 1960. (Reproduced courtesy Ursula Bogan Carmena)

HELEN'S TOUCH

Most women remember that going to Fonville's studio for a portrait was fun, and that Helen played a big part in that total experience. Fonville's wife kept the books and made appointments. Her presence also added a touch of glamour, with her colorful skirts, dangle earrings, and oversized rings. Sometimes she would wear hats. It wasn't unusual to find a cigarette wedged between her long, meticulously manicured fingers, and her shoulder-length auburn hair tucked behind her ear in the fashion of the day.

Helen, like Fonville, enjoyed chatting with clients. But she was the type who rarely held back her opinions, and she did not have Fonville's knack for easily making friends. She did, however, have a strong interest in cultivating wealthy friends, many of whom she met through the activities of the Mardi Gras Krewe of Romany. Those who knew her best believe the relationships Helen nurtured were mostly related to business; Helen always had her eye out for potential customers, and she was arguably the power behind Fonville's success.

Not only did she run the administrative end of things but, in this, the age before the invention of Kodachrome color film (which Fonville shunned to his dying day), Helen hand-colored her husband's prints. Known as a colorist, she studied her craft early in his career, and in his studio she practiced her trade by applying oil paint with wooden pickup sticks with cotton applied to the tips. Fonville swore by this coloring method, not only for its beauty, but because it lasts virtually forever. Helen gained a professional reputation as an excellent colorist, receiving four certificates of merit from the PPA.

Helen also applied makeup to clients. Her flair for accentuating facial features with powder and rouge, together with Fonville's mastery of angles and light, made a winning combination.

TOO MUCH OF A GOOD THING

In the early 1960s, the stress of Fonville's full schedule took its toll in the form of a physical breakdown. Youngest son Walker remembers the day at their home when his father suddenly became crippled, crawled to a door, and couldn't reach high enough to touch the knob. An ambulance rushed Fonville to the hospital, where he was diagnosed with a small stroke. The family's doctor put him in traction. The ailing photographer went home after a week and spent a few months hanging his head in a sling. After he recovered, Fonville jacked his studio rates way up, but that did little to discourage bookings.

He paid the bill for this hospital visit, along with all health-care expenses for his family, from his own pocket. Fonville refused to ever buy health insurance or any other kind of insurance. Helen, therefore, purchased policies for the business, the car, and the house behind his back. Because his parents had lost everything they had had in a bank in the Great Depression, Fonville also didn't keep a bank account. Helen openly kept a bank account for the business, and Fonville paid everything else with cash.

In 1975, despite Fonville's physical setback over a decade earlier, his portrait business was still going strong. That was the year he bought a new car for a little over $11,000. He paid for it with twelve one-thousand-dollar bills. The last thousand-dollar bill had been printed in 1945 and was discontinued in 1969. Since Fonville didn't believe in banks, he had a stack of cash, which included the obsolete bills. The car dealer couldn't make change and had to run to a bank while Fonville waited.

Helen at the Spotting Table, ca. 1950. (T. Fonville Winans Collection,
Louisiana State Museum Historical Center)

Fonville demonstrating his cooking skills on *Midday in Louisiana* with Jean Wheeler.
(T. Fonville Winans Collection, Louisiana State Museum Historical Center)

SHOW TIME

Fonville was such an accomplished cook that through the 1960s and 1970s, he did cooking demos with host Jean Wheeler on the *Midday in Louisiana* show on local television station WBRZ. Not surprisingly, Fonville was entertaining. But a lack of urgency and his uncontrolled enthusiasm did not always make him a good fit for live television. (His most memorable mishap was calling chicken fricassee "fricken chickassee.")

His TV career ended with one exceptionally heavy wedding season, when he was entirely booked for months, sometimes with three weddings on one Saturday. His resignation was okay with Wheeler, who had tired of him going over time limits and who complained that he was "too hard to control." Upon his departure, Fonville recommended a drinking buddy and fellow food enthusiast as his replacement, Cajun humorist and cook Justin Wilson. Wilson went on to author seven best-selling cookbooks and to develop several series of television cooking shows, which aired nationally on public television and worldwide on armed services television.

Justin Wilson. (Fonville Winans Photograph Collection, Mss. 4605,
Louisiana and Lower Mississippi Valley Collections, LSU Libraries, Baton Rouge, LA)

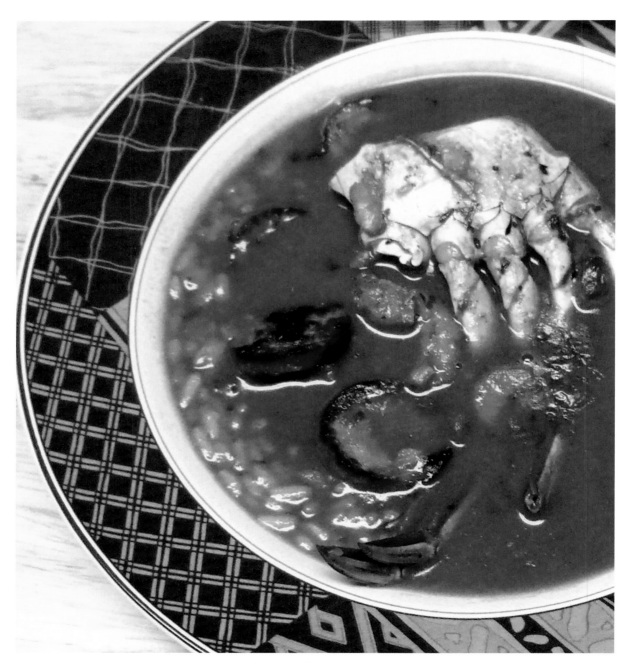

Fon's Studio Gumbo. (Photo by Walker Winans)

FON'S STUDIO GUMBO
(Sausage, Shrimp, and Crab Gumbo)

Makes 6–8 servings

Fonville put this gumbo together using dried and frozen ingredients he had hanging around the kitchen in his studio.

1. Heat a Dutch oven over a medium flame and fry sausage until brown. Remove sausage from pot and add flour and oil. Make a roux by stirring constantly until mixture is dark brown, about 7 minutes. Carefully stir in water.

2. Add browned sausage, dried shrimp, bay leaves, onion, parsley, salt, garlic powder, black pepper, cayenne pepper, and thyme. Bring to a simmer and cook, stirring occasionally, 5 minutes.

3. Add crabs, bring to a boil, lower heat, and simmer 1 hour. Add fresh shrimp, bring to a boil, reduce heat, and simmer 5 minutes. Remove bay leaves and serve hot in bowls over rice.

1 (6-inch) link hot smoked pork sausage, cut into ¼-inch slices

4 tablespoons all-purpose flour

4 tablespoons vegetable oil

2 quarts water

½ cup dried shrimp

3 bay leaves

1 tablespoon dried onion

1 teaspoon dried parsley

½ teaspoon salt

½ teaspoon garlic powder

¼ teaspoon ground black pepper

⅛ teaspoon cayenne pepper

Pinch dried thyme

4 frozen cleaned gumbo crabs

½ cup fresh or frozen shrimp, peeled and deveined

Hot cooked rice for serving

STUDIO CABBAGE ROLLS

Makes 20

1. Remove 20 outer leaves from cabbage. Bring a large pot of water to boil and submerge leaves. Simmer until wilted, 30–60 seconds. Drain and trim off large, tough center ribs. Set cabbage leaves aside.

2. In a small bowl, soak bread in milk for 5 minutes. In a medium bowl, combine ground beef, rice, ½ cup water, garlic, salt, black pepper, cayenne pepper, and nutmeg. Add soaked bread and combine mixture well.

3. Place 2–3 tablespoons of meat mixture on the base of a cabbage leaf. Fold in sides and wrap into a neat roll, to resemble an eggroll. Repeat with remaining leaves.

4. Line the bottom of a 4 to 5-quart saucepan with unused cabbage leaves. On top of the leaves, pack cabbage rolls tightly together in layers. Pour on tomato juice and add enough water to just cover cabbage rolls. Place a small saucer or plate on top of rolls to hold them down. Bring to a boil, cover tightly, and reduce to a simmer. Cook 1 hour.

5. Fish out the rolls and arrange on a serving platter. Strain and reserve liquid. Pour reserved liquid into a pan, bring to a boil, and thicken with cornstarch dissolved in 3 tablespoons water. Check for seasoning. Pour sauce over the cabbage rolls. Serve hot.

1 large head of green, leafy cabbage

1 slice bread

¼ cup milk

1 pound ground beef

½ cup raw rice

Water

3 cloves garlic, minced, or ½ teaspoon garlic powder

1½ teaspoons salt

½ teaspoon ground black pepper

¼ teaspoon ground cayenne pepper, or to taste

⅛ teaspoon freshly grated nutmeg

1 (13.5-ounce) can tomato juice

1 tablespoon cornstarch

Studio Cabbage Rolls. (Photo by Cynthia LeJeune Nobles)

CHICKEN SALAD SANDWICHES

Makes 6 whole sandwiches

Fonville liked to joke that going to so many weddings had made him a connoisseur of chicken salad sandwiches.

1. In a medium bowl, combine all ingredients except bread and butter. Toss with a fork until well mixed.

2. Lightly spread one side of all bread slices with butter. Top half of the buttered bread slices with chicken salad, then top with remaining buttered slices. Slice on the diagonal into fourths.

1½ cups finely chopped cooked chicken

¼ cup mayonnaise, homemade (*recipe follows*) or purchased

1 hard-boiled egg, finely chopped

2 tablespoons finely chopped celery

2 tablespoons finely chopped pimento-stuffed olives

1 tablespoon finely chopped onion

1 tablespoon sweet pickle relish

1 teaspoon lemon juice

⅛ teaspoon salt

Dash of white pepper

12 slices white bread, crusts removed

Soft butter

BLENDER MAYONNAISE

Makes 1 cup

Fonville adapted this recipe from one in Gourmet *magazine. He commented that it was very good but not that easy to make.*

Put egg, vinegar, dry mustard, and salt into blender and turn on high. Add oil in a thin, steady stream and turn motor off when thick. If mixture gets too thick, add up to 1 tablespoon warm water.

1 large egg

5 teaspoons vinegar

1 teaspoon dry mustard

¾ teaspoon kosher salt

1 cup neutral-tasting vegetable oil

1 tablespoon warm water (if needed)

OVEN FRY CHICK (Chicken to Hell and Back)

The title of this recipe was a play on Helen's name, and the dish was a staple on the Winans dinner table. Fonville seasoned it with "Chik Mix," one of several seasoning mixes he concocted and stored in his pantry to sprinkle on various meats and seafood. Fonville had wanted to demonstrate Chicken to Hell and Back on Jean Wheeler's Midday in Louisiana *television show, but she questioned using the word "hell" on television. The suggested replacement title was Chicken Diablo. Fonville defiantly proclaimed that "diablo" was a "wimpy, overworked" adjective. No one remembers which version of the title was aired.*

1 whole chicken, cut into 8 pieces

1½ teaspoons Chik Mix, or to taste (*recipe follows*)

1. Preheat oven to 500°F (or the hottest your oven can be set). Sprinkle chicken pieces with Chik Mix. Arrange chicken in a shallow pan. (For easy cleanup, Fonville usually lined the pan with "tin foil.")

2. Bake, uncovered, 20 minutes. Turn off the oven and leave chicken in *without opening the oven door* for 15 minutes.

3. Remove pan from oven and serve warm.

CHIK MIX (Chicken Seasoning Mix)

Makes 1¾ cups

Mix all ingredients together and store in a sealed container. Good on chicken and fish.

*If you don't want to use MSG, increase the garlic powder to ½ cup.

½ cup salt

½ cup black pepper

½ cup MSG*

¼ cup garlic powder

FON'S SCALLOPED OYSTERS

Makes 4 servings

Fonville cooked this restaurant-quality recipe on the Midday in Louisiana *television show on April 22, 1965. If you like the flavor of the oysters to shine through strong, lessen or eliminate the cayenne pepper and thyme.*

1. Preheat oven to 425°F. Drain oysters and save juice. Put oysters in a bowl and stir in sherry. In a measuring cup, combine oyster juice and enough milk to make 1 cup of liquid.

2. Place crumbled crackers in a medium bowl and stir in butter, salt, black pepper, cayenne pepper, and thyme.

3. Butter a 1½-quart baking dish or 4 individual ramekins. Arrange in baking dish in this order: ⅓ of cracker mixture, ½ of oysters, another ⅓ of crackers, remaining ½ oysters, milk mixture, and finish with remaining ⅓ crackers. If using ramekins, follow the same pattern.

4. Bake until light brown, 25–30 minutes. Serve immediately.

1 pint oysters, with juice

¼ cup sherry

½ cup milk (approximately)

¼ pound (37) salted soda crackers, crumbled

½ cup (1 stick) butter, melted, plus additional for buttering baking dish or ramekins

¼ teaspoon salt

¼ teaspoon ground black pepper

¼ teaspoon cayenne pepper, or to taste

¼ teaspoon powdered thyme, or to taste

Fon's Scalloped Oysters. (Photo by Cynthia LeJeune Nobles)

STUFFED CUCUMBERS

Makes 4 servings

1. Preheat oven to 400°F. Cut cucumbers in half lengthwise. Scoop out insides, leaving ¼ inch of pulp along the insides of the shells. Reserve both shells and pulp.

2. In a skillet set over a medium flame, sauté diced bacon until crisp. Remove bacon and leave rendered grease in skillet.

3. In bacon grease, sauté onion and celery until light brown, about 3 minutes. Add reserved cucumber pulp and cook until liquid has evaporated. Add soaked bread crumbs, salt, black pepper, and garlic powder. Remove skillet from heat. Cool mixture 5 minutes and stir in egg.

4. Stuff cucumber shells with filling mixture and sprinkle tops with cracker crumbs. Bake until heated through and crumbs are golden brown, about 30 minutes. Serve warm.

4 medium cucumbers

3 thin slices bacon, cut in ¼-inch dice

1 small yellow onion, diced

1 stalk celery, diced

2 slices white bread, pulsed to crumbs in a blender and softened with 1 teaspoon water

Salt, ground black pepper, and garlic powder to taste

1 large raw egg

¼ cup cracker crumbs

CHERRIES JUBILEE

Makes 4 servings

For this now-retro recipe, Fonville liked using Brown's Velvet ice cream, a treat manufactured in New Orleans. Unfortunately, it is no longer available.

1. Add 2 scoops of ice cream to each of 4 dessert bowls. Place bowls in freezer.

2. Place cherries in a wide, shallow saucepan with a handle. Add 3 tablespoons cherry juice and powdered sugar. Turn heat to low and stir until sugar melts and mixture begins to boil.

3. Add brandy. Light a match and carefully let it touch the brandy; brandy should flame.

4. After flames die out, remove pan from heat. Divide hot cherry sauce over the 4 bowls of ice cream. Serve immediately.

8 scoops vanilla ice cream

1 can (14.5 ounces) dark pitted cherries, drained, reserving 3 tablespoons juice

3 tablespoons powdered sugar

2½ ounces brandy (Note from Fonville: "Use cheap brandy, quality brandy does not ignite well.")

Self-Portrait, probably late 1940s. (Courtesy Melinda and Walker Winans)

CHAPTER 6

Bringing Up Bob, Meriget, and Walker

Dad would give me three licks with his belt and say the matter was closed.

—Walker Winans, youngest of Fonville and Helen's three children

In between photography sessions, and sometimes even during them, Fonville and Helen were raising three children. Bob was born in 1939, daughter Meriget in 1943, and youngest son Walker in 1945.

The family lived in a three-bedroom, two-story house on two-and-one-half acres on Lobdell Avenue—an area that, at the time, was considered the country. Typical of middle-class families of the day, the children grew up with dogs, board games, and bicycles. They rode in a station wagon. When one of them was sick with a cough, Helen and Fonville mixed up bourbon and honey hot toddies. For most other illnesses, the recuperating patient dined on cornmeal gruel.

Fonville's family was the last of their circle to own a television set. The frugal Fonville actually rented their first TV because he thought they were too expensive and

that the new electronic device was a fad that wouldn't last. The first TV show the family watched was *Dragnet*. Helen, in particular, was hooked.

Like fathers everywhere, Fonville gave his loved ones nicknames: Bob was Bobbie and Meriget was Gay Gay. After Walker learned to walk he talked nonstop, so he was Walkie Talkie. Helen was affectionately called Honeypot (after a mule in a movie).

The siblings remember their parents as loving but somewhat removed from their children's daily lives. In the years Bob, Meriget, and Walker lived at home, Fonville and Helen were consumed with growing their business. They were also deeply involved in the Baton Rouge social scene, which left little time for helping with homework and coddling. This meant that during summers, Bob and Walker spent a lot of time at camps,

Henrietta "Penny" Hawkins. (Courtesy Melinda and Walker Winans)

while Meriget would be unceremoniously flown off to stay with grandparents. It wasn't until the three grew into adulthood that Helen and Fonville took strong interest in their activities or routinely included them in their own.

The job of day-to-day parenting was mainly left to Henrietta Hawkins, known as "Penny," the family's housekeeper. As with many white families at midcentury, Fonville and Helen hired an African American woman to clean and cook. Penny was hired in 1945, and she did all the housework and prepared meals five-and-a-half days a week.

A typical workday for Penny started around 6:00 a.m., when she made the family's breakfast. A day of cleaning and tending to the children might end with a dinner of one of her specialties, such as stewed chicken wings and dumplings over rice.

Fonville and Helen encouraged their children to reject the bigotry typical of the Jim Crow–era South. Bob, Meriget, and Walker all became attached to their caretaker, and Meriget recalls never understanding why she would be left to sit in the front of a bus while Penny sat in the back. Penny worked for the family until she retired. She passed away in 1990.

ROBERT LEWIS WINANS

The three Winans siblings agree that Bob, who most closely resembles his father, was the favored child, and that he retained that pet status until the day Fonville died.

As a youngster, Bob wasn't interested in playing sports, and in high school he took dancing lessons. At age seventeen, he left home for prep school in Washington, DC. From there he studied at the U.S. Naval Academy for three years, but resigned when his sight deteriorated, affecting his eligibility to become a line officer. Bob came back to Baton Rouge and enrolled at LSU as a senior. He did not study, however, but gravitated to a crowded

social schedule, cigarettes, and alcohol. To his regret, he didn't graduate.

In his early twenties, Bob needed a job and took advantage of Fonville's friendship with portrait photographer Olan Mills. Fonville and Mills became acquainted the day the owner of the high-profile national chain of photography studios was visiting Baton Rouge and sought out Fonville, who had been referring an enormous number of budget-minded clients to Mills's studio. The two instantly became drinking buddies. They grew so close that Mills insisted that Fonville photograph his daughter's wedding. Mills even sent his personal airplane to fly Fonville to Chattanooga and back for the festivities. In time, Fonville designed a "goofproof" studio lighting system for Mills, one that flattered all clients.

Bob's duty with Mills was to process photographs. This work started with a visit to his new boss's home at Possum Kingdom Lake, a reservoir on the Brazos River west of Dallas, Texas. Bob arrived in style on one of Mills's private planes. On the job in Dallas, Mills was a tough taskmaster, but Bob easily kept up with the work.

After that job ended, Bob grew serious about finding a career, and he eventually became an engineer/designer in the marine engineering industry. His main focus was designing ships, and he spent twelve years on projects at Ingalls Shipyard in Pascagoula, Mississippi. He then became a "job shopper," traveling throughout the United States and developing initial drawings of ships to fulfill government contracts.

Bob also had a serious interest in photography, and at one point he spent a week at the Winona School of Photography, a PPA-affiliated school in Winona Lake, Indiana. At the time, Fonville was a PPA master photographer, on the speaker circuit for the organization and in high demand at state conventions. Since everyone at Winona knew and respected Fonville, Bob was treated like a celebrity, and his work was often used as an ex-

Bob as Rice King, International Rice Festival, Crowley, Louisiana.
(Courtesy Melinda and Walker Winans)

Bob in His Navy Uniform, hand-colored by Helen.
[Courtesy Melinda and Walker Winans]

Once, in the early 1960s, Fonville's son Bob returned on leave from the U.S. Naval Academy, where he had learned how to make distilled alcohol. Father and son were anxious to test out this new knowledge, so they constructed their own still behind the photography studio. In the middle of downtown Baton Rouge, the two vigilantly taught themselves the process of turning potato mash into moonshine, right down to using a hydrometer to find the lowest possible specific gravity of fermented liquid. Those moonshining days came to an end when Fonville snapped a photograph of Jake Netterville, a federal agent stationed at Ethyl Corporation to monitor the plant's output of alcohol. Fonville, who typically befriended most of his clients, innocently telephoned Netterville and asked him how to build a more efficient still. Netterville promptly informed Fonville that his unlicensed and therefore illegal hobby could land him "under the jail." (The State of Louisiana defers to federal law, which, on the grounds of zero quality control, tax avoidance, and possible explosions, strictly prohibits the activity.) Bob and Fonville ceased distilling, but not before they had set a sufficient amount of product aside to "age." This process involved punching out the eye of a coconut and draining and filling the shell with freshly distilled liquor. The hole was capped with candle wax, and the hooch-filled coconuts would sit in a dark closet about six weeks.

ample. Bob even won a few photography contests, but he freely admits he often entered using prints Fonville helped develop. Bob did not become a master photographer, but since he absorbed some of the artistic skills Fonville so instinctively practiced, as well as most of his father's technical ability, he worked successfully for Fonville for several years. For a time, Bob also operated his own studios in Baton Rouge and in Ocean Springs, Mississippi.

In the late 1980s, Bob gave up his well-paying engineer/design career to look after his aging parents and to run the family photography business. Bob and his wife moved into his childhood home, where they were able to care for Helen and Fonville until they passed away.

MERIGET WINANS TURNER

Middle child Meriget says her unusual name was Helen's way of "Frenchifying" the name "Mary Gay." It wasn't until years after Meriget's birth that Helen learned that Mary Gay was an actual family name.

To Meriget, her mother seemed extremely elegant, with her starlet face, proper manners, and long fingers that cradled "stylish" cigarettes. Meriget, too, had tried smoking for a time. At first, Helen worried about her daughter's health and pleaded with her to quit. When that didn't work, Helen ended up teaching Meriget how to "smoke like a lady," which basically involved tilting the lit end of a cigarette up so that the holding fingers wouldn't get stained. Helen also gave a pointer for smoking in a bar: If a lady is sitting at a bar and a gentleman invites her to his table, she should put her cigarette in an ashtray, which a bartender should carry as he follows her to the table.

Fonville, too, smoked, but only for two five-year stretches. One reason he gave it up was that he had a tendency to burn his clothes. One time he decorated an entire side table with cigarette burns.

Meriget spent much of her youth going to voice lessons and charm schools. When she wasn't learning about singing and proper posture, she was spending long hours in the kitchen with her father, who taught her his cooking techniques. At around age ten, she became Fonville's *sous chef,* and would chop vegetables, serve meals, and wash dishes. One of the first things her father taught her to make was a white sauce that called for equal parts flour, butter, and milk. She and Fonville also often made eggs goldenrod—the biscuit, white sauce, and hardboiled-egg dish that's been around since the turn of the twentieth century. Another favorite the two made together was a salad of lettuce topped with green and red grapes that were covered with a mixture of whipped cream cheese and pressed garlic.

Meriget remembers that Fonville was always testing recipes, and that he loved trying out unusual food combinations, such as laying thin slices of lemon on barbecued hamburgers. She believes that the reason he experimented with recipes multiple times was that he would not taste as he went along; he only tested a dish for seasoning after it was completely cooked.

Meriget studied fine arts at LSU and worked for a time as a flight attendant. She eventually went to nursing school and worked for years in public health as a registered nurse.

In between it all, Meriget managed her father's photography studio in her mother's absence. One task she particularly enjoyed was dabbing color onto finished photos, which her mother would later blend in. Like her older brother, Meriget also did a little photography. She was literally thrown into the business one day when Fonville, who had forgotten about an appointment, dashed off and left her to handle a sitting for two children. Up until that time, Fonville had taught his daughter technical aspects of the profession, such as how to print proofs, cut, mat, and spot. But on that fateful day, she

Meriget, hand-colored by Helen. (Courtesy Melinda and Walker Winans)

realized she didn't know the fine points of actually taking a picture.

Luckily, she did remember her father preaching to "go for expression," and she faked the rest. When he returned to the studio, Fonville did the developing work for that sitting. He had always maintained that any negative, no matter how imperfect, could be rescued in the darkroom. He proved his point by producing handsome prints from Meriget's less-than-perfect shots. Surprising to her, the composition for those unsuspecting clients was excellent. And from that experience, Meriget learned that she had her father's eye for focusing on what was important. She inherited his artistic talents, as well as Helen's critical eye for coloring.

Like Bob, Meriget enrolled in a photography course at Winona. Once there, however, Meriget found her instructors too rigid when it came to technique. She was, after all, the daughter of one of the country's most inventive photographers, and she quickly surmised that Fonville knew more than the school's faculty. She did stay long enough to enter one photo competition, and she won an honorable mention.

Meriget has been married since 1968 to James Turner, an artist, illustrator, and retired landscape architect and teacher, who received the Rome Prize for his work in landscape architecture and a Fulbright professorship to lecture in Jordan.

James's initiation into the world of Winans family cuisine began the day his future father-in-law served him "ancient eggs." Fonville occasionally made the Asian preserved dish, commonly known as hundred-year eggs, by thickly coating raw chicken eggs with a plaster of lime, ashes, and salt and burying them in the backyard for a few months. The shells would become black, the albumen green and runny, and the yolks creamy and dark gray. The finished eggs were typically spread over a plate of ground pork, then steamed. James grew up in a meat-and-potatoes family, so it took him a while to warm up to such exotic specialties. That was fine with Fonville, who, while stirring a pot of duck liver soup one day, jokingly said upon the arrival of Meriget's suitor, "Break out the peanut butter and jelly, James is here."

Meriget's relationship with her parents matured over the decades. As a registered nurse, she looked after Fonville and Helen's health. She also worked with them at the studio, did their taxes and accounting, and, of course, collaborated with Fonville in the kitchen. She remembers this particular period with her parents as a "grand time," and an era she will always fondly remember.

WALKER DRAKE WINANS

Walker was given his maternal grandmother's surname. Like Fonville, he was always curious about the way things worked. At the age of twelve, for example, he took Helen's sewing machine completely apart, and then put it back together perfectly. Walker's most dangerous escapade occurred when he was ten, when he sneaked out of his bedroom one night and rode his bicycle to a friend's house. While pedaling home through the ditch in his own front yard, he was hit hard from behind by a drunk driver swerving off the road. At the hospital, Fonville saw that his son's leg was scraped down to the bone. He promptly passed out, leaving Helen to handle the medical decisions. In the end, Dr. Tommy Thompson packed the torn-off muscle tissue back onto the leg and put Walker in a cast. A year later Walker received a skin graft, and he was soon walking without a limp.

While a senior in high school, Walker joined the U.S. Navy Reserve. After graduation, he moved to Treasure Island, California, to attend the Navy's electronics technician school. He became a licensed electronic technician as well as a licensed amateur radio operator. He is still a ham operator today (WB5MPV).

Walker. This photo was used as part of a fire-prevention campaign.
(Courtesy Melinda and Walker Winans)

Bob, Meriget, and Walker, 2015. (Photo by Cynthia LeJeune Nobles)

From 1965 to 1968, Walker spent time aboard the aircraft carrier USS *Wasp* as an electronics technician. The ship was the primary recovery vessel for the Gemini IV, VI, VII, IX, and XI manned space missions.

Walker's jobs in Baton Rouge included conducting ship radar and safety inspections, as well as two-way radio service. For a short time, he operated his own radio repair and installation business on Winbourne Avenue. At one point Walker took flying lessons, as his workplace was within walking distance of the old Baton Rouge airport, which is now the location of Independence Park on Lobdell Avenue.

During a brief tenure at a local television shop, Walker gave Fonville his first microwave oven. Fonville called the new contraption an "electronic oven." One of his favorite uses for a microwave was to put live, unshelled oysters inside and cook them a minute or so until they popped open, thereby cutting out a lot of hard work.

Walker spent the majority of his working career at the LSU Coastal Studies Institute, where, for thirty-two years, he designed and built oceanographic, geological, and meteorological instruments. His work allowed him to travel to such far-flung locations as China, the Arctic, Egypt, Greece, Indonesia, and Australia.

Although Walker clearly inherited his father's talent for inventing and tinkering, he did not have much interest in professional photography. He took portraits in his father's studio for only a year before calling it quits.

EXTRA GOOD TOMATO SOUP

Makes 3 cups

Note from Fonville, January 25, 1972: "Somehow or another this turned out to be the best T.S. I've ever made—this was 'by ear.'"

1. In a medium saucepan, place tomatoes, water, butter, salt, pepper, thyme, and parsley. Bring to a boil over medium heat and cook, uncovered, 5 minutes.

2. Cool tomato mixture slightly and puree in a blender. Press through a sieve to remove any remaining seeds and peel.

3. In a medium saucepan over medium heat, bring to a boil the milk, baking soda, sugar, and food color. Stir in the tomato puree and bring to a simmer. For thicker soup, dissolve flour in a few tablespoons of water, add to soup, and simmer 2 minutes. Serve hot with crackers.

2 large tomatoes, sliced

½ cup water

1 tablespoon butter

¾ teaspoon salt

¼ teaspoon ground black pepper

⅛ teaspoon dried thyme

Pinch of dried parsley

1 cup whole milk

½ teaspoon baking soda

½ teaspoon sugar

Drop or 2 red food color, optional

1 teaspoon all-purpose flour, optional

Crackers for serving

CHICKEN and ANDOUILLE GUMBO

Makes 4–6 servings

According to Fonville's notes, this was the first gumbo he ever cooked using andouille, the smoked coarse-grind pork sausage so popular in south Louisiana. Surprisingly, the date on this recipe is December 15, 1986, more than fifty years after he had "discovered" Grand Isle's Cajuns, the people who taught him how to make gumbo. The notes also reveal that Meriget and James were the lucky guests for this particular dinner.

1. Cover chicken with water in a large pot and simmer until done, about 45 minutes. Remove chicken from pot, reserving broth. When chicken is cool enough to handle, remove skin and bones and throw away. Chop meat and set aside.

2. Brown andouille in a large skillet over medium-high heat. Remove from skillet and set aside.

3. In a heavy-bottomed soup pot set over medium heat, make a roux by combining flour and oil and cooking, stirring constantly, until a rich brown color, like a walnut. Remove from fire and add bell peppers, celery, onion, and garlic. Stir until the pot stops sizzling.

4. Mix together the broth from the chicken and enough additional chicken broth to equal 5 cups. Carefully stir broth into the pot with the roux. Season with salt, black pepper, crab boil, and cayenne pepper. Simmer 1 hour.

5. Add chicken and andouille and boil 5 minutes. Ladle gumbo over rice in bowls and garnish with chopped parsley.

4 large chicken legs (thighs and drumsticks)

4 cups water

1 pound andouille, in ⅜-inch slices

¾ cup all-purpose flour

¾ cup vegetable oil

3 bell peppers, any color, seeded and chopped

3 stalks celery, chopped

1 medium onion, chopped

1 teaspoon minced garlic

4 cups chicken broth (approximately)

2 teaspoons salt

1 teaspoon ground black pepper

1 teaspoon dry crab boil (found in specialty stores or online), crushed in a mortar and pestle or spice grinder

¼ teaspoon cayenne pepper

Hot cooked rice for serving

¼ cup chopped parsley for garnish

MELINDA'S SAUERBRATEN with GINGERSNAP GRAVY

Makes 6 servings

A memory from Melinda: *"This is the recipe for that first dish I cooked for Fonville and Helen, and it's one Fonville cooked for Helen over and over again."*

1. Rub meat with salt and pepper. Place in a deep earthenware crock or a glass bowl. (Do not use a metal bowl.) Add onions, carrot, celery, bay leaves, cloves, and peppercorns.

2. Heat vinegar and 2½ cups water to boiling and pour hot liquid over the meat. Let liquid cool at room temperature. Cover the bowl tightly and refrigerate. Marinate for 72 hours, turning the meat twice each day.

3. When ready to cook, remove meat from the marinade and pat dry with paper towels. Strain and reserve marinade.

4. Melt butter in a heavy-bottomed Dutch oven set over medium-high heat. Brown meat well on all sides, being careful to not let it burn. Pour reserved marinade over the meat. Cover tightly and cook over a low simmer until fork tender, 2½ to 3 hours. Remove meat to a warm platter and cover with foil while making gravy.

5. To make the gingersnap gravy, heat 1½ cups of the marinade to a simmer. In a small skillet set over medium heat, melt the sugar and stir constantly until golden brown. Gradually stir in the hot marinade and ½ cup water. Add crumbled gingersnaps. Cook, stirring constantly, until thickened, about 10 minutes. Add sour cream if desired, and adjust for seasoning. Slice sauerbraten and serve with gravy over rice.

1 (3 to 4-pound) beef round or rump roast, cut thick

1 teaspoon salt

½ teaspoon ground black pepper

2 medium onions, sliced

1 small carrot, minced

1 stalk celery, chopped

4 bay leaves

8 whole cloves

½ teaspoon peppercorns

1½ cups red wine vinegar

Water

¼ cup (½ stick) butter

2 tablespoons sugar

⅔ cup crumbled gingersnaps (about 8 cookies)

½ cup sour cream (*optional*)

Hot cooked rice for serving

Melinda's Sauerbraten with Gingersnap Gravy. (Photo by Cynthia LeJeune Nobles)

CREAMED CHIPPED BEEF

Makes 4 servings

When Walker was a child, this was one of his favorite dishes.

1. Crumble 2 slices of toasted bread onto each of 4 plates. Set aside. Rinse beef well and chop. (If you don't rinse the beef, the dish will be too salty.) Set aside.

2. To make the sauce, in a medium saucepan over low heat, melt butter, stirring constantly, until it starts to turn golden brown, but not browned. Remove from heat.

3. Add flour, salt, and peppers and stir until mixture is smooth. Return to heat. Add milk all at once and stir until thick, about 1 minute. You should have two cups of white sauce.

4. Mix beef and eggs into white sauce and ladle over bread. Garnish with chives. Serve hot.

8 slices toasted bread

1 (4-ounce) jar dried beef

¼ cup butter

¼ cup all-purpose flour

1 teaspoon salt

¼ teaspoon cayenne pepper

⅛ teaspoon white pepper

2 cups milk

1½ teaspoons Worcestershire sauce

½ teaspoon instant minced onions

3 hard-boiled eggs, peeled and chopped

Chopped chives, green onions, or parsley for garnish

RED BEANS and RICE

Makes 8 generous servings

Fonville prepared bean dishes frequently. According to his notes, he created this recipe on December 17, 1958, and it was not perfected until January 4, 1989.

1. Place beans in a large bowl and cover with water by 2 inches. Cover and let soak overnight at room temperature.

2. Drain beans and put in a large pot. Add the ham bone, bell peppers, celery, Creole seasoning, salt, and cumin. Add enough water to cover by an inch. Bring to a boil and lower to a simmer. Cook, uncovered and stirring occasionally, until beans are tender and creamy. This will take at least 1 hour and up to 2 hours. While beans are cooking, add a little water if needed and be sure to stir occasionally so beans don't stick to the bottom. Serve warm over rice.

One-pound bag dried red beans

Water to cover beans

One leftover ham bone with meat

½ cup diced bell peppers

½ cup diced celery

1 tablespoon Creole seasoning (Fonville used Tony Chachere's brand)

1 tablespoon salt

1 teaspoon cumin

Hot cooked rice for serving

CREAM CHEESE and GARLIC–COATED GRAPES

Makes about 40

1. Separate grapes from stems. Wash grapes and dry well.

2. In a large bowl, mix cream cheese and garlic together until cheese is extremely smooth and free of lumps. Use a rubber spatula to gently stir in grapes. Cover and refrigerate 2 hours.

3. To serve, line individual salad plates with lettuce and spoon cheese-coated grapes on top.

1 pound seedless red or green grapes

8 ounces cream cheese, softened

2 tablespoons pressed garlic

Lettuce for serving

Cream Cheese and Garlic–Coated Grapes. (Photo by Cynthia LeJeune Nobles)

COLE SLAW

1. Mix cabbages and carrot in a medium bowl and keep chilled in refrigerator while making sauce.

2. In the top of a double boiler, whisk together the egg, vinegar, sugar, flour, salt, and peppers. Whisk constantly until mixture is the consistency of custard.

3. Remove from heat and whisk in oil, mustard, and dill. Pour hot dressing over cabbage. Stir well and chill completely before serving. Keeps covered in the refrigerator for 2 days.

½ small head green cabbage, shredded

½ small head purple cabbage, shredded

¼ cup shredded carrot

1 hard-boiled egg, finely chopped

¼ cup cider vinegar

¼ cup sugar

1 tablespoon all-purpose flour

1 teaspoon salt

Cayenne pepper and ground black pepper to taste

¼ cup vegetable oil

1 tablespoon prepared mustard

½ teaspoon dried dill

Cole Slaw. (Photo by Cynthia LeJeune Nobles)

BAKED PATTYPAN SQUASH

Makes 6 servings

Meriget says pattypan—a small, flattish-round summer squash with scalloped edges—was her father's favorite variety. According to Fonville's notes, leftovers of this particular dish were excellent.

1. Preheat oven to 350°F. Cook rice according to package directions. Meanwhile, add bread to a blender and process into bread crumbs. Set aside.

2. In a large frying pan over medium heat, fry bacon until crisp. Remove bacon and reserve. Leave rendered fat in pan. Add squash, onion, celery, and bell pepper and cook, stirring occasionally, until squash and onion are soft, about 7 minutes.

3. Add rice, bread crumbs, broth, jalapeño pepper, peppercorns, salt, crab boil, and garlic powder. Cover and cook over medium-low heat 5 minutes, stirring occasionally. Remove pan from heat and let mixture cool 5 minutes.

4. Mix egg and parsley into squash mixture. Transfer into an oiled 2-quart casserole dish and top with cracker crumbs, reserved bacon, dots of butter, and basil. Bake until brown and bubbly, about 30 minutes. Let sit at least 5 minutes. Serve warm.

½ cup Minute (instant) rice, uncooked

2 slices stale white bread

3 slices thick bacon

2¼ pounds pattypan squash, unpeeled, cubed

1½ large yellow onions, diced

1 cup diced celery

1 large bell pepper, diced

½ cup chicken broth

1 jalapeño pepper, seeds and spine removed and finely diced

12 black peppercorns, crushed

1½ teaspoons salt

1 teaspoon dry crab boil (found in specialty stores or online), crushed in a mortar and pestle or spice grinder

¼ teaspoon garlic powder

1 large egg

4 teaspoons minced parsley

8 saltine crackers, crushed into crumbs

1 tablespoon butter

2 tablespoons minced fresh basil

Self-Portrait, 1950s. (Courtesy Melinda and Walker Winans)

In Search of Perfect Pig's Feet

There's a diff[erence] between pig's feet and pig's feet. Some are small and some big.
There seem to be no small ones, rather big ones—hog's feet!

—Fonville Winans, notes on his recipe for pickled pig's feet

Fonville recycled before it was hip, and his abhorrence of wasting anything was reflected in his studio, that happy mishmash of clutter. But although he was famously disorganized, when it came to developing photographs, he demanded perfection. Prints lesser photographers would have celebrated as magnificent were routinely tossed into the trash. And he did not quibble about using up expensive photographic paper, chemicals, or any other raw materials he might need to produce an impeccable shot. Spending whatever it took to achieve excellence, however, usually stopped in the darkroom. In the kitchen, and just about anyplace else, perfection certainly was the norm, but the Daddy Warbucks mentality definitely was not.

To prove their point, the Winans family likes to tell the story of the gallon of pickled pig's feet that seemed always to be stashed in the refrigerator. Fonville was what we now call a grazer. Instead of sitting down and consuming a whole meal, he would pick and nibble throughout the day. The jars of brined pork served as a handy snack, and they were also often a meal.

As with most of his favorite foods, Fonville tried hard to perfect a pickled pig's feet recipe. He could have easily bought a jar whenever he wanted, but the cost would have been double or triple, and the quality would not have met his standards. Instead, he lavished large amounts of time on pig's feet experiments and revised his recipe at least ten times.

As usual, he made sure the ingredients he purchased were the best bargain. Raw pig's feet typically came from a grocery on Washington Street in South Baton Rouge. The market was nowhere near his home, but he drove the many miles it took to get there to take advantage of cut-rate prices. (This same store also sold alligator meat, a delicacy Fonville took home but cooked only once because of unfavorable reviews.)

Ice on the Mississippi River. (Fonville Estate Collection, courtesy Robert L. Winans)

With each testing he made meticulous notes, including scribblings that show his frustration with finding a uniform size of raw hoofs. One time, his pressure cooker overcooked the feet. After several more experiments, he discovered that a Dazey slow cooker is best for the task.

Aside from pickling his own pig's feet, Fonville tried to save money by foraging. In the fast-growing era of convenience foods, the 1950s–70s, this fascination with picking wild foods could have also branded him a culinary rebel.

Fonville did not have the patience to cultivate a garden, but a gigantic fig tree and six large banana trees grew in the backyard. Wild blackberries clung to the fences, and in the front yard grew palatable wild onions.

Some of the more unusual edibles he occasionally served were considered weeds. Before subdivisions grew up around the family's Old Goodwood neighborhood, the area was surrounded by pastureland, in which grew thistles and poke. To Fonville, the prickly, flowering thistle was a delicacy. Once he had gathered enough, he would skin the tough inner cores, braise them, and serve them dressed with vinaigrette.

Poke is a leafy green that is poisonous unless picked at the right time and prepared properly. Fonville boldly and regularly gathered the leaves of these young plants, and he would boil them and serve his greens with cornbread.

Another food he foraged was mushrooms, which he typically stir-fried Chinese style. Gathering mushrooms was often a Sunday afternoon activity in the summer. When the children were young, Sundays usually began with services at St. James Episcopal Church downtown, followed by lunch at the Piccadilly Cafeteria on Third Street. Afterwards, Fonville often packed everyone into the car and drove south about twenty minutes to an oak tree in a cow pasture on Gardere Lane, which was home to the chantrelle, a gold-tinged, smooth-capped fungus. Another Gardere Lane field was full of *Agaricus campestris,* a wild mushroom commonly known as the field or meadow mushroom, and closely related to the button mushroom common in grocery stores. *Agaricus campestris* also occasionally grew in the Winanses' front yard and in an empty lot next door. This brown-gilled white fungus was Fonville's favorite mushroom.

A professor at LSU taught Fonville how to distinguish mushrooms, but he apparently did not learn his lesson well. At least twice, he was hospitalized for consuming poisonous mushrooms. In 1972, he contracted hepatitis after eating contaminated mushrooms. Unable to make a diagnosis and fearing that Fonville was carrying something contagious, his doctors quarantined him in the hospital. Fonville finally figured out that mushrooms were the culprit. His embarrassed doctors did not charge him for their services or that hospital stay.

This obsession with finding thrifty food sources came to the forefront during a family fishing trip. Typically, whatever came home from the coast ended up on the Winanses' dinner table. One April day in 1975, Fonville took Helen on an outing to Grand Isle. There, Helen purchased squid for bait. No one remembers if she caught any fish. But saved slips of paper show that her package of bait weighed five pounds, and that three recipes were printed on the box in German.

Apparently, Helen only used half the squid to bait her hook. Fonville, the original frugal gourmet, took the rest back to Baton Rouge, where he found someone to translate one of the recipes. He then turned Helen's bait into a dinner of squid braised in tomato sauce. His notes reveal that the squid did not taste that good. But he did like the fact that it made a cheap meal.

Helen Fishing. [Fonville Estate Collection, courtesy Robert L. Winans]

Fishing on False River. (Fonville Estate Collection, courtesy Robert L. Winans)

PICKLED PIG'S FEET

Makes 1 pint

1. Place pig's feet in a large stockpot or slow cooker. Cover with water and add salt. Bring to a boil, lower to a simmer, cover, and cook until the bones come loose, about 2 hours.

2. Meanwhile, in a medium saucepan, combine ½ cup water, bay leaves, cloves, black pepper, mace, and cayenne pepper. Bring to a boil, lower to a simmer, and cook 2 minutes. Remove from heat and allow to sit at room temperature.

3. When pig's feet are tender, strain and discard liquid. When meat is cool enough to handle, remove bones and excess fat.

4. To the prepared seasoning liquid in the saucepan, add vinegar and bring to a boil. Pack meat in a clean glass pint jar. Pour pickling juice over feet, making sure they are completely covered. Cover tightly and refrigerate 2 to 4 hours before serving. Keeps up to 2 weeks in the refrigerator.

2 large pig's feet (2 pounds), each split in half

Water

2 teaspoons salt

2–3 bay leaves

½ teaspoon whole cloves

½ teaspoon ground black pepper

¼ teaspoon ground mace

¼ teaspoon cayenne pepper

¾ cup cider vinegar

SUNDAY POT ROAST

Makes 6 servings

Fonville would put this roast in a slow cooker before church on Sunday, and the family would sit down to dinner in the late afternoon.

1. Wipe roast with damp paper towels. Combine 2 tablespoons flour, salt, and pepper and rub on all sides of the roast.

2. Heat vegetable oil in a large skillet or Dutch oven over medium-low heat. Using tongs to turn, brown meat well on all sides.

3. Transfer meat to a slow cooker. (Don't clean pan you browned the meat in.) To the slow cooker, add wine, bay leaf, and enough water to cover the meat. Add carrots, potatoes, onions, and celery and cook on low setting until meat is tender, about 4–5 hours. Discard bay leaf. Remove meat and vegetables to a platter and keep warm in oven on a low setting.

4. To make gravy, skim off fat and strain cooking liquid through a coarse sieve, pressing down hard on any remaining vegetables. Add water to make 2½ cups liquid and pour into pan you browned the meat in. Turn heat to high, and as liquid boils, scrape up the brown bits at the bottom. Boil hard 2 minutes.

5. Combine remaining 2 tablespoons flour with ½ cup cold water and stir until smooth. Slowly stir into hot liquid. Bring back to a boil, stirring constantly. Reduce heat and simmer 5 minutes. Add salt and pepper to taste.

6. Pour gravy into a gravy boat and serve over rice, along with the warm pot roast and vegetables.

3½ to 4-pound eye of round roast

4 tablespoons all-purpose flour, divided

Salt and pepper to taste

1 tablespoon vegetable oil

1 cup dry red wine

1 bay leaf

Water

6 whole baby carrots

6 baby potatoes, cut in half

2 onions, chopped into quarters

2 stalks celery, chopped into large pieces

Hot rice for serving

Shrimp and Ham–Stuffed Mirlitons. (Photo by Cynthia LeJeune Nobles)

SHRIMP and HAM–STUFFED MIRLITONS *Makes 4 servings*

Although Fonville did not grow mirlitons in his yard, a producing vine did grow wild by Ward's Creek, which ran just behind the Winans property.

1. Cut the mirlitons in half lengthwise. Boil until fork tender. Drain and cool. Remove seeds and scoop out the mirliton pulp, leaving a ¼-inch of pulp in the shell. Reserve both the pulp and the shells.

2. Preheat oven to 350°F. In a skillet set over a medium-high flame, heat the oil and sauté onion, celery, and bell pepper until tender, about 5 minutes. Mash the reserved mirliton pulp with a fork and add it, along with the ham and shrimp. Cook until shrimp turn pink, about 2 minutes.

3. Add ¼ cup bread crumbs, rice, salt, and cayenne pepper. Fill the reserved mirliton shells with the stuffing.

4. Dust tops with remaining ¼ cup bread crumbs and bake until deep brown, about 30 minutes. Garnish each with chopped parsley, green onions, and a shrimp.

- 2 large mirlitons (vegetable pears)
- 1½ teaspoons vegetable oil
- ¼ cup diced onion
- 2 tablespoons diced celery
- 2 tablespoons diced red and yellow bell pepper
- ½ cup chopped ham
- ½ cup chopped shrimp, plus 4 whole cooked shrimp for garnish
- ½ cup seasoned Italian bread crumbs, divided
- 2 tablespoons cooked rice
- 1 teaspoon salt
- Dash of cayenne pepper
- Chopped parsley and green onions for garnish

OYSTER-STUFFED MUSHROOMS *Makes 8 appetizer servings*

1. Preheat oven to 425°F. Remove stalks from mushrooms and discard. Wipe caps dry. In a large skillet, heat 4 tablespoons butter over medium heat. Sauté mushrooms until just cooked through.

2. Put mushrooms, open side up, into a shallow baking dish. Place an oyster in each mushroom. Sprinkle with sherry, salt, and pepper. Top each with a dab of remaining 2 tablespoons butter.

3. Bake until edges of oysters begin to curl, about 10–15 minutes. Remove from oven, garnish with parsley, and serve immediately.

- 8 large *Agaricus campestris* mushrooms, or purchased button mushrooms
- 4 tablespoons (½ stick) butter, plus 2 tablespoons
- 8 raw oysters, patted dry
- Sprinkles of dry sherry
- Salt and pepper to taste
- Chopped parsley for garnish

WILD ONION CASSEROLE

Makes 6 servings

1. Preheat oven to 350°F. In a large skillet set over medium heat, cook bacon until crisp. Remove and crumble bacon and set aside. Reserve grease in pan.

2. To same skillet with bacon grease, add flour and stir over medium heat 1 minute. Add milk and then onions and cook, stirring constantly, until smooth and thick, about 2 minutes. Remove skillet from heat and stir in reserved bacon, cheese, pulverized bread, cayenne pepper, and salt. Pour into a 9-inch glass pie plate and top with bread crumbs.

3. Bake until set and lightly browned, 25–30 minutes. Let sit at room temperature at least 15 minutes. Serve warm.

2 slices bacon

2 tablespoons all-purpose flour

1 cup milk

2 cups minced wild onions or purchased small green onions, bottoms and tops

½ cup grated rat cheese or Cheddar cheese

2 slices stale bread, pulverized in a blender

¼ teaspoon cayenne pepper, or to taste

¼ teaspoon salt

¼ cup bread crumbs

PEAS and MUSHROOMS

Makes 4 servings

Helen developed this "exquisite" recipe, and Fonville enjoyed cooking it in his "electronic oven," his 800-watt microwave. Although he often cooked wild mushrooms he collected from his front yard and the lot next door, for this recipe he wrote, "We used fresh mushrooms from the grocery store as some wild mushrooms are poisonous."

1. If using dried mushrooms, soak in warm water 20 minutes and drain. Discard water.

2. Combine all ingredients in a microwaveable dish. Cook for 8 minutes at 100% power in a microwave with wattage of 700–800, which Fonville owned, or at 50% power in a microwave with 1100–1200 wattage. Serve hot.

¼ cup dried *Agaricus campestris* mushrooms, or fresh button mushrooms

1¼ cups frozen green peas

2 tablespoons butter (no more)

2 teaspoons cornstarch

A sprinkle of tarragon

A sprinkle of salt

A sprinkle of cayenne pepper

Peas and Mushrooms. (Photo by Walker Winans)

Fried Bananas. (Photo by Walker Winans)

FRIED BANANAS

Makes 6 servings

1. In a large bowl, combine flour, molasses, cinnamon, and baking powder. Add buttermilk and eggs and whisk until batter is smooth. Set batter aside.

2. In a deep fryer or a large, deep pot, heat 2 inches of oil to 350°F. Use a long fork to dip chunks of banana in batter. Drop coated bananas into hot oil and fry until golden, about 3–4 minutes. Drain on paper towels and transfer to a serving platter. Sift confectioners' sugar liberally on top. Serve warm.

1 cup all-purpose flour

2 tablespoons light molasses

1 teaspoon cinnamon

½ teaspoon baking powder

¾ cup buttermilk

2 large eggs

Vegetable oil for frying

6 large, firm bananas, peeled and sliced on the diagonal into 2-inch chunks

Confectioners' sugar for dusting

BLACKBERRY COBBLER

Makes 8 servings

1. Preheat oven to 350°F. Butter a 2-quart baking dish. In a large saucepan, combine blackberries, 1 cup sugar, and cinnamon. Bring to a full boil over medium heat. In a small bowl, combine water and cornstarch and stir until smooth. Add cornstarch mixture to berries, bring back to a boil, and cook 2 minutes. Mixture should be thick. Pour into prepared dish.

2. In a large bowl, combine flour, baking powder, salt, and remaining tablespoon sugar. Cut in butter until mixture resembles coarse crumbs. Stir in egg until everything is well combined and forms a stiff dough. Crumble dough evenly over hot berries.

3. Bake, uncovered, until bubbly and brown, about 30–35 minutes. Let cool at least 30 minutes before serving. Serve topped with whipped cream.

1 quart fresh or frozen blackberries

1 cup, plus 1 tablespoon sugar, divided

½ teaspoon cinnamon

⅓ cup water

3 tablespoons cornstarch

1¼ cups all-purpose flour

1½ teaspoons baking powder

½ teaspoon salt

6 tablespoons cold butter, cubed

1 large egg, beaten

Whipped cream for serving

Blackberry Cobbler. (Photo by Cynthia LeJeune Nobles)

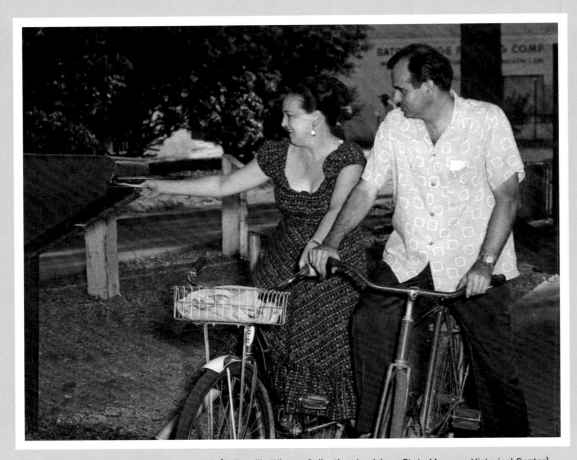

Helen and Fonville on bicycles, ca. 1950. (T. Fonville Winans Collection, Louisiana State Museum Historical Center)

The World from a Bicycle

Schwinn sent me about a dozen caps, saying it was the least they could do
for a fellow who started bicycling in the South.

—Fonville Winans to Anne Price of *Baton Rouge Advocate Sunday Magazine* (March 11, 1990)

Fonville was a dedicated bike rider, and virtually every working day of the last half of his life, he pedaled the six miles it took to reach his downtown studio. His typical riding outfit was a blue or gray jumpsuit and a beret or a white baseball cap emblazoned with the word "Schwinn."

As with most everything he pursued, he became obsessed with bicycling. He bought two custom-made bikes in the 1950s, while on a trip speaking at a photography convention in Chicago. In the audience was an ardent hobbyist who also happened to be a manager for the Schwinn bicycle factory. The two connected by discussing photography, which led to an invitation to the Schwinn plant to be measured for a bike. Fonville ordered two identical bicycles, both chrome with Cinelli wheels, Campagnolo derailleurs, and custom gear ratios tailored for his strengths. He paid $1,200 for each, quite a price tag for the time. He was also schooled on maintaining these newfangled vehicles, which ran on ten

gears. When ten-gear bicycles appeared in Baton Rouge, bike shops called Fonville for help.

Fonville was pleased as he could be with his new bikes, and he began riding long distances, either with other cyclists or on his own. He would think nothing of pedaling eighteen miles to visit his friends Jack and Glenna Uhler in the town of Plaquemine across the Mississippi River. He would also catch up with the Uhlers at their fishing camp, some thirty miles south of Baton Rouge near the Intracoastal Canal. On these trips, Helen often motored down behind him in the family car. Depending on the amount of alcohol Fonville consumed, she might return to Baton Rouge with his bicycle in the trunk.

After work, Fonville often rode to the homes of family friends, such as May Gunderson, Jack Gremillion, and Marjorie Matey, who would provide snacks and cocktails. Throughout the years, while riding both tipsy and

One day a policeman pulled Fonville over on his bicycle for exceeding the speed limit in a thirty-mile-per-hour zone. He was released with a verbal warning.

sober, Fonville was struck many times by automobiles. His ninth clash with a car was a hit-and-run. While interviewing him at the hospital, the police tried to get all the details they could, and they asked if he could describe the vehicle. Fonville couldn't recall much, but he volunteered that it "felt like a Volkswagen."

His worst bicycle accident happened while he wasn't riding. Fonville often visited the small historic town of St. Francisville, some thirty miles north of Baton Rouge. On one particular trip in the summer of 1967, he was in a friend's driveway on his bike trying to show off a balancing act. Things went horribly wrong and he fell over, breaking his leg in three places and ending up crippled for a year. While recovering at home, the restless Fonville turned to cooking, among other activities. The most memorable dish he created during this convalescence was a dessert he named Leg-in-a-Cast Flan, which remains a family favorite to this day.

In his later years, Fonville hosted bicycle tours. Sometimes his groups would drive cars to St. Francisville, where they would unload their bikes. If the guided tour was in Baton Rouge, the route typically wound around City Park and University Lakes. Baton Rouge trips usually included a stop at a coffee shop in Tiger Town or brunch at a nearby restaurant. On at least one occasion, Fonville invited his group of cyclists to his home, where he cajoled guests into preparing hot dogs. Diane Saye, who was on that trip, recalls that the impromptu cooks were required to use Fonville's precise instructions. She kept notes on the process, which involved throwing three packages of wieners into a pot of cold water, bringing the pot to a boil over high heat, and simmering the wieners until they were ready to pop open, but not split. The cooking process took exactly twenty-nine minutes.

Back in 1964, Fonville and fellow bicycle enthusiast Roy Odom formed the Baton Rouge Bicycle Club. Today, under the name Baton Rouge Bike Club, that organization is still going strong.

By the 1980s, despite his national fame as a photographer, Fonville was known by many in Baton Rouge simply as the gray-haired man in a jumpsuit and baseball cap who pedaled down Government Street every morning. Today, one of his bicycles resides at the Cabildo in New Orleans, and grandson Beau (Fonville) has the other.

St. Francisville was at one time a major producer of sweet potatoes. One of the friends Fonville would bicycle to see there was the owner of Solitude Plantation and was also in the sweet potato processing business. After a day of catching up on things, Fonville often arrived home from Solitude with a free load of defective cans of sweet potatoes.

Fonville with Pace the Dove. (Line drawing by James Turner)

St. Peter Street in New Orleans.
(Fonville Estate Collection, courtesy Robert L. Winans)

AVOCADO DIP

Makes 12 servings

Mix avocados with all ingredients except paprika, until slightly creamy but still chunky. Sprinkle with paprika. Serve immediately with chips.

3 avocados, peeled, seeded, and chopped

8 ounces cream cheese, softened

2 tablespoons freshly squeezed lemon juice

1½ tablespoons minced onion

1½ teaspoons Worcestershire sauce

1½ teaspoons salt

½ teaspoon garlic juice

Sprinkle of paprika

Corn chips for serving

JOOK (Congee, Rice Soup)

Makes 4 servings

Jook is a creamy Chinese-style rice soup appropriate at any meal, and Fonville served it often. Many traditional recipes call for embellishing jook with meat and vegetables. Fonville's favorite style was plain, but occasionally he did serve it with salty or spicy accompaniments.

1. Rinse rice under running water, rubbing the grains together between the palms of your hands. Continue rinsing until the rice water runs clear.

2. Put rice, water, tangerine, ginger, sugar, and salt in a large, deep saucepan. Bring to a boil. Reduce heat to low and simmer, covered, until rice thickens and becomes porridge-like, about 2 hours. Stir occasionally to prevent rice from sticking. Use a whisk to make it creamy, and adjust with water to make thicker or thinner.

3. Serve hot in individual soup bowls. Top with accompaniments.

½ cup raw rice

6 cups water

1 tablespoon chopped dried tangerine, optional

¼-inch piece peeled, minced fresh ginger, optional

½ teaspoon sugar, optional

Salt to taste

Optional toppings: mint, scallion, cilantro, soy sauce, chili sauce, cooked beef, chicken, turkey, pork, or fish

FON'S BEEF and SQUASH PIE

Makes 4 servings

Note from Fonville: "10-22-67 (Edna, Helen, Fon) I didn't leave the house today. Excellent."

1. Cut unpeeled squash into 1-inch pieces and steam until tender. Drain and set aside.

2. In a large skillet set over medium-high heat, fry beef in bacon drippings until brown, about 5 minutes. Add squash, onion, salt, and basil and cook 5 minutes, stirring constantly. Remove from heat and set aside to cool while making crust.

3. Preheat oven to 350°F. To make crust, combine crushed crackers, grated cheese, and melted butter. Divide in two and press one half into bottom of a 9×5×4-inch loaf pan.

4. Stir egg and sherry into cooled squash mixture and spoon over crust in pan. Crumble remaining half of crust on top and sprinkle with crushed pepper. Bake until light brown, 25–30 minutes. Cool slightly and serve warm.

1 pound pattypan squash, or any summer squash

¼ pound ground beef

1 tablespoon bacon drippings

1 tablespoon minced, dehydrated onion, or ¼ cup fresh

1 teaspoon salt

1 teaspoon finely chopped sweet basil

16 saltine crackers, crushed fine

2 ounces hot pepper cheese, grated (½ cup grated, packed)

3 tablespoons butter, melted

1 large egg

1 teaspoon sherry

Crushed red pepper, without seeds, to taste

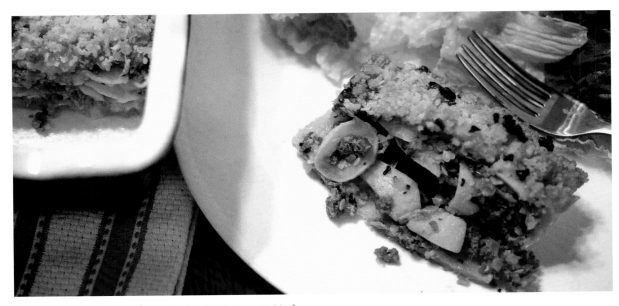

Fon's Beef and Squash Pie. (Photo by Cynthia LeJeune Nobles)

CRAWFISH STEW

Fonville developed more than twelve recipes for crawfish stew. His notes hint that this version is the one he thought the best.

1. Mince 1 pound of crawfish tails. Bring water to a boil in a large saucepan and add minced crawfish. Add red food coloring if desired and simmer 15 minutes. Remove from heat and set aside to "ripen" for 1 hour.

2. While crawfish is cooling, in a small bowl, combine onion, celery and tops, green onions, garlic, crab boil, and thyme. Set aside. In a separate small bowl, combine salt, sugar, and cayenne pepper. Set aside.

3. In a 7-quart iron pot set over medium heat, make a roux by mixing together flour and oil and cooking, stirring constantly, until the mixture is the color of dark chocolate, about 7 minutes. Stirring constantly, add onion mixture. Continue to stir constantly until onion is tender, about 7 more minutes.

4. Add salt mixture. Stir in minced crawfish and its liquid and remaining half pound of whole crawfish tails. Bring to a boil and lower to a simmer. Cook 5 minutes. To serve, spoon over rice and garnish with parsley and green onions.

1½ pounds peeled, fresh or frozen crawfish tails, divided

5¾ cups water

1 to 2 drops red food coloring (*optional*)

2 cups chopped yellow onion

⅓ cup chopped celery, with tops

⅓ cup minced green onion tops, plus additional for garnish

6 cloves garlic, minced

½ teaspoon dried crab boil (found in specialty stores or online), crushed in a mortar and pestle or spice grinder

¼ teaspoon dried thyme or ½ teaspoon fresh

1 teaspoon salt

½ teaspoon sugar

⅛ teaspoon cayenne pepper

1 cup all-purpose flour

1 cup vegetable oil

½ teaspoon ground black pepper

Chopped parsley for garnish

Fast, Simple
SHRIMP SCAMPI with LINGUINI

Makes 4 generous servings

Fonville often purchased shrimp in frozen five-pound blocks, and he would save the defrosted freezer-burned "edges" and the shrimp tails to make stock. For this recipe he used bagged frozen shrimp. Blanched fresh shrimp works wonderfully, too.

1. Run hot water over shrimp to defrost. Remove tails and discard or freeze for another day to make stock. Drain shrimp on paper towels.

2. Heat bacon grease and butter in a wok set over medium-high heat. Add garlic and sauté until light brown, about 30 seconds. Add shrimp and parsley and sauté 2 more minutes. Stir in wine and Creole seasoning. Remove from heat and set aside.

3. Stir linguini into mixture in the wok. Serve immediately.

1 (1-pound) bag cooked, frozen shrimp (51–60 count), peeled, with tails

4 tablespoons bacon grease or vegetable oil

4 tablespoons butter

3 large cloves garlic, minced

½ bunch fresh parsley, finely chopped

1 jigger Chardonnay wine

A sprinkle of Creole seasoning (Fonville used Tony Chachere's brand)

8 ounces linguini, cooked and drained

FANCY SWEET POTATOES

Makes 6 servings

1. Heat oven to 350°F. Mix together sweet potatoes, ¼ cup brown sugar, 4 tablespoons butter, milk, eggs, and vanilla. Pour evenly into a 2-quart casserole.

2. In a small bowl, mix together the remaining cup of brown sugar, remaining 4 tablespoons melted butter, coconut, pecans, and flour. Sprinkle over top of potatoes. Bake until coconut is browned, about 30 minutes. Serve warm.

3 cups cooked, mashed sweet potatoes

1¼ cups light brown sugar, divided

8 tablespoons (½ stick) butter, melted, divided

½ cup whole milk

2 large eggs

1 teaspoon vanilla extract

1 cup flaked coconut

1 cup chopped pecans

½ cup all-purpose flour

Mint Julep. [Photo by Cynthia LeJeune Nobles]

MINT JULEP

Makes 1 drink

Crushed ice

1 cube sugar

Leaves from 4 sprigs fresh spearmint, plus a sprig for garnish

2 ounces good Kentucky bourbon

Powdered sugar

1. Fill a tall glass with crushed ice and set aside. In an old fashioned glass, crush sugar cube. Add mint leaves and bruise slightly.

2. Add bourbon and mix together. Pour over the crushed ice in the tall glass. Stir briskly until glass is frosted on the outside.

3. Garnish with a sprig of spearmint and sprinkle with powdered sugar.

EVOLUTION OF A RECIPE

Fonville was a perfectionist, and he was rarely satisfied with any recipe. Even if he liked what came out of the pot, curiosity drove him to try to make things better. In addition to ingredient and procedure changes, his pages and pages of recipes include dates, guest lists, and ratings. Diners, who were usually family members, were typically listed by first name only. When it came to recording the taste of recipes, his notes often included his own coded rating system: VG (very good), VVG (very, very good), and NG (no good).

Leg-in-a-Cast Flan illustrates Fonville's recipe development. He took an interest in making this silky, caramel-topped dessert in 1963, and he perfected his recipe in 1968 while recuperating at home from a broken leg. Over the years, he made small adjustments to the basic recipe and kept meticulous notes on these experiments. The following recipe (page 138) is based on the version he created on January 23, 1968. His notes on this recipe page reveal that he made essentially the same version on December 13, 1968, December 21, 1968, March 21, 1970, November 27, 1983, December 4, 1983, April 27, 1985, and February 13, 1989. He also left behind several subsequent versions, but his family remembers that he always came back to this one, recognizing it as his "classic." He called this one "perfect," and his family considers it one of his best dishes.

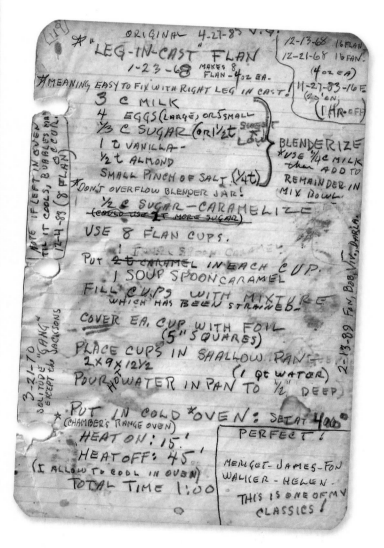

Left: Flan recipe 1 (October 26, 1963) and flan recipe 3 (November 27, 1963). *Right:* Fonville's "Classic" Leg-in-a-Cast Flan recipe (January 23, 1968). (Photos by Walker Winans)

LEG-IN-A-CAST FLAN

Makes 8 (4-ounce) servings

Make this recipe a day ahead.

1. Put milk, eggs, ⅓ cup sugar, vanilla extract, almond extract, and salt in a blender and blend until smooth. Strain and set aside.

2. Caramelize the remaining ½ cup sugar by placing it in a small cast-iron skillet over medium-high heat and stirring constantly until it melts and just starts to foam. At the first inkling of foaming, remove from heat and keep stirring until it reaches an amber color.

3. Divide caramel among 8 oven-safe ½-cup custard cups. Top the caramel with the custard mixture. Center a foil square on top of each cup and wrap tightly down the outer sides of cups to form a tight, flat cover.

4. Stand cups in a 9×12-inch baking pan with at least 1-inch sides. Pour 1 quart of hot water into the pan around the cups. Water should reach a depth of ½ inch. Put pan with custard cups into a cold oven and set temperature to 400°F. Bake 15 minutes and turn off heat.* Let sit in unopened oven 45 minutes.

5. Remove cups from pan and chill overnight. The next day, remove the foil, run a knife around the sides of the custard cups, and flip the flans over onto serving plates. Serve cold. (Before flans are flipped out of their cups they can be refrigerated up to three days. This longer sitting time also makes the caramel more liquid and less likely to stick.)

*Fonville's oven would heat quickly. After starting in a cold oven, his flan took only 15 minutes to bake. If your oven does not get up to temperature fast, consider preheating it first.

3 cups whole milk

4 large or 5 small eggs

⅓ cup, plus ½ cup sugar

1 teaspoon good vanilla extract

½ teaspoon real almond extract

Just less than ¼ teaspoon salt

8 (5-inch) squares of aluminum foil

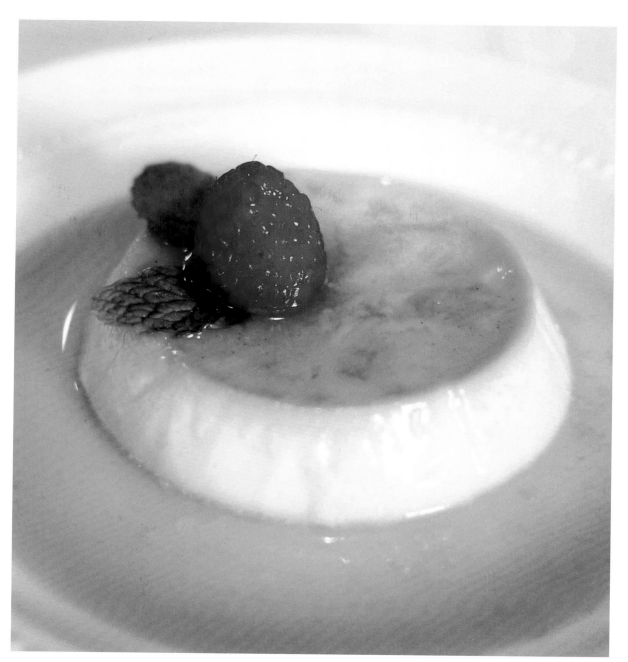

Leg-in-a-Cast Flan. (Photo by Cynthia LeJeune Nobles)

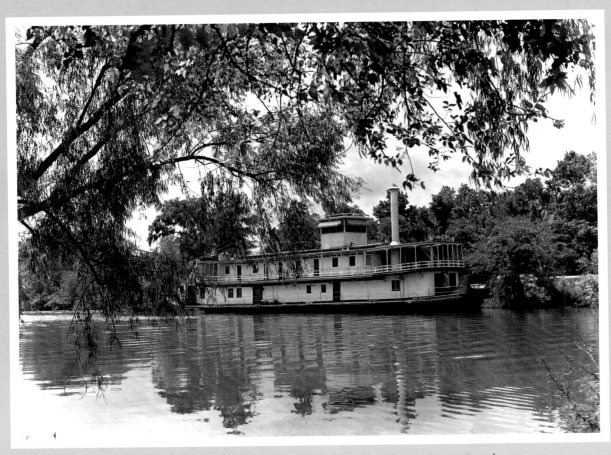

River Boat on Bayou Teche. (Fonville Estate Collection, courtesy Robert L. Winans)

CHAPTER 9

If It Lives in Water . . .

I can call alligators, but you have to watch and not do it near the water or they will come after you.
—Fonville Winans to writer Anne Price of *Baton Rouge Advocate Sunday Magazine* (March 11, 1990)

Fonville Winans was always drawn to bodies of water. Even at home in Baton Rouge, where he lived miles away from any natural waterway, it was not unusual to find him spending the cocktail hour soaking in the backyard plastic kiddie pool.

Fonville's favorite water spots were, of course, Louisiana's marshes and swamps, as well as the Gulf of Mexico. Helen, too, was a fanatic about spending time on Louisiana's coast, and she liked to fish. Unlike his wife, Fonville was too restless to sit around and hold a pole. He did, however, like the relatively more fast-paced activity of catching crabs.

During the three decades or so that Fonville's son Walker worked as a science support technician for the LSU Coastal Studies Institute, he had access to the latest information on aquatic activity on Louisiana's coast, including when crabs were running. He was always happy to share this news with his father, who often recommended that the two take a trip to Grand Terre, the still

virtually uninhabited island Fonville had spent so much time on in the 1930s.

To reach Grand Terre, the impatient Fonville preferred to travel the 150 miles by air. In the early to mid-1970s, a typical day of crabbing started with Walker and Fonville leaving home around seven o'clock and driving two blocks to what was then known as the "downtown airport," on Goodwood Boulevard. Walker, like his father, was a licensed pilot, and the two would jump into his 1948 Piper Vagabond side-by-side two-seater airplane and take off.

At Grand Terre, Walker would descend his Piper over the remains of the island's nineteenth-century defense fort, Fort Livingston. Working hard to avoid hitting power lines, he would land the plane on a grass strip that ran parallel to the beach.

Armed with an ice chest, bucket, string, and chicken necks, father and son would jump out of the plane and scour the beach for the stones and long sticks needed to

Crowd Gathering for Blessing of the Fleet. (Fonville Estate Collection, courtesy Robert L. Winans)

It's been said that Fonville had a strong Peter Pan complex. One water story has a bit of the poignant truth of that accusation. One day Meriget and I invited Helen and Fonville to our camp in Whitehall, Louisiana, about eighteen miles up the Amite River from Lake Maurepas. Our boat, named After You, was a sixteen-foot V-bottom cruiser with a canvas top and a 40 hp Evinrude motor. Fonville brought a gift of a large compass to mount on the boat's dashboard; he insisted that "we have a compass as good as the Pintail's," a boat fifty years older than mine.

For lunch that day, we boated to Middendorf's Restaurant on Lake Maurepas. As we remember, Fonville ordered a favorite, crispy fried catfish. On the way home, he talked us into going for a swim in the picturesque Amite River, with its ancient cypress trees and overhanging mosses. Though we were all full of good seafood and cold beer, we took a dip, and we like to never got Fonville back in the boat.

—Fonville's son-in-law, James Turner, 2016

create crab lines. Fonville had learned how to make the low-tech crab-catching mechanism back in 1932, when he cruised the area in the *Pintail*. The technique involved planting a four-to-five-foot stick in the sand along the shore. A long string was tied to the tip of the stick. Bait and a stone were tied onto the other end of the string, which was then tossed into the water. If Fonville and Walker tugged on the line and felt the line tug back, that meant a crab was chewing on the bait. The crab was gently pulled in by hand.

On good days, the two would fill their ice chest in just a few hours. Then they would climb back into the plane and fly home. By 2:00 p.m., the day's catch would be boiling on the kitchen stove or outside in a washtub. Sometimes Fonville used one of his favorite recipes, and sometimes he experimented with a new one.

Dinner guests included whoever happened to be around. That could be a houseful, since many people liked to drop by the Winans residence for afternoon cocktails. And, yes, in the days before air conditioning, imbibing guests would sometimes cool down with Fonville in that plastic backyard pool.

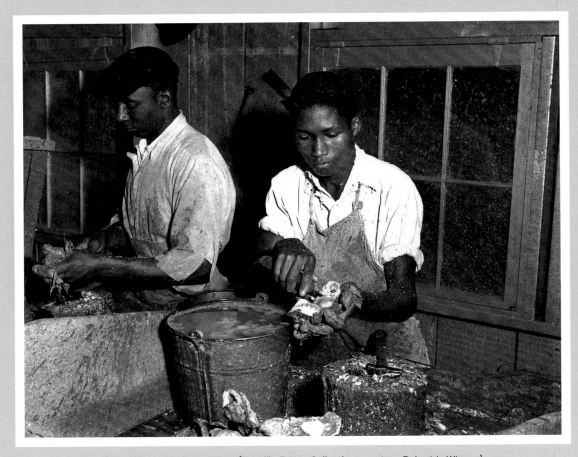

Shucking Oysters, late 1930s. [Fonville Estate Collection, courtesy Robert L. Winans]

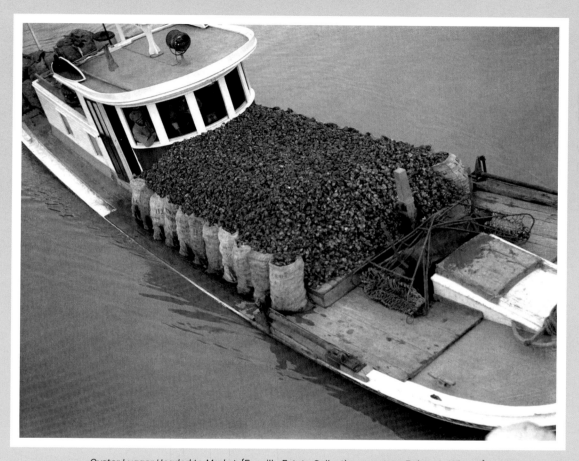

Oyster Lugger Headed to Market. [Fonville Estate Collection, courtesy Robert L. Winans]

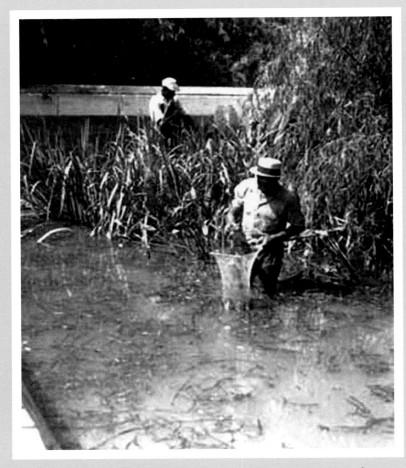

Men with Nets. (Fonville Estate Collection, courtesy Robert L. Winans)

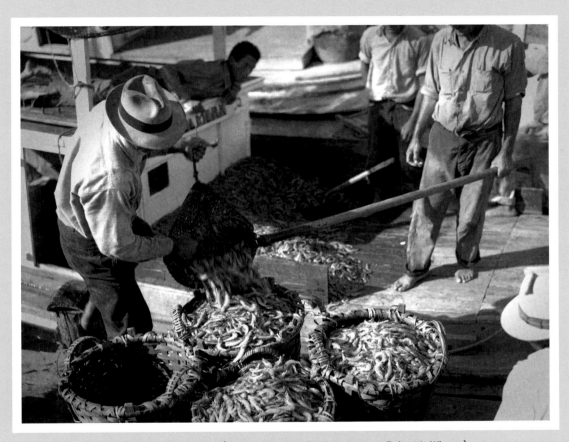

Shrimp Ready for Market. [Fonville Estate Collection, courtesy Robert L. Winans]

COOKING WITH JACK UHLER

Another watery destination where Fonville spent a lot of time was ten miles west of Plaquemine, near the junction of Upper Grand River and the Intracoastal Canal. It was there that his closest friend, Jack (John) Uhler, and his wife, Glenna, both librarians, kept a tin-roofed Cajun-style cottage with a wraparound porch. Jack had been a combat photographer in World War II. Like Fonville, he was a pilot, and he also loved to cook and observe cocktail hour.

Fonville and Jack had already been palling around for a long time when, in 1956, Fonville coordinated Jack's elopement with Glenna Knight, a teetotaler who grew up on a dairy farm and who was seventeen years younger than her new husband. Glenna remembers first meeting Fonville in 1955. He was already an established wedding photographer and, to her, he seemed larger than life and was extremely entertaining. She also fondly recalls that Fonville was one of the most personable human beings she has ever encountered, and that he "collected people"; he didn't care who—newspaper people, society types, trash collectors—it didn't matter.

In the heyday of their friendship, when Jack and Fonville took over the kitchen, which was most of the time, the menu almost always revolved around seafood prepared Cajun style, which was what Jack knew best. Jack was a so-called "dump" cook who never measured anything, while Fonville's ingredient amounts were always exact. Without ever arguing, they managed to combine their radically different cooking styles to produce outstanding meals that attracted a large array of guests.

Glenna and Jack were so fond of Louisiana cooking that they wrote two cookbooks. *Cajun Country Cooking* appeared in 1966, and in 1969 they published *Royal Recipes from Cajun Country*. In 1966, they also wrote a compendium of local cookbooks titled the *Rochester Clarke Bibliography of Louisiana Cookery*.

Jack was an avid fisherman, and Fonville, who liked the social aspect of the sport, often accompanied his friend. One day, the two went deep-sea fishing and their boat ran out of gas. The empty fuel tank apparently was not a problem until they also ran out of liquor. Only then did they shoot a flare, and they were eventually rescued.

One Halloween night, the foursome of Helen, Fonville, Glenna, and Jack were at the Winans home and did a little too much celebrating. They ended up driving to Plaquemine and waking up the owner of Wilbert's Funeral Home and Cemetery and demanding that he sell them four plots next to one another. The astonished funeral home owner obliged and made the sale that night. The friends all agreed that each would be buried with a shot glass, and that the last would be buried with a bottle of Tom Moore bourbon.

The Uhlers had two children, Anne "Anna Banana" Arbour, who was Helen's godchild, and Camille Thibodeaux. When Jack died at a relatively young age, four-year-old Camille looked to the also-grieving Fonville as her surrogate dad. Fonville was the third of the four to die, and he was buried with the bourbon. As of this writing, Glenna's tomb is the only one unoccupied. On special occasions she still lays flowers on Fonville's grave.

FINAL CRUISE

Sons Bob and Walker were part of Fonville's last trip to the swamps. That excursion took place around 1975, when the three sailed from Plaquemine to Shell Beach along Lake Borgne, and then to Morgan City, a coastal town along the banks of the Atchafalaya River due south of Baton Rouge.

For the trip, Bob bought a wooden cabin cruiser boat for $500 at Chef Menteur Pass near Lake Pontchartrain. Reminiscent of Fonville's nautical adventures in the 1930s, the drive shaft of the 33-foot vessel was slipping out. Adding to their challenges, the boat did not have a

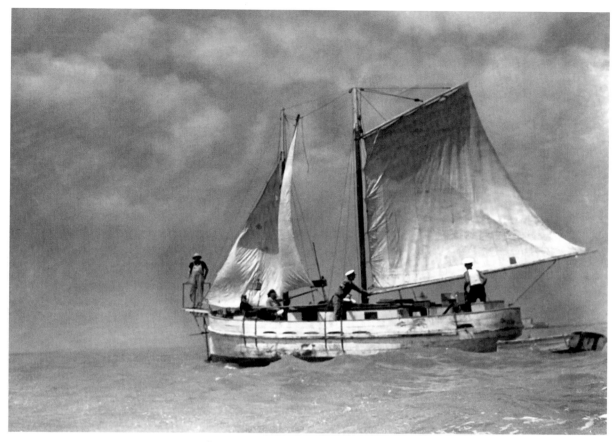

Sailboat. (Fonville Estate Collection, courtesy Robert L. Winans)

motor, so they improvised by installing a 1956 Buick V8 engine. The trio christened it *Pintail II.*

Sailing east through the marshes, the family crew caught fish for supper at Alligator Bayou. In this swampy body of water, they saw skinned nutria carcasses float by. At one point they heard dogs howling and then a loud splash. In the distance they noticed an animal swimming toward them, and before they knew it, they had taken on a desperate Catahoula hound.

With their aging father on board, Bob and Walker decided to spend only one night on the water. The details of the trip were burned into the siblings' memories but, unfortunately, no one took photographs of this final jaunt.

Fisherman's Paradise, late 1930s. (Fonville Estate Collection, courtesy Robert L. Winans)

BOILED CRABS in an Ice Chest

Makes 4 dozen

This is one of the many recipes Fonville used when boiling crabs.

1. In a large pot (60–80 quarts), bring to a boil enough water to completely cover the crabs when they are added. Plunge crabs into boiling water. When water comes back to a boil, cook 10 minutes, uncovered.

2. Remove crabs from water and immediately place 1 layer of crabs in the bottom of the ice chest. Sprinkle with ¼ of the salt and the contents of 1 bag of crab boil. Add another layer of crabs and repeat the seasoning process until all crabs are used and seasoned.

3. Cover with newspaper and close top of ice chest securely. Let sit 1 hour. (Residual heat will steam the crabs.)

4. Remove crabs from ice chest and serve, or let sit in ice chest up to 6 hours.

4 dozen live blue crabs
A large ice chest
1 box (26 ounces) salt
4 (3-ounce) bags dry crab boil (found in specialty stores or online)
4 large lemons
Sheets of newspaper

BROILED SOFT-SHELL CRABS

Makes 10

1. Clean crabs by removing eyes, mouth, and gills underneath shell. Pat crabs dry and coat outsides with oil. Season all over with salt, cayenne pepper, and Creole seasoning.

2. Heat a broiler to hot (500°F) and place oven rack 4 inches from heat source. Broil crabs, turning every 2 minutes, for a total of 10 minutes. Lay each crab on a slice of toast and top with melted butter, parsley, and green onions. Garnish with lemon slices and serve immediately.

10 soft-shell crabs
1½ cups vegetable oil
½ teaspoon salt
½ teaspoon cayenne pepper, or more
Creole seasoning to taste
10 slices toast
¾ cup (1½ sticks) butter, melted
2 teaspoons minced parsley
2 teaspoons minced green onions
3 lemons thinly sliced, for garnish

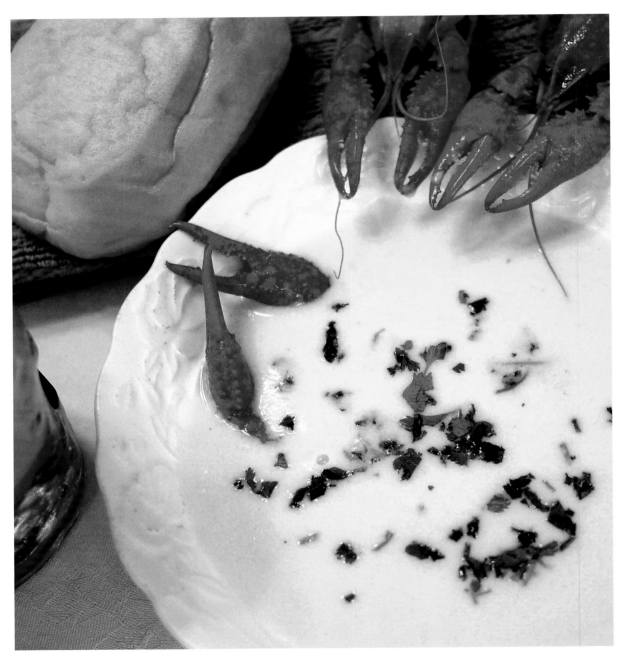

Crawfish Claw "Coquina" Stew. (Photo by Cynthia LeJeune Nobles)

CRAWFISH CLAW "COQUINA" STEW

Makes 4 servings

Tiny, jewel-toned coquina clams burrow themselves into the Gulf Coast's beaches, and many cooks use them to make broth. Coquina soup and the thicker stew typically don't contain any clam meat, but they're packed with seafood flavor. Fonville's adaptation of traditional coquina stew uses crawfish claws, which are not much bigger than coquinas. For an extra-spicy version of this recipe, use claws reserved from a crawfish boil—just be sure to taste the stew for seasoning before adding the salt and pepper.

1 pound crawfish claws, cooked, plus 8 for garnish, or substitute small crab claws

1 quart whole milk

8 salted soda crackers, crumbled with a rolling pin

1 teaspoon salt

¼ teaspoon crushed red pepper

1 tablespoon finely minced parsley

1. Crush or crack the crawfish claws with a pair of pliers. If they are frozen, they won't splatter. (In his day, Fonville didn't have plastic food storage bags, but a modern way to prevent splatters is to seal the claws in a plastic gallon bag and then crush.) Put the crushed claws, shell and all, in a stew pan with the milk and bring slowly to a boil. As soon as mixture comes to a full boil, remove from the fire and let stand, covered, an hour.

2. Drain all the milk from the claws into another saucepan. Discard crawfish shells. To the milk, add crumbled crackers, salt, and red pepper. Heat slowly, stirring constantly, until the stew just comes to a simmer.

3. Ladle hot stew into 4 bowls. Sprinkle with parsley and put two claws into each bowl for garnish.

CRAWFISH BISQUE

Makes 10–12 servings

This is a roux-based Cajun-style bisque. Today, most cooks who make this specialty bake the stuffed crawfish heads, but Fonville deep-fried his.

1. In a large skillet or Dutch oven set over medium-high heat, melt butter and sauté onion, celery, and bell peppers until vegetables are soft but not brown, about 10 minutes. Add garlic and sauté 1 more minute. Remove from heat and cool a few minutes. Grind vegetables finely in a food processor, blender, or food grinder. Set aside.

2. Heat 1 cup of vegetable oil in a Dutch oven set over medium heat. Stir in flour and make a roux by stirring constantly until mixture turns the color of peanut butter.

3. Remove pot from heat and add half of the sautéed vegetables. Stir in broth and water. Return to medium-high heat and bring to a boil. Add one pound of crawfish tails and fat, sherry, bitters, 1 teaspoon salt, ½ teaspoon black pepper, and ⅛ teaspoon cayenne pepper. Return to a boil, lower to a simmer, and cook, uncovered, until slightly thick, at least 1 hour. Stir every 15 minutes or so.

4. While bisque is simmering, make crawfish heads or balls. To a large skillet set over medium-high heat, add remaining half of ground vegetable mixture, remaining 1 pound crawfish tails and fat, 1½ teaspoons salt, remaining ¾ teaspoon black pepper, and remaining ⅛ teaspoon cayenne pepper. Cook, stirring occasionally, until crawfish are cooked through, about 10 minutes.

5. Cool slightly and coarsely grind mixture in a food processor, blender, or food grinder. Place mixture in a large bowl and stir in bread crumbs and 1 egg. Stuff mixture into cleaned crawfish heads or roll into 48 balls, using 1 tablespoon of the mixture for each. Add any remaining stuffing mix to simmering bisque.

6. To fry crawfish heads or crawfish balls, bring 1½ inches of vegetable oil to 350°F in a fryer or large pot over medium-high heat. Beat remaining egg in a small bowl. Add cracker crumbs to another bowl and add remaining ½ teaspoon salt. Dip exposed part of stuffing in the heads or entire crawfish balls in beaten egg, then in cracker crumbs. Fry whole heads or balls until golden, about 3 minutes. Drain and set aside.

½ cup (1 stick) unsalted butter

3 cups chopped onion

3 stalks celery, chopped

2 medium bell peppers, chopped

8 cloves garlic, chopped

1 cup vegetable oil, plus additional for deep-frying crawfish heads*

1 cup all-purpose flour

2 quarts seafood broth

1 quart water

2 pounds cleaned crawfish tails, with fat, divided

3 tablespoons sherry

3 dashes bitters (Fonville used Angostura brand)

3 teaspoons salt, divided

1¼ teaspoons ground black pepper, divided

¼ teaspoon cayenne pepper, divided

½ cup fine bread crumbs

2 large eggs, divided

48 cleaned crawfish heads (*optional*)

1 cup fine cracker crumbs

¼ cup finely chopped green onion

Hot white rice for serving

¼ cup minced parsley for garnish

7. After bisque has simmered 1 hour, taste for seasoning. Add fried heads and green onion and simmer 15 minutes. If bisque gets too thick, add water as necessary. Ladle bisque and stuffed heads over cooked rice in serving bowls. Sprinkle with parsley and serve hot.

*The "head" of a crawfish is actually the part of the exoskeleton that covers the cephalothorax, scientifically known as the carapace.

Crawfish Bisque. (Photo by Cynthia LeJeune Nobles)

Oyster Stew. [Photo by Cynthia LeJeune Nobles]

OYSTER STEW

Note from Fonville: "February 1966, at Juan's house—Best ever."

1. In a large saucepan, heat the oyster juice, milk, and butter until the mixture starts to simmer but does not come to a boil. Over very low heat, stir in both the crushed and crumbled crackers.

2. Add the oysters, bring back to a simmer, and cook until curly, only a few minutes. Do not overcook! Ladle hot soup into bowls and garnish with parsley.

1 quart oysters, drained, reserving ½ cup juice

1 quart whole milk

A few knobs (4 teaspoons) butter

16 salted crackers, 8 crushed with a rolling pin and 8 coarsely crumbled by hand

1 teaspoon dried parsley or 1 tablespoon minced fresh parsley, for garnish

SHRIMP and CRAB with RICE

Serves 4–6

1. Heat a skillet over a medium flame and add oil. Sauté shrimp and crab until shrimp just turns pink, about 2 minutes.

2. Add onion, celery, and bell pepper and cook, stirring constantly, until vegetables are wilted but not browned, about 2 minutes.

3. Stir in everything else, bring to a boil, and transfer to a stovetop rice steamer set over moderately boiling water. (You can also use an electric rice cooker with an additional ⅓ cup water, or use a tightly covered saucepan with an additional ¾ cup water and cook over low heat.) Cook until rice is tender, about 30–40 minutes. Toss with a fork before serving. Serve hot.

¼ cup corn oil

1 pound medium shrimp (30–40 count), shelled and deveined

½ pint crab claw meat

1 small yellow onion, chopped

1 stalk celery, chopped

1 small bell pepper, chopped

1½ cups raw rice

1 (10.75-ounce) can cream of mushroom soup

1 cup water

½ cup grated sharp Cheddar cheese

¼ cup diced green onions, tops and bottoms

¼ cup sliced and sautéed mushrooms, canned or fresh

½ teaspoon salt

¼ teaspoon ground black pepper

¼ teaspoon cayenne pepper

SHRIMP TOAST

Fonville made shrimp toast frequently for cocktail parties.

1. Finely mince shrimp and water chestnuts. Combine in a bowl with gingerroot.

2. In a separate medium bowl, beat egg lightly. Stir shrimp mixture into egg. Blend in cornstarch, sherry, salt, and black pepper.

3. Trim crusts off bread. Spread shrimp mixture evenly on top of each slice, pressing shrimp down so that the tops are smooth and even. Dip a knife into cold water and cut each bread slice into 4 squares or triangles.

4. In a fryer or heavy-bottomed pot, heat 1½ inches oil to the smoking point, about 375–400°F. Place a piece of bread, shrimp side down, on a slotted spoon and gently lower into hot oil. Cooking only a few pieces at a time, reduce heat slightly and fry until edges of bread are a deep golden brown, about 1½ minutes. Turn each piece over and fry a few seconds more. Drain on paper towels. Serve hot.

½ pound shrimp, shelled and deveined

5 whole canned water chestnuts

1 teaspoon freshly grated gingerroot

1 large raw egg

1½ teaspoons cornstarch

1 teaspoon dry sherry

½ teaspoon salt

Dash of ground black pepper

4 slices white bread

Vegetable oil for deep-frying

Shrimp Toast. (Photo by Cynthia LeJeune Nobles)

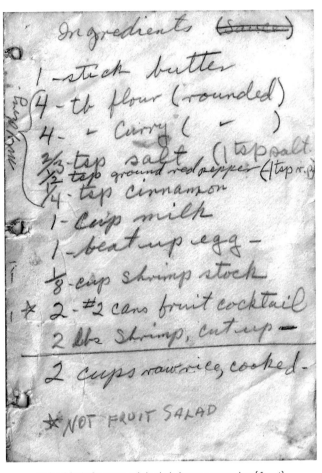

Jack Uhler's famous original shrimp curry recipe [*front*].
(Photo by Cynthia LeJeune Nobles)

JACK UHLER'S SHRIMP CURRY

Makes 6–8 servings

The story goes that one afternoon a group of acquaintances was gathered at Fonville's home, where they were having a particularly "enriched" cocktail hour. Fonville's good friend Jack Uhler, who had spent military time in India and who now was a few sheets to the proverbial wind, decided he wanted to make a shrimp curry. Uhler started throwing things into the pot. As he did, Fonville carefully wrote down each ingredient and the instructions on the back of an envelope. The curry was a huge success, but unfortunately for Uhler, he could not remember what he had put into his concoction. When he was later asked to cook his famous dish for friends in their homes, which reportedly happened often, Uhler would be forced to bring along the owner of the secret recipe, Fonville Winans. Over the years, Fonville tweaked the recipe, and this one was his final attempt.

Water

1 (3-ounce) package dry crab boil (found in specialty stores or online)

1 tablespoon salt, plus 1 teaspoon

3 oranges, juiced, and zest from 1 orange

3 lemons, juiced, and zest from 1 lemon

2 pounds fresh medium shrimp, headless and unpeeled

1 large egg, beaten

4 tablespoons all-purpose flour

4 tablespoons curry powder, hot or mild

½ teaspoon cayenne pepper

¼ teaspoon ground cinnamon

½ cup (1 stick) butter, melted

2 (15¼-ounce) cans fruit cocktail, with juice

1 cup whole milk

2 tablespoons shrimp stock (reserved from boiling shrimp)

Hot cooked rice for serving

1. In a stockpot, bring to a boil 1½ quarts water, crab boil, and 1 tablespoon salt. Boil 10 minutes. Add orange and lemon juices, and orange and lemon zests. Add shrimp and bring to a boil again. Immediately remove pot from heat and allow to cool to room temperature.

2. Drain shrimp, reserving the stock. Peel and devein shrimp and chop coarsely. Set aside.

3. Bring several inches of water to boil in the bottom of a double boiler. In a large metal bowl, mix together remaining teaspoon salt, egg, flour, curry powder, cayenne pepper, and cinnamon. Whisk in the melted butter and stir in the fruit cocktail.

4. Place the bowl over the boiling water. Stirring constantly, add the milk. Add 2 tablespoons shrimp stock and stir until sauce is the consistency of thick gravy. If sauce gets too thick, stir in more stock.

5. Stir in the cooked shrimp and heat through. Serve hot over rice.

Self-Portrait, Fonville with his Nikon Rangefinder camera.
[Fonville Estate Collection, courtesy Robert L. Winans]

Tamales Today . . . and Tomorrow

I . . . particularly enjoy making (and eating) hot tamales. They are delicious,
even if I do say so myself. But everybody else agrees also!

—Fonville in a letter to his parents, September 10, 1956

Fonville was hosting tamale parties at his home in the 1950s, a time when Mexican food certainly was not in vogue in Louisiana, and it was virtually unheard of to make tamales from scratch. But Fonville was extraordinarily fond of the Mexican specialty, and he dibbled and dabbled until he came up with what he thought was the perfect combination of ingredients.

The recipe he settled on feeds a lot of people, which always made it the perfect excuse to throw a party. With a menu of nothing more than tamales and margaritas, these soirees were usually attended by about ten guests, who would be taught to roll corn husks with masa and filling. Sometimes bullfighting music played in the background. When Helen's father was there, the piano was always going. The evening would usually end with more margaritas and a lot of singing. Fonville never liked keeping leftovers, so any uneaten tamales went home with guests.

Chili, too, was the impetus for many a party. And although chili did not originate in Mexico, at the Winans home it still merited margaritas and mariachi music. Fonville would cook a huge batch of chili and serve it with sides of rice, pickles, cheddar cheese, and onions.

Fonville was attracted to most foods associated with Mexico. His love of anything made with chili peppers and cumin began with visits to his in-laws, who had moved from Fort Worth to Donna, a south Texas town. There Helen's mother, Noni, was in charge of tending the family's orchards of grapefruit, oranges, and avocados, as well as fifteen acres of cotton and a henhouse full of chickens. Donna was only a few miles north of the Rio Grande River and the Mexican border, and Fonville took his family there every summer.

To get to Donna, the five members of the Winans clan usually took a train from downtown Baton Rouge to McAllen, Texas, and drove the remaining thirteen

> *My older brother Fred, visiting from Florida, was a great cook. I wanted to impress him, so I made hot tamales. He admitted they were good and asked me where I got the recipe. I told him* River Road Recipes, *page 234. "Oh," he said, "Fonville Winans's recipe." I was in shock! I had used Fonville's recipe many times and never realized it. My wife, Lois, and I were never aware that he was the source of that recipe in the chapter "How Men Cook," in* River Road Recipes. *I sure did want to rectify my omission by thanking him, but unfortunately, Fonville died in 1992, making that impossible. Woe is me.*
>
> —A memory from Baton Rouge resident Jerry Thompson, 2015
>
> *P.S. Using Fonville's basic recipe, I have taught all of my family how to make hot tamales, and untold others.*

miles. A few times, however, Fonville flew the family in his airplane, with Fonville and Helen occupying the front two seats and the three children in the one wide backseat. It took an uncomfortable two to three hours to fly to Longview, where Fonville refueled, and another hour to reach Donna. Things grew tense if the children became nauseated from the bumpy ride or if someone needed a bathroom break. Several times, Fonville threatened to put a chicken-wire floor in the plane, and one time Helen used his shoe to relieve her bladder.

If the family arrived by plane, Fonville would buzz over his in-laws' roof and land on the street or in the pasture in front of their house. To reach Mexico, they would drive over the border from Donna. One favorite destination was the border city of Reynosa, where they would dine on local specialties, like cabrito (a charcoal-roasted goat kid), enchiladas, tacos, chalupas, charro bean soup, chili, tamales, and black, green, and chicken moles, along with homemade tortillas and salsas.

Fonville also enjoyed spending time in bars sipping margaritas. If he drank straight tequila, he would chase shots back with the spicy nonalcoholic drink commonly known as sangrita, and which he called *sangre de la viuda,* blood of the widow. Food historians agree that this aperitif was created in the central-western state of Jalisco, Mexico, and that it may have started out as a simple mixture of sour pomegranate juice and chili. Today, sangrita is typically made with tomato juice, orange juice, lime juice, onion, salt, and hot chili peppers. Fonville wanted to create his own version, and after exhaustive testing, he settled on a recipe that is close to the modern original, but made without tomato juice. To make the drink's color red, he used grenadine.

After a trip to Mexico, the family never came home empty-handed. Naturally, Fonville wanted to cook his favorite Mexican dishes in his own kitchen, so he would load up on herbs and spices. One such spice was azafrán, a seasoning that gives savory dishes a vibrant yellow color like saffron, but without saffron's distinctive flavor.

The one thing the family never left Mexico without was liquor. At the time, residents of Texas could leave with only a quart, but with a Louisiana identification,

Fonville with actor Stanley Reyes in Reyes's Piper Cub. (T. Fonville Winans Collection, Louisiana State Museum Historical Center)

how about tieing like this

How to Wrap a Tamale.
(Drawing by Fonville Winans,
courtesy Walker Winans)

anyone eighteen years or older could bring back a gallon. A day or two before returning to Baton Rouge, Fonville would cross the Mexican border and use his Louisiana address to get one gallon of duty-free liquor per family member. Two of his favorite spirits were Kahlúa and tequila, which were not yet available in Louisiana. Fonville often used his tequila to wow guests with margaritas, a frozen drink virtually no one in Baton Rouge had yet seen.

When it came time to cook Mexican favorites, Fonville made his own tortillas by flattening masa into rounds in his tortilla press, or he rolled the dough in a tortilla mold. A look at his recipe journals shows that making perfect tamales took a lot of tries. For all the versions he created, Fonville left behind over one hundred recipes. Fillings could be made with corn, pinto beans, chicken, beef, or pork. Three recipes were for low-calorie tamales. There were numerous tamale-tasting notes, along with hand-drawn diagrams that show how to tie a shuck.

Fonville's quest to create the perfect chili took "only" fourteen attempts. To reach chili nirvana, he obsessively experimented every night for two weeks straight, with the family's taste buds suffering through his trials and triumphs. In the end, he developed a reputation for making an outstanding beefy, jailhouse-style chili con carne. Jailhouse chili has no beans and is named after the bowls of chili served in Texas prisons during the Great Depression.

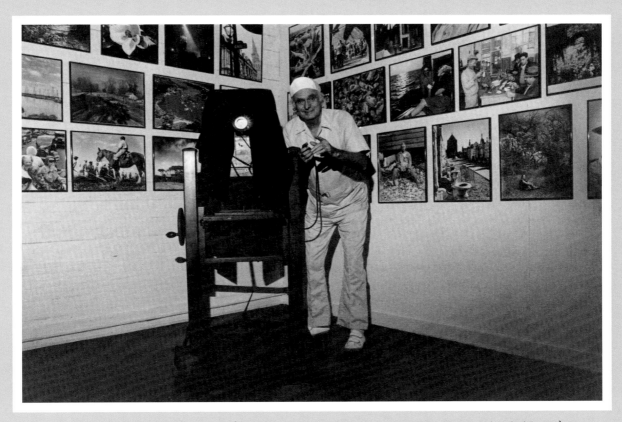

Self-Portrait (walls staged), in studio. (T. Fonville Winans Collection, Louisiana State Museum Historical Center)

FONVILLE'S ORIGINAL BEEF or PORK HOT TAMALES

Makes 75–100 small tamales

Adapted from Fonville's Hot Tamales recipe (September 1959) in the Baton Rouge Junior League's River Road Recipes. *This recipe reflects his final tweaks, which he made after publication of the Junior League cookbook.*

1. Soak corn shucks in hot water for 2 hours. While shucks are soaking, remove excess fat and bones from beef. Boil beef in water 45 minutes. Transfer beef to a bowl to cool and reserve broth for filling and for sauce. When beef is cool enough to handle, grind in a meat grinder or food processor.

2. To cooked ground beef, add the cup of warm beef broth, garlic, chili powder, paprika, cumin seed, black pepper, oregano, cayenne pepper, and salt. Set aside and make the masa.

3. Drain the corn husks and wipe them dry. To the lower left-hand corner of the smooth side of each soaked shuck, apply about ¼ cup soft, warm masa. Use a table knife to cover an area 2×4 inches and about ⅛-inch thick. Spoon a tablespoon of beef mixture down the center of the masa. Loosely roll the long sides together like a cigarette. Fold over the end of the shuck without masa. (The folded part should be about 2 inches. You want the tamale to be about 4 inches in length in the shuck.)

4. Tie the tamales into bundles of 6 and place tightly side by side, with the folded ends on the bottom, in the top of a steamer. Cover and steam gently over boiling water for one hour.

5. Serve tamales hot and covered with Sauce for Hot Tamales.

100 corn shucks, trimmed to 4×6-inch rectangles (brown paper bags or parchment paper can also be used)

3 pounds lean beef chuck roast or pork shoulder or butt, cut into 3- to 4-inch chunks

2 quarts water

1 cup warm beef broth (from boiled beef)

4 cloves garlic, minced

4 tablespoons chili powder

4 tablespoons paprika

2 teaspoons ground cumin seed

2 teaspoons ground black pepper

1 teaspoon oregano

1 teaspoon ground cayenne pepper

1 teaspoon salt

Masa (*recipe page 171*)

Sauce for Hot Tamales (*recipe page 171*)

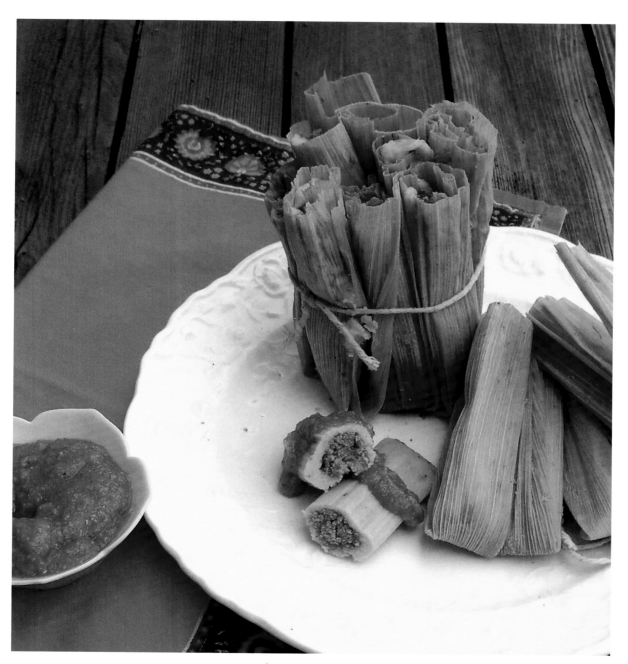

Pork Tamales. (Photo by Cynthia LeJeune Nobles)

Tamales standing in steamer. (Photo by Cynthia LeJeune Nobles)

MASA (Corn Dough)

Makes enough for 100 small tamales

In a large bowl, use low speed of an electric mixer to combine the masa, broth, lard, and salt. Mix until paste is the consistency of cookie dough. Follow recipe directions for rolling tamales.

1 pound corn masa (Fonville used Tamalina brand)

2⅔ cups warm beef broth

½ pound lard, softened

4 teaspoons salt

SAUCE for HOT TAMALES

Makes about 8 cups

According to Fonville's notes, this is exactly enough sauce for 182 tamales. Adjust quantities according to the number of tamales you are making. Fonville always used this same sauce for his various tamales. The broth usually came from whatever meat he had simmered for the tamale filling.

Mix all ingredients together in a saucepan and bring to a boil over medium-high heat. Lower to a simmer and cook until thick, about 2 minutes. Spoon warm over steamed tamales.

60 ounces (7½ cups) pork or beef broth

¾ cup masa harina (very finely ground corn flour)

6 tablespoons chili powder

1 tablespoon salt

CHICKEN TAMALES

Makes about 60 tamales

1. Boil chicken in water for 1 hour. Remove chicken from pot, reserving broth. When chicken is cool enough to handle, remove skin and bones and add them to reserved broth. Simmer broth with skin and bones for 1 hour. Remove from heat and strain.

2. Meanwhile, shred chicken and put in a large bowl. Stir in ½ cup chicken broth, 2 tablespoons corn oil, chili powder, paprika, 1 teaspoon salt, cumin, black pepper, cayenne pepper, and garlic powder.

3. When ready to assemble tamales, make masa by stirring together grits, remaining 4 cups broth, remaining 2 cups oil, and remaining 4 teaspoons salt in a large saucepan. Bring to a boil, lower to a simmer, and cook until it is a thick but workable paste.

4. To the lower left-hand corner of each paper wrapper, apply about ¼ cup soft, warm masa. Use a table knife to cover an area 2×4 inches and about ⅛-inch thick. Spoon a tablespoon of chicken mixture down the center of the masa. Loosely roll the long sides together like a cigarette. Fold the open ends over about 2 inches. You want the tamale to be about 4 inches in length in the shuck.

5. Tie the tamales into bundles of 6 and place tightly side by side, with the folded ends on the bottom, in the top of a steamer. Cover and steam gently over boiling water for one hour.

6. Serve tamales hot and covered with Sauce for Hot Tamales.

60 (4×6-inch) paper tamale wrappers (make your own from parchment paper or brown paper bags)

1 (3-pound) chicken, cut in half

2 quarts water

4½ cups chicken broth (from boiling the chicken), divided

2 cups corn oil, plus 2 tablespoons

2 tablespoons chili powder

2 tablespoons paprika

5 teaspoons salt, divided

1 teaspoon cumin

1 teaspoon ground black pepper

½ teaspoon cayenne pepper

¼ teaspoon garlic powder

2 cups (12 ounces) corn grits

Sauce for Hot Tamales (*recipe page 171*)

PINTO BEAN TAMALES

Makes 75–100 small tamales

Follow instructions for Fonville's Original Beef or Pork Hot Tamales (page 168), substituting 1 pound dried pinto beans for the beef or pork, and ground white pepper for the black pepper. To cook beans, simmer in plain water until tender, stirring occasionally, about 2 hours. Drain well and proceed with recipe.

CHICKEN MOLE

Makes 4 servings

A memory from Melinda: "Shortly after Walker and I were engaged, Fonville and Helen invited us to their home for a dinner of chicken mole. I had never eaten this Mexican specialty and was anticipating a treat. The dish was so appealing with what I thought was a generous sprinkling of paprika. As soon as I put a forkful near my mouth, however, my eyes teared up and my nose started running. One bite, and my throat was on fire: the paprika was actually cayenne pepper. For the first part of the meal, I must have put ten miles on my plate as I moved the mole around to make it appear I was eating. To my relief, Helen eventually served a beautiful loaf of garlic bread. Finally, something I could really eat. But what I thought was paprika on the garlic bread was actually Italian crushed red pepper. I only took one bite of the bread, and that was my meal for the night." You just couldn't get mole too peppery for Fonville and Helen. We have modified Fonville's recipe for those who enjoy chicken mole, but not so hot.

3 chicken legs and thighs, with skin and bones

1 quart water

1 (8-ounce) jar mole sauce (Fonville used Rogelio Bueno brand)

1 teaspoon salt

1 teaspoon sugar

¼ teaspoon Tabasco sauce

Dash cayenne pepper

Hot cooked rice for serving

1. Simmer chicken in water until tender, about 45 minutes. Set aside to cool and reserve the cooking liquid for mole sauce.

2. When chicken is cool enough to handle, remove skin and bones and discard. Cut the meat into bite-size pieces. Set aside.

3. In a medium saucepan set over medium-high heat, add the reserved cooking liquid, the mole sauce from the jar, salt, sugar, Tabasco sauce, and cayenne pepper. Bring to a simmer and cook 10 minutes. Add chicken and simmer an additional 10 minutes. Serve warm over rice.

FON'S CHILI CON CARNE

Makes 6 servings

Note from Fonville: "2/10/67—Excellent! I knocked off after my 1:00 sitting and rode my bike home, buying meat at the A&P on the way. A three-pound pork shoulder at $1.16 a pound. Got home as Penny was leaving and poured myself a sherry. Next thing I did was set the pork rendering in the wok with the greatest leaf lard."

1. In a large, heavy-bottomed saucepan, sauté pork and beef in 2 tablespoons lard until brown. Remove to a bowl.

2. In same saucepan set over medium heat, make a roux by stirring together flour and remaining 2 tablespoons lard and cooking, stirring constantly, until dark brown.

3. Add water, beef broth, chili paste, garlic, salt, oregano, and cumin and stir well to blend. Add cooked meat. Bring to a boil and lower to a bare simmer. Cover and cook 1 hour, stirring occasionally and adding water as necessary to keep from sticking. Serve hot in bowls with toppings.

*Leaf lard, the highest quality of lard, is rendered from the soft fat around a pig's kidneys and loin.

1 pound lean pork, chopped into ½-inch cubes

1 pound lean ground beef

4 tablespoons leaf lard* or vegetable oil, divided

2 tablespoons all-purpose flour

2 cups water

1 cup beef broth

8 ounces ancho chili paste

3 cloves garlic, thinly sliced

1½ teaspoons salt

1 teaspoon dried oregano

½ teaspoon cumin

For serving: cooked pinto or kidney beans, diced raw onion, dill pickles quartered lengthwise, crackers. (To drink, Fonville wrote he would have "sweet milk or beer.")

Fon's Chili Con Carne. (Photo by Cynthia LeJeune Nobles)

AZAFRÁN RICE

Azafrán *is the word for "saffron" in Spanish. It is also the name of the deep orange endosperm of the seed of the azafrán plant,* Ditaxis heterantha, *that grows wild in Guanajuato, Mexico. The spice sometimes goes by the names false saffron and Mexican saffron. Dried azafrán is common in Hispanic cooking, and although it gives food a bright yellowish-red color and makes a good substitute for saffron, it does not have the intense flavor of true, more expensive saffron. Fonville must have been fond of this recipe for Azafrán Rice, because in his notes he often recommends it as a side dish.*

1 teaspoon dried azafrán (found at Hispanic markets)

1½ cups warm water

1 cup raw white rice

1 teaspoon vegetable oil

½ teaspoon salt, or to taste

1. Soak the azafrán in the warm water for 30 minutes.

2. In a medium saucepan, combine the azafrán water, rice, oil, and salt. Bring to a boil and lower temperature to a bare simmer. Cover and cook 20 minutes.

3. Remove pan from heat and allow to sit, covered, 10 minutes. Fluff with a fork and serve warm.

FRIJOLES NEGROS (Cuban Black Beans)

Makes 6 servings

Fonville frequently served these beans as a side with Mexican entrees or as a stand-alone meal. (Soak the beans a day ahead.)

1. Pick over beans and discard any that are shriveled or broken. Wash well, put in a large glass bowl, cover with water by 2 inches, and let soak overnight at room temperature.

2. The next day, discard any beans that are split or float to the top. Drain and rinse in fresh water. Put beans in a large pot with 2 quarts of water and bring to a rolling boil. Reduce heat to low, cover, and simmer 45 minutes.

3. Meanwhile, heat oil in a frying pan and sauté the ham cubes, onion, garlic, celery, and bell pepper 10 minutes. Add tomatoes and their liquid and stir. Add tomato mixture to the beans.

4. Stir in bay leaves, sugar, cumin, black pepper, oregano, salt, and cayenne pepper. Cover and simmer 1 hour on low heat, stirring occasionally. Add vinegar and cook until creamy and thick, about 20–30 more minutes. Add more water as necessary.

5. Taste for seasoning. Remove bay leaves and serve hot over rice and garnish with green onions and cilantro. Keeps well, covered in the refrigerator, up to 2 days.

1 pound dried black beans

Water

⅔ cup vegetable oil

1 cup cubed smoked ham

1 yellow onion, chopped

3 cloves garlic, finely minced

1 rib celery, chopped

½ large red bell pepper, chopped

½ (14.5-ounce) can fire-roasted tomatoes, with all of liquid

2 bay leaves

1 teaspoon sugar

½ teaspoon ground cumin

¼ teaspoon ground black pepper

¼ teaspoon dried oregano

Salt and cayenne pepper to taste

1 teaspoon white wine vinegar

Hot cooked rice for serving

½ cup mixture of green onion tops and cilantro for garnish

CORNBREAD BY "EAR" (Jalapeño Cornbread)

Makes 6–8 servings

Note from Fonville: "Serve with buttermilk and raw onions."

1. Preheat oven to 425°F. Lightly oil an 8-inch cast-iron skillet or cake pan and heat in the hot oven 5 minutes.

2. Mix all ingredients together in a bowl and pour into hot skillet. Level off the top. Bake until lightly browned and a skewer inserted into the center comes out clean, about 20 to 25 minutes. Cool at least 5 minutes and serve.

1 small can (8.25 ounces) cream-style or regular corn, drained, or fresh off the cob

¾ cup cornmeal

½ cup buttermilk

1 large egg

1 large fresh jalapeño pepper (or more!), seeded and diced

2 tablespoons all-purpose flour

1 tablespoon melted butter

1 tablespoon dried onion flakes

1 teaspoon baking powder

½ teaspoon salt

¼ teaspoon baking soda

Cornbread by "Ear." (Photo by Cynthia LeJeune Nobles)

CUBA LIBRE

Makes 1 drink

Squeeze the juice from the lime into a 10-ounce collins glass and drop in lime shell. Add ice and rum. Fill the glass with Coca-Cola and stir. Serve immediately.

½ **fresh lime**

3 **ice cubes**

1½ **ounces Cuban white rum**

Coca-Cola

SANGRE DE LA VIUDA (Blood of the Widow)

Makes 2 cups

This is Fonville's version of what is commonly known as sangrita, the traditional Mexican chaser for tequila shots.

Combine all ingredients in a blender and puree well. Serve cold in shot glasses.

1 **cup water**

½ **cup grenadine**

6 **ounces frozen orange juice**

1 **tablespoon salt**

1 **tablespoon Tabasco sauce**

"Genius of Fonville." Fonville checking a negative.
(T. Fonville Winans Collection, Louisiana State Museum Historical Center)

Father of Many Inventions

Now, I am mechanically minded and always have been—ever since I worked as a carpenter for my father.
—Fonville Winans to Dalt Wonk of *Louisiana Life*, July/August 1991

Fonville obviously inherited his civil engineer father's curiosity about how things worked. Like his father, he was an incessant tinkerer.

As a youngster, Fonville built many fanciful things, such as a four-bladed "Dutch" windmill. However, since his contraptions were the unpolished work of a child, they often caused mild havoc. One memorable creation was a raft he built in Tom Sawyer fashion. At the time, he was only eleven, and to his parents' horror, he poled his sisters up and down Texas's Trinity River. Around the same time, he built a ferris wheel that didn't hold up well, causing one of his sisters to fall and break an arm. He also hot-wired the woven straw seat of a chair and shocked his mother with electricity, which prompted her to chase her mischievous son around the block with a broom.

Fonville made his first successful invention soon after he married Helen, in 1936, while the couple was living in Kansas City, Missouri, and Fonville was pho-tographing chickens. The company he worked for also published musical scores. One day he was taking pictures of a new style of music rack, which didn't work properly, so he invented a better one. Jenkins Music Company of Kansas City paid Fonville $125 for that creation. On November 8, 1938, Fonville received a patent, number 2135928A, for his "Auxiliary Music Rack." The Jenkins Company then asked him to come up with an innovative footrest, a piano pedal extender for children, which he did, and was paid another $125. Fonville and an Elmer Grant Ege filed for a patent on their "Piano Pedal Oper-ating Attachment," and on September 3, 1940, they were granted patent number 2213800A. At that point, the invention bug bit Fonville hard, and he set up a whole machine shop and almost gave up photography.

His most heralded gadgets were, naturally, in the field of photography. And although they were highly functional, his innovations weren't always glamorous. He created an accent spotlight by soldering a painted

Fonville changing film during a sitting, 1980s. (T. Fonville Winans Collection, Louisiana State Museum Historical Center)

coffee can onto a gooseneck lamp. For a splotchy effect, he would shine a light through crinkled newspaper set about five feet behind his subject. One time he was determined to dramatically light a background, so he found a heavy hubcap, which he used as a base, and soldered a metal rod up the middle. He attached a light bulb on top of the rod and placed his invention between his subject and a rear screen, which created a glowing rim light.

Some inventions were adaptations of existing supplies and equipment. For example, he made D76 liquid developer from his own formula. One important equipment conversion was to a Century camera Fon-

ville bought in the early forties. The camera had actually been built in the 1920s and was designed to use 8×10 film. Fonville modified it by adding the back of a Speed Graphic camera and started using the smaller 4×5 sheet film. Throughout his career, this hybrid was the main camera he used to take portraits.

Part of Fonville's success with wedding photography was his skill at using "bounce flash." This technique involves bouncing light off a reflective surface onto the subject to create a softer lighting effect. Bob remembers how Fonville was determined to eliminate harsh shadows on brides at weddings, and that he kept ex-

perimenting with flashes and his 4×5 press camera until he perfected the process of achieving a more flattering light. Fonville became such an expert on the subject that in the early 1950s, he demonstrated bounce flash around the United States at PPA conventions.

Bob also recalls that his father invented a device that utilized double exposure to allow four shots to be taken on one piece of film. Although widely praised, this machine was never named. Bob tells the story, too, how Fonville was the first professional photographer to put up to eight photos on one page. He was able to achieve this breakthrough by opening doors to the darkroom to expose a sheet of photographic paper. No one who visited the studio could understand how Fonville did it, even when they stood at his side watching the entire process.

Two of Fonville's time-saving machines in the field of photography were patented. One was a film processing rack, also called a film loading jig, patented in 1950, with U.S. patent number 2506401. His most notable invention was an automatic film processing machine, patented in 1940, patent number 2194345. The processing machine automatically dipped photographic films and plates in various liquids. It could hold twenty-four 4×5s or three rolls of 35mm film. At night, Fonville would load the machine in the dark, check the temperature and developer, set a timer for the developer, and go home. During the night, an arm above the developing tanks would systematically dunk the film into the tanks, where chemicals would fix and wash the film. A blower would dry the negatives, and they would be ready for proofing in the morning. He used the machine until his death in 1992. During the whole time he used his developer, it needed only one repair. Fonville's automatic film developer was what largely allowed him to remain a one-man operation until his old age.

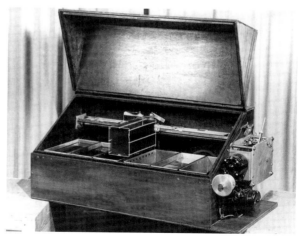

Film-loading jig (*top*) and film-developing machine (*bottom*). (T. Fonville Winans Collection, Louisiana State Museum Historical Center)

Fonville with patented film-processing machine.
[T. Fonville Winans Collection, Louisiana State Museum Historical Center]

FIVE-FLAVOR BEEF

Makes 8–12 servings

When Fonville had leftovers of this flavorful beef, he would chill and cut it into paper-thin slices for sandwiches and stir-fries.

1. Heat a Dutch oven or large, heavy pot over medium-high heat. Add oil and sear the meat until browned well on all sides, about 15 minutes.

2. Mix the remaining ingredients, except the sherry, and pour over meat. Cover the pot and cook on low heat until tender, 2–3 hours. Stir sauce and spoon it over the meat from time to time. During the last hour of cooking, add the sherry.

3. After meat is tender, increase heat to medium-high and cook until practically all the gravy is absorbed into the meat. Remove meat to a cutting board, and slice and serve hot. Leftovers keep in the refrigerator up to 3 days.

4 tablespoons vegetable oil

4-pound piece of beef brisket or chuck roast, with very little fat

2 cups soy sauce

2 cups water

1-inch cinnamon stick

1 tablespoon ground ginger

1 tablespoon cumin

1 tablespoon salt

½ teaspoon anise seeds

1 cup dry sherry

CHINESE BEEF and BELL PEPPER

Makes 4 servings

1. Cut flank steak into ⅛-inch slices and sprinkle with 1 tablespoon soy sauce, 1 teaspoon cornstarch, and baking soda. Set aside.

2. To make sauce, in a medium bowl, stir together remaining 2 tablespoons soy sauce, remaining tablespoon cornstarch, sherry, garlic powder, cayenne pepper, and black pepper. Set aside.

3. In a wok set over high heat, heat oil and sauté bell pepper until just tender, about 1 minute. Add steak and ginger and cook until beef is cooked through and no longer red, about 1 minute.

4. Add sauce ingredients from bowl and cook until slightly thick and beef is well coated. Thin with water if necessary. Serve warm over rice.

1 (5 to 6-ounce) flank steak, semi-frozen

3 tablespoons soy sauce, divided

1 tablespoon, plus 1 teaspoon cornstarch

½ teaspoon baking soda

2 tablespoons dry sherry

Dash of garlic powder

Dash of cayenne pepper

Dash of ground black pepper

1 tablespoon vegetable oil

1 very large green bell pepper, seeded and cut into 1-inch squares

2 slices fresh ginger, peeled and grated

Hot cooked rice for serving

Fantastic Beef and Onions. (Photo by Cynthia LeJeune Nobles)

FANTASTIC BEEF and ONIONS

Makes 4 servings

One of the cuisines Fonville experimented with the most was Asian. Although he never set foot in that part of the world, he was intrigued by the region's food, and a look inside his refrigerator on any day might reveal stashes of fresh ginger, tree fungus, and bean sprouts. Fonville also often adapted American ingredients to traditional Chinese recipes. Many of his Asian hybrid dishes were rousing successes. But some, such as Stir-Fry Bitter Melon with Pork, were so awful that his written remarks would have to be censored.

For Fantastic Beef and Onions, Fonville liked to briefly marinate the beef in baking soda, which makes the meat expand and stay tender when quickly cooked.

¼ pound beef sirloin, partially frozen

¼ teaspoon baking soda

4 tablespoons vegetable oil, divided

1 tablespoon soy sauce

1 tablespoon cornstarch

½ teaspoon salt

⅛ teaspoon ground black pepper

1 large onion, sliced in half lengthwise, then into ⅛-inch lengthwise slices

Hot cooked rice for serving

Cilantro or parsley for garnish

1. Slice the beef thinly and cut into shreds. Place in a bowl, coat with baking soda, and set aside 15 minutes.

2. In a large bowl, mix together 1 tablespoon vegetable oil, the soy sauce, and cornstarch. Mix in the meat and let stand 10 minutes.

3. Heat a wok over a medium-high flame. Add 1 tablespoon oil and when it is very hot, add salt, pepper, and onion. Sauté the onion 2 minutes. Remove and set aside.

4. Heat the pan again with remaining 2 tablespoons oil. When it is boiling hot, add the meat and stir quickly 4 to 5 times, being careful not to let the meat burn. Add the onion and stir once. Turn off the heat and sauté until onion is heated thoroughly, about 5 seconds.

5. Place rice in a shallow serving dish and spoon beef and onions on top. Garnish with cilantro. Serve immediately.

BEEF SAUTÉED with SNOW PEAS

Makes 4–6 servings

1. Wash the snow peas and snip off the stems. Set aside.

2. Pat meat dry. Heat the oil in a wok set over medium-high heat. When oil is very hot, sauté the beef 1 minute. Add the peas and stir another minute.

3. Pour broth slowly into the wok. Sprinkle sugar, salt, and pepper over the broth and mix well. Cover the wok and turn down the heat to a simmer. Cook 5 minutes.

4. Mix water and cornstarch in a small bowl and stir into the beef mixture. When the gravy is smooth and thick, pour into a shallow serving bowl. Top with cooked rice and serve immediately.

1 pound snow peas

¼ pound flank steak, sliced very thin

2 tablespoons vegetable oil

1 cup beef broth

½ teaspoon sugar

½ teaspoon salt, or to taste

⅛ teaspoon ground black pepper

¼ cup water

1 tablespoon cornstarch

4 cups hot cooked rice

BEEF with MUSHROOMS, ONIONS, and GINGER

Makes 4–6 servings

1. Soak mushrooms in hot water for 20 minutes. Drain, reserving 1 cup liquid.

2. Heat 2 tablespoons of oil in a wok over medium-high heat and sauté onion until just starting to turn brown, about 3 minutes. Remove from pan. Add beef and sauté until just cooked through, about 3 minutes. Remove from pan.

3. Reheat wok and add remaining 2 tablespoons of oil, mushrooms, soy sauce, ginger, salt, black pepper, and cayenne pepper. Heat until bubbly.

4. In a small bowl, mix the reserved cup of mushroom liquid with the cornstarch. To the wok, add onion, beef, and cornstarch mixture. Cook a few seconds to thicken, stirring slowly. If too thick, add beef broth as needed. Serve with rice or noodles.

¾ cup dried mushrooms

2 cups hot water

4 tablespoons vegetable oil, divided

3 cups onion, cut lengthwise

1 pound beef flank steak, thinly sliced

4 tablespoons soy sauce

2 tablespoons shredded ginger

Salt, ground black pepper, and cayenne pepper to taste

1 cup mushroom water (reserved from rehydrating dried mushrooms)

2 tablespoons cornstarch

Beef broth as needed

Hot cooked rice or noodles for serving

BEEF with RADISHES

1. Coat the beef slices with a mixture of 2 tablespoons cornstarch and the soy sauce and let stand 10 minutes.

2. Make a sauce by combining the remaining tablespoon cornstarch, water, sugar, vegetable oil, and vinegar in a medium saucepan set over medium-high heat. Bring to a boil and cook 1 minute. Add the beef and cook 2 more minutes.

3. Add the sliced radishes. Remove pan from the fire when the radishes are heated through, but not limp, after about 1 minute. Arrange rice on a shallow rimmed plate or small serving platter. Pour beef and radishes over rice and serve immediately.

½ **pound flank steak, sliced very thin**

3 **tablespoons cornstarch, divided**

2 **tablespoons soy sauce**

6 **tablespoons water**

4 **tablespoons sugar**

2 **tablespoons vegetable oil**

2 **tablespoons vinegar**

8 **radishes, sliced**

4 **cups hot cooked rice for serving**

SOY SAUCE CHICKEN

Makes 6 servings

1. Preheat oven to 345°F. Season both sides of chicken thighs with salt, black pepper, cayenne pepper, and garlic powder.

2. In a small bowl, combine regular soy sauce, sweet soy sauce, and sherry. Stir well and paint mixture all over chicken thighs. Press candied ginger and fresh ginger into coated chicken.

3. Bake, uncovered, until browned and juices run clear when stuck with a fork, 22–25 minutes. Garnish with star anise and chopped green onions. Serve warm.

6 boneless, skinless chicken thighs

Salt, ground black pepper, cayenne pepper, and garlic powder to taste

¼ cup regular soy sauce

¼ cup sweet soy sauce (kecap manis)

¼ cup dry sherry

2 tablespoons finely chopped candied ginger

1-inch piece fresh ginger, peeled and grated

Star anise and chopped green onions for garnish

Soy Sauce Chicken. (Photo by Cynthia LeJeune Nobles)

> *Dearest Mother and Father . . . My [cooking] specialty is "Sweet and Pungent [Sour] Pork."*
> *This is a little troublesome, but quite worth the effort. Roughly, it is a sauce of vinegar, water and*
> *sugar with bell peppers and pork added, then served with rice and soy sauce. If you know of any*
> *unusual native dishes there in Guam, please send me the recipe and I'll give it a whirl. I can get*
> *almost any ingredient I want at import food stores in New Orleans. I was in New Orleans*
> *over the weekend and picked up a few rare items. One of them is sesame oil.*
>
> —Letter from Fonville to his parents, September 10, 1956

FONVILLE'S SWEET and SOUR PORK

Makes 4–6 servings

Fonville used the word "hack" to refer to double scoring. For this recipe, he hacked each cube of pork on opposite sides and in opposite directions.

1. In a medium bowl, make a marinade by whisking together the egg, 1 tablespoon cornstarch, and five-spice powder. Add pork chunks and marinate at room temperature for at least 30 minutes.

2. Heat 1½ inches of oil to 350°F in a fryer or deep pot. Shake marinade off pork chunks and drop in small batches into hot oil. Pork is done when it is brown on all sides and it floats, about 3 minutes total. Transfer cooked batches to a paper towel–lined plate and set aside.

3. In a large saucepan, heat ⅔ cup water and vinegar until the liquid just comes to a boil. Add sugar and salt. When liquid boils again, add bell peppers. Boil 1 minute, stirring constantly.

4. Dissolve remaining 2 tablespoons cornstarch in remaining ⅓ cup water. Add to the vinegar and bell pepper mixture and cook, stirring constantly, until sauce thickens, about 2 minutes.

5. Stirring constantly, add cooked pork and pineapple. Continue to stir until heated through, about 2 minutes. Serve hot over rice.

1 medium egg, beaten

3 tablespoons cornstarch, divided

½ teaspoon five-spice powder

1 pound pork loin, cubed into 1-inch squares, sides "hacked"

Vegetable oil for frying

1 cup water, divided

½ cup white vinegar

½ cup sugar

1 teaspoon salt

2 green bell peppers, seeded and cut into ½-inch squares

1 (5½-ounce) can pineapple chunks, drained

4 cups hot cooked rice for serving

SHRIMP with PEAS and ALMONDS

Makes 8 servings

Fonville called this a "Fonville Special," and he gave it an "extra good!!!" rating.

1. Heat vegetable and sesame oils in a skillet set over a medium-high flame and sauté almonds and shrimp for 1 minute. Add peas and bouillon stock. Simmer, covered, 2 minutes.

2. Add sherry and cornstarch mixture. Stir and simmer 2 minutes. Stir in salt, MSG, and sugar. Add black pepper and cayenne pepper to taste. Simmer 1 minute.

3. Serve hot over rice and garnish with chiffonade of spinach leaves.

2 tablespoons vegetable oil

1 teaspoon sesame oil, optional

1 cup slivered or chopped almonds, toasted

1 cup raw medium shrimp, peeled and deveined

1 cup fresh or frozen green peas

1 chicken bouillon cube dissolved in ¾ cup hot water

2 teaspoons dry sherry or 1 teaspoon Curaçao

1 tablespoon cornstarch dissolved in 2 tablespoons water

½ teaspoon salt

½ teaspoon MSG (*optional*)

½ teaspoon sugar

Ground black pepper and cayenne pepper to taste

Hot cooked rice for serving

4 large leaves of raw spinach rolled and sliced thinly crossways to make a chiffonade, for garnish

CHINESE PICKLED RADISHES

Makes 8–10 servings

1. Slice tops and tips off radishes and wash and dry well. Crush with the blade of a chopper or hand chop coarsely.

2. Sterilize a glass pint jar and add vinegar, soy sauce, and sugar. Cover and shake well to combine. Add radishes and shake again. Refrigerate 2 hours.

3. Remove from refrigerator and stir in sesame oil. Serve in a shallow bowl as a garnish for meat. Keeps for 24 hours in the refrigerator.

1 bunch small radishes

3 tablespoons white vinegar

3 tablespoons soy sauce

1 tablespoon sugar

2 tablespoons sesame oil

Chinese Pickled Radishes. (Photo by Cynthia LeJeune Nobles)

Fonville living it up. [Fonville Estate Collection, courtesy Robert L. Winans]

Living It Up at Fonsvilla

One has the impression that Fonville has entertained and enlivened many an evening gathering, and that even in his absence stories of his various wide-ranging exploits have regularly pushed duller topics aside.

—English professor and author Ben Forkner, in his book *Cajun* (Marval Publishing, 1992)

The sprawling Winans family home on Lobdell Avenue was christened "Fonsvilla." At one point, the family even erected a "Fonsvilla" sign along the street.

Between the house and that street lay a spacious yard filled with oaks and elms that always seemed to be falling. In 1965, Hurricane Betsy knocked down nineteen of the Winans trees. To clean up the mess, Fonville bought his first chainsaw, and the family used the resulting cords of wood in their living room fireplace. The ashes that accumulated provided a necessary ingredient for making hominy. Their housekeeper, Penny, had grown up making the corn dish, and she taught Fonville her technique.

The process started with Fonville purchasing a sack of feed corn at the Tobias-Gass hardware store on North Street. Once home, he would gather the family in the backyard, where he would bring water and fireplace ashes to a boil in a galvanized washtub over burning logs. In went the corn, which would simmer until soft.

Next was a rinsing and separating procedure that resulted in a big batch of soft hominy. The family would eat some of it doused with butter, and Helen would preserve the remainder in glass jars.

Half of the Winans backyard was wooded. In the far left corner of those woods the family would mow a 25-foot circle, which they called the barbecue room. This is where most home entertaining took place, including actual barbecues using Fonville's Hasty Bake barbecue pit.

The barbecue room had no roof, floor, or walls—just a string of yellow bug lights that trailed from the utility room to the tree-lined space. The carved-out area was used often until the late 1950s, when Fonville remodeled the house, put in central heating, closed in the garage, and added a freeform concrete patio for entertaining, complete with an outside bathroom.

With its spacious rooms, shady yard, and fun-seeking owners, the Winans home was a popular place for social-

Fonville cooking in his backyard. (Fonville Estate Collection, courtesy Robert L. Winans)

When Baton Rouge resident Doc Hopkins was about six years old, he accompanied his friend Brian Wexley and Brian's parents to a barbecue at Fonville's home. Hopkins remembers Fonville out on the patio barbecuing chicken and pulling Spanish moss from an oak tree and throwing it onto the coals. The chicken ended up with a distinctive, strong, earthy flavor. Doc, who named the dish "moss chicken," was fascinated by the process. When he returned home, he told his mother he had just dined on the best barbecued chicken he had ever tasted. Today, Doc grills and barbecues often, and he still occasionally prepares moss chicken.

izing. Almost every day, Fonville and Helen upheld the sixties tradition of a cocktail hour. Without invitations, old friends would show up just about every afternoon. Total strangers were always welcome, too, and even plumbers and electricians working on the house often ended up having a drink with Fonville.

At least once a week, Helen and Fonville hosted a planned party. Some were as simple as a crab boil or a chili party. For more formal soirees, such as Meriget's wedding or socials for the Krewe of Romany, Helen mailed invitations and hired Penny and other servers. Walker would be assigned parking duty for the sixty-plus cars that might jam in the front yard, and a band, such as Cy Holly and the Dukes of the Blues, would play.

Alcohol, of course, was a staple at Winans hospitality events. Aside from Tom Moore bourbon, Fonville especially liked margaritas. He made great Bloody Marys, and on occasion he was even known to unscrew a few bottles of Ripple and Thunderbird.

Helen was good at blending stingers, hers a frozen version of the straight-up cocktail made with cognac and white crème de menthe. When she had too many, she often pranced up in front of whoever was assembled

and sang. The Winans children remember Helen serving Fonville steaks one night, but before they dug in, she blended up a batch of frozen stingers. The next morning, those untouched steaks were still on the table.

Fonville certainly enjoyed entertaining, and he also got a kick out of using his guests as guinea pigs for his ever-changing recipes. The stove he used for his experiments was a white, gas-fueled, chrome-top Chambers. This workhorse featured a built-in oven and three burners. In place of a fourth burner was a deep well with a burner at the bottom, which kept things warm, or into which a deep pot was inserted to simmer stews.

For special occasions, Fonville would don an apron loudly printed with some sort of joke. One holiday that merited an apron was Thanksgiving, which always meant turkey. Sometimes Helen would also soak a Virginia ham in the bathtub and score and stud it with pineapple, cherries, and cloves. Sides would be sweet potatoes stuffed in hollowed-out oranges topped with marshmallow, peas with mushrooms and slivered almonds, and homemade cranberry relish. If Helen's mother, Noni, attended, the family would be treated to homemade bread and pies.

Christmas in the Winans home started with flames dancing in the fireplace, gifts from Santa, and a big batch of Tom and Jerrys, the hot rum and brandy cocktail made creamy with beaten egg whites. Even the three children were allowed to sip on the stiff drink that special day.

Christmas dinner would be prepared by both Helen and Fonville. The menu was traditional—turkey, stuffing, cranberry sauce made from fresh berries, sometimes Grandmother Noni's tomato aspic, and oyster dressing, a holiday side dish common in south Louisiana. And there was always the family's special favorite of green grapes coated with cream cheese mixed with pressed garlic. Dessert was simply pumpkin, sweet potato, and pecan pies. If Noni was there, she would make apple and cherry pies, as well as peach and blackberry cobbler.

In quieter moments at the Winans home, the contents of the dented cans of sweet potatoes Fonville received from his friends at Solitude Plantation served as a lure for a family of raccoons that lived in the backyard. One summer, Fonville spent so many hours squatting out on the back porch holding sweet potatoes that a raccoon family became comfortable enough to eat out of his hand. Not to be outsmarted, a squirrel he named Knock-Knock would also come begging, but his preferred delicacy was pecans.

Helen suffered a heart attack in 1982, but that did little to squelch the parties. Big gatherings at the Winans home ended with Helen's death from lung cancer on January 19, 1988. Soon after his wife's passing, Fonville lost his sense of taste, and along with that went his desire to cook. One day Fonville offered Meriget a serving of canned chili, and he exclaimed that it was as good as his own. Meriget, who sadly knew it was not, framed that can wrapper and hung it in her kitchen, where it still hangs as a symbol of her father's past culinary successes and spectacular parties.

Christmas in the Winans home, 1979. Fonville is standing at far right. (Courtesy Melinda and Walker Winans)

BARBECUED CHICKEN

Makes 8 servings

1. Prepare a covered barbecue pit with coals on one side. Season chicken generously with Barbecue Seasoning Powder.

2. Barbecue the chicken, skin side down, on the cool side of the grill, covered, for 30 minutes, flipping pieces over every 10 minutes.

3. Move the chicken over the coals and baste with the sauce. Cover and cook 10 more minutes. Turn and baste again. Cover and cook 5 more minutes. Turn and baste again. Chicken is done when the inside is 165°F and the juices run clear. Remove to a platter and let rest 5 minutes. Serve with extra sauce on the side.

2 whole chickens, each cut into quarters

Barbecue Seasoning Powder (*recipe follows*)

Fon's Original Barbecue Sauce (*recipe page 201*)

BARBECUE SEASONING POWDER

Makes about ⅔ cup

Combine all ingredients and store in an airtight container.

¼ cup salt

¼ cup ground black pepper

2 teaspoons garlic powder

1 teaspoon cayenne pepper

FON'S ORIGINAL BARBECUE SAUCE

Makes 1 quart

Combine all ingredients in a large measuring cup and add enough water to make a quart. Bring to a boil in a saucepan and simmer 2 minutes. Cool at room temperature and store in the refrigerator in an airtight jar. Keeps 2 weeks.

1 (14-ounce) bottle ketchup

1 cup vinegar

4 tablespoons (½ stick) butter, melted

2 tablespoons Worcestershire sauce

4 heaping teaspoons chili powder

2 teaspoons sugar

1 teaspoon salt

1 teaspoon ground black pepper

¼ teaspoon Tabasco brand hot sauce or cayenne pepper

Water

SPANISH RICE

Makes 4 servings

1. In a skillet set over medium-high heat, add oil and brown onion lightly, about 6 minutes.

2. Mix in all other ingredients and bring to a boil. Transfer to a stovetop rice cooker, an electric rice cooker with an additional ⅓ cup water, or a covered pot with ½ cup additional water and set over low heat. Cook until rice is tender, about 40 minutes. Remove from fire and let sit 10 minutes. Fluff with a fork and serve warm.

4 tablespoons corn oil

1 large yellow onion, chopped

1 (14-ounce) can tomatoes, with juice

1 cup raw rice

1 cup sharp Cheddar cheese, cut into ½-inch pieces

¾ cup chopped stuffed green olives

¼ cup boiling water

1 teaspoon salt

3 drops Tabasco sauce

Sweet 'n Hot Beans. (Photo by Cynthia LeJeune Nobles)

SWEET 'N HOT BEANS

Makes 4 servings

This simple dish was a must at the Winanses' backyard barbecues. It grew so popular with guests that Fonville gave the recipe to the owner of Joe D's grocery store on Jefferson Highway, where the deli made these beans fresh daily and sold them alongside their ham, roast beef, and fried chicken. If Fonville's family was having a large party and everyone was too busy to make these famous beans, they would run over to Joe D's and buy it. This recipe appeared in the Baton Rouge Junior League's River Road Recipes, with Fonville writing, "This one is 'sure-fire,' especially for that 'patio affair.'"

¼ pound bacon, sliced into ½-inch pieces

4 onions, chopped (should be enough to fill the empty bean can)

1-pound can pork and beans (Fonville left a note that he bought his from the A&P)

½ cup dark brown sugar, packed, or ½ cup blackstrap molasses

¼ teaspoon cayenne pepper (mild), or ½ teaspoon (for those who like a little heat)

1. Fry bacon over medium heat in a large skillet until just crisp. Add onion and cook until just translucent, about 3 minutes.

2. Stir in beans, sugar, and pepper. Bring to a boil, lower to a simmer, and cook, stirring occasionally, 2 minutes. Serve warm.

MALAY RELISH

Makes 1 pint (Make a day ahead.)

Cut unpeeled orange and lemon into sections and remove seeds. Place in a blender, along with cranberry sauce and pineapple. Blenderize until everything is finely chopped. Transfer to a bowl and stir in curry powder. Refrigerate overnight before serving. Keeps 2 weeks in the refrigerator.

1 whole navel orange

½ Meyer lemon

1 (16-ounce) can whole cranberry sauce

1 cup crushed pineapple, drained well

1 teaspoon curry powder

HOT FRUIT CASSEROLE

Makes 12 servings

This rich fruit salad was extremely popular in the fifties and sixties, and it appeared in the Winans household during most holidays. The recipe can easily be halved. (Start one day ahead.)

1. The day before serving, drain the canned fruits, discarding juices, and pat fruit dry with paper towels. Store each fruit separately in the refrigerator. Crumble macaroons into tiny pieces, but not too fine. Store macaroon pieces, covered, at room temperature.

2. The day of serving, preheat oven to 300°F. Slice the bananas into a large bowl and sprinkle with lemon juice. Mix in all the other fruits. Layer half of the fruit and half of the macaroon pieces on the bottom of a 2-quart casserole. Sprinkle with ¼ cup brown sugar and half of the slivered almonds. Dot with 1 tablespoon butter. Repeat the process.

3. Pour Cointreau evenly over the top and sprinkle with coconut. Bake until hot and bubbly, about 20–30 minutes. Serve warm.

1 (15-ounce) can apricot halves in lite juice

1 (14-ounce) can peach halves

1 (14-ounce) can peach slices

1 (14-ounce) can pear halves

1 (8-ounce) can pineapple chunks

30 coconut macaroons

2 medium bananas

Juice from ½ lemon

½ cup light brown sugar, divided

⅓ cup slivered almonds, divided

2 tablespoons butter, divided

¼ cup Cointreau

½ cup flaked, sweetened coconut

BLOODY MARY

Makes 1 drink

Add all drink ingredients and cracked ice to a shaker and shake vigorously. Strain into an old fashioned glass over a lump of ice. Garnish with celery salt, celery stalk, and mint.

3 ounces tomato juice

1½ ounces vodka

Juice of ½ lemon

½ teaspoon Worcestershire sauce

Salt and pepper to taste

¼ teaspoon sugar

Cracked ice, plus a lump of ice

Dash of celery salt, 1 stalk celery with leaves, and a sprig of fresh mint for garnish

Bloody Mary. (Photo by Cynthia LeJeune Nobles)

EGGNOG

(Note from Fonville: "I introduced eggnog ice cream to this drink—1 scoop per drink.")

Shake all drink ingredients, except nutmeg, together with ice. Strain into a large highball glass and serve topped with nutmeg.

1 cup whole milk

1 large egg

1 jigger of good bourbon

1 tablespoon powdered sugar

Ice cubes

Freshly grated nutmeg for garnish

FROZEN STINGER

Makes 2 cocktails

Pour all ingredients into a blender and blend at low speed for five seconds, then blend at high speed until frothy. Serve in champagne coupe glasses.

1½ cups crushed ice

4 ounces brandy

2 ounces white crème de menthe

2 chilled champagne coupe glasses

TOM and JERRY

1. Separate the egg white from the yolk and beat them in separate bowls, beating the white until stiff. Fold the beaten eggs together and pour into an Irish coffee glass.

2. Add rum, cognac, and simple syrup. Fill cup with hot milk and stir well. Garnish top with grated nutmeg.

1 large egg

1 ounce rum

1 ounce cognac or brandy

½ ounce simple syrup or 1 teaspoon powdered sugar

Hot milk or hot water

Grated nutmeg for garnish

Self-Portrait. [Fonville Winans Photograph Collection, Mss. 4605, Louisiana and Lower Mississippi Valley Collections, LSU Libraries, Baton Rouge, LA]

Au Revoir

Life is such a gamble and I have nothing to lose. So, I'll gamble!

—Fonville Winans diary entry, 1934

Many artists don't become famous until after their death. Fonville lived to the age of eighty-two and was able to enjoy at least some of his acclaim.

SHOWING OFF TO THE WORLD

The first time anyone laid eyes on Fonville's now-famous Cajun swamp photos was in 1968. That was the year Fonville spent recuperating from a broken leg. While laid up and bored, he not only created his signature flan dessert, but also decided to print some of the old negatives he had taken around Morgan City and Avoca Island back in the 1930s. At the urging of friends Jack and Glenna Uhler, some of these prints were hung for viewing at the Plaquemine Library. The Old State Capitol in Baton Rouge also hosted a show of several of these photographs in February–March 1968.

An important international showing occurred in Amman, Jordan, in February 1979. At that time, Fonville's son-in-law, James Turner, was on a Fulbright professor-ship teaching architecture in Amman, while Meriget stayed home to care for her ailing mother. James received mail through the American embassy in Amman, and he became friendly with the diplomats he met there. Eventually, he convinced them to sponsor a show of Fonville's work. Fonville did not fly to Jordan for this event. Meriget coordinated the exhibit, which she named "Louisiana Look-See."

The same year Helen died, 1988, photographer James Fee of California was visiting Baton Rouge and chanced upon Fonville's studio. Fee curiously walked in, and the conversation between the two ended with Fonville having a retrospective show at the Gallery at 817 in Los Angeles in December 1990. The photographs on view were taken from 1939 through 1943, and they featured Fonville's unspoiled views of the Cajun South. At the time of the showing, Fonville was seventy-nine years old, and he flew to California for opening night.

One of those who attended the Los Angeles show was

the late-middle-aged Charmaine Tinney, the subject of Fonville's photograph titled *Ebb Tide*. Fonville had taken the photo when she was eighteen years old.

Among those paying tribute to Fonville's talent locally was attorney general Jack P. F. Gremillion, who made Fonville an honorary Louisiana attorney general. In 1990, Governor Buddy Roemer gave Fonville a certificate of special recognition, and Mayor Tom Ed McHugh made him an honorary mayor-president of Baton Rouge. That same year, the Foundation for Historical Louisiana recognized Fonville by bestowing upon him its Preservation Award for his contributions to the historical record.

Although he had long been a celebrity in Louisiana, it was the 1990 Los Angeles show that catapulted Fonville's work into the national spotlight. When musician Bruce Springsteen bought two signed prints, paying one thousand dollars for a photo of Cajuns eating oysters at an oyster camp, Fonville was "shocked." In spite of his steamrolling fame, he was having a hard time comprehending why anyone would pay that much for his black-and-white works. To himself, he was just a photographer, not a bona fide artist, and enjoying life was more important than pushing prints. Throughout his life, even when fortune was smiling upon him, the self-described bon vivant had little interest in aggressively marketing his work.

In October 1991, Fonville flew to France with several family members for a showing of his work sponsored by the French Photographic Society, the oldest such organization in the world. By this time, the octogenarian photographer had eye implants, wore a hearing aid, had suffered through two strokes, and walked with an aluminum cane.

Fonville had also given up taking photographs. But that didn't stop Bob, who accompanied his father on the trip, from urging him to take a few shots of the French sights, which irritated Fonville. Bob vividly remembers Fonville finally snatching the camera out of his son's hand and taking one unfocused shot, exclaiming, "Does that suffice?" This was his last photo, a 35mm of the Eiffel Tower.

The prestigious Société Française de Photographie held Fonville's showing October 17–November 16, 1991. Today, the society has five of Fonville's prints in its permanent collection. While in France, Fonville also had a show in the city of Angers, which coincided with the launch of the book *Cajun* by Ben Forkner, an American professor of English at the University of Angers. The large, handsome hardcover book is a tribute to Fonville, showcasing many of his Cajun-era photographs taken between 1931 and 1950.

THE END

One day not long after his return from France, Meriget was visiting her father and noticed he was behaving erratically. Concerned about his health, she drove him to Our Lady of the Lake Hospital, where he was diagnosed with digitalis toxicity. It seems that while at home alone, Fonville had forgotten he had taken his prescription medication, and had taken another dose too soon. After a week in the hospital, on September 13, 1992, Theodore Fonville Winans died, officially of renal failure.

Fonville's funeral was held at St. James Episcopal Church in Baton Rouge. He was buried in his trademark jumpsuit and Schwinn hat, along with a bottle of Tom Moore, at Grace Memorial Park Cemetery in Plaquemine. His plot lies next to that of his friend Jack Uhler.

Oldest son Bob was bequeathed the business and Fonville's signed prints, which are currently stored at Louisiana State University. The Cabildo in New Orleans also holds a 50-print collection, along with much of Fonville's personal and studio equipment. Bob has the first

Ebb Tide, featuring eighteen-year-old Charmaine Tinney.
(T. Fonville Winans Collection, Louisiana State Museum Historical Center)

Legs and Crutches. [Fonville Estate Collection, courtesy Robert L. Winans]

Cemetery. (Fonville Estate Collection, courtesy Robert L. Winans)

professional photo Fonville ever made—*Street Scene*—as well as his last—*The Eiffel Tower*. The family home went to Meriget and Walker.

A year before Fonville's death, Bob had converted the studio into a restaurant he named Fonville's Café. On weekends, musicians gathered there to jam for tips, and Fonville would talk music and photography. The restaurant's stove was the old white Chambers that Fonville had cooked on at home for so many years. In 1994, Bob closed the business and sold the building, complete with stove, to a restaurant that opened as M's Café. Later, the building housed a restaurant called City Deli. As of this writing, the building is occupied by a local architect and preservationist. In 1999, Fonville's Laurel at Seventh Street studio was listed on the National Register of Historic Places.

Fonville's Studio, 1940s. (Fonville Estate Collection, courtesy Robert L. Winans)

Fonville's last interview was in 1991, with reporter Leo Honeycutt at local television station WBRZ. Honeycutt recalls that setting up the meeting was difficult; Fonville always seemed to be out of town or busy, and he was in poor health.

When the two finally met, the visibly frail Fonville still exhibited spunk. During the interview, he talked mostly about his early days of photography and the swamps and their inhabitants. Fonville told Honeycutt that his favorite photographic subject was his wife, Helen. He also reminisced about taking pictures of Governor Huey Long and LSU president James Smith on the steps of the State Capitol.

After the interview, the ever-affable Fonville took a photograph of Honeycutt and signed it; it was one of the last portraits Fonville took.

Honeycutt's interview with Fonville had gone on for over an hour, and the resulting three-minute tape was aired after Fonville's death in 1992. Honeycutt, now an author, television host, and avid home cook, stresses how Fonville's work seemed to grow in importance as time went on, and particularly after the photographer's death.

Governor Huey P. Long with President Smith of LSU, 1934. (Fonville Estate Collection, courtesy Robert L. Winans)

DOLMAS (Stuffed Grape Leaves)

Makes 72

We know from his writings that Fonville prepared a version of this dish a few hours after a small kitchen disaster. One morning he put lamb scraps in water to make stock and went shopping. When he returned, he found the house full of smoke. "Sure blew that lamb stock," he wrote. His notes also indicate that he shrugged the mishap off, aired out the house, cleaned up the kitchen from that morning's breakfast of brains and eggs, and started working on his dolmas.

75 grape leaves packed in brine (Fonville's note: "Cushaw leaves are excellent, also.")*

Water

3 ounces raw long-grain rice

1½ pounds lean ground lamb

1 cup minced onion, packed

½ teaspoon crushed dill seed

4 teaspoons fresh minced mint leaves, divided

1½ teaspoons salt

1 teaspoon white pepper

¼ cup freshly squeezed lemon juice

Pats of butter

Yogurt Dressing (*recipe follows*)

1. Remove grape leaves from jar and drain. Put them in a bowl of cold water. Wash the rice, soak a few minutes in water, and drain well.

2. Mix together the rice, lamb, onion, dill seed, 2 teaspoons mint, salt, and pepper. Blend well.

3. Place a grape leaf, shiny side down, on a flat surface and add ¾ tablespoon of filling in the center. Roll into a little bundle with the ends tucked in, like a package of meat. Continue until all the filling has been used.

4. Place a few of the unused larger grape leaves on the bottom of a Dutch oven or deep electric skillet. On top of the plain leaves, add a layer of stuffed grape leaves with the seam side down, very close together to make a snug fit. Put another layer of plain grape leaves on top and continue to layer. When all the grape leaves are in the pot, add water almost to cover. Put a plate over the grape leaves to weigh them down. Cover the pot, bring to a boil, and lower to a bare simmer and steam ½ hour.

5. In a small bowl, combine lemon juice, remaining 2 teaspoons mint, and enough water to make a cup of liquid. Pour over grape leaves. Replace the lid and simmer another ½ hour. Serve hot or cold with Yogurt Dressing.

*Cushaw is a large, long-necked, green-striped squash with light yellow flesh. In south Louisiana, cushaw is typically prepared as a pie filling or as a savory or sweetened vegetable.

YOGURT DRESSING

Makes approximately 4 cups

1. Cut cucumbers into thin slices. Place into a bowl and refrigerate 1 hour.

2. In a medium bowl, mix together the yogurt, mint leaves, garlic, and salt. Drain the cucumbers and add to yogurt mixture. Refrigerate 1 hour before serving.

3 small cucumbers, peeled

2 cups plain yogurt

12 fresh mint leaves, coarsely chopped

2 cloves garlic, minced

Salt to taste

EGGPLANT and SHRIMP CASSEROLE

Makes 6 servings

1. Preheat oven to 350°F. Fry bacon in a large skillet until crisp. Leaving drippings in pan, remove bacon to paper towels and drain. Crumble bacon and set aside.

2. In same skillet with bacon drippings, sauté onion on medium-high heat until soft, about 3 minutes. Add garlic and sauté 30 seconds. Add eggplant and cook, stirring occasionally, until soft, about 2 minutes.

3. Add shrimp, basil, salt, and pepper flakes. Lower heat to medium and cook, stirring occasionally, until shrimp turn pink, about 1 minute. Remove skillet from heat and stir in crumbled bacon, cubed bread, water, and parsley.

4. Spoon mixture into a shallow, greased 2-quart casserole dish. Combine bread crumbs and Romano cheese and sprinkle on top. Bake until golden brown and bubbly, about 45 minutes. Serve hot.

4 slices bacon

¾ cup chopped onion

2 large cloves garlic, minced

2 (1-pound) eggplants, peeled and cubed

1 cup peeled, deveined shrimp, coarsely chopped

1 teaspoon dried basil, or 2 teaspoons fresh

1 teaspoon salt

Red pepper flakes to taste

6 slices bread, toasted slowly in the oven and cubed

1 cup water

¼ cup minced fresh parsley

3 tablespoons bread crumbs

2 tablespoons freshly grated Romano cheese

LEFTOVER CHICKEN STIR FRY

Makes 4 generous servings

1. Bring broth to a boil in a large saucepan. Add chicken, string beans, water chestnuts, and onion. Return to a boil and cook briskly 5 minutes.

2. Stir in the soy sauce, sugar, salt, cayenne pepper, and garlic powder. Lower heat to a simmer.

3. Mix the cornstarch with the water and stir into the chicken mixture. Cook until thickened, about 2 minutes. Serve at once over rice.

Variation: Add ½ cup chopped mushrooms and ½ cup chopped celery and omit the onion.

1 cup chicken broth or water

2 cups or more of diced cooked chicken

2 cups raw string beans

½ cup diced, canned water chestnuts

½ cup diced onion

1 tablespoon soy sauce

½ teaspoon sugar

½ teaspoon salt

Pinch of cayenne pepper

Pinch of garlic powder

5 teaspoons cornstarch

¼ cup cold water

Hot cooked rice for serving

Leftover Chicken Stir Fry. (Photo by Cynthia LeJeune Nobles)

Oatmeal Bread. (Photo by Cynthia LeJeune Nobles)

OATMEAL BREAD

Makes 2 loaves

1. Scald milk in a medium saucepan. Remove from heat and stir in oats, brown sugar, butter, and salt. Set aside and cool until lukewarm.

2. Meanwhile, in a small bowl, stir yeast into lukewarm water and allow to sit 5 minutes.

3. In a large bowl or the bowl of a very large standing mixer, combine milk mixture, yeast mixture, and eggs. One cup at a time, stir in 4½ cups flour. Add additional flour to make a medium-soft dough. Knead on a floured board until elastic and satiny, about 10 minutes, or 8 minutes on medium mixer speed, using a dough hook.

4. Place dough in a large greased bowl and cover with a damp cloth. Let rise in a warm place until doubled in bulk, about 1½ hours.

5. Punch down and let rise again, about 1 hour.

6. Preheat oven to 375°F. Grease two 9×5-inch loaf pans. Punch dough down and divide into two. Form dough halves into loaves and transfer to prepared pans. Cover lightly with a dish towel and let rise until dough has risen ½ inch above rim of pan, about 45 minutes.

7. Bake until bread is golden and sounds hollow when tapped on bottom, about 40 minutes. Remove from pans and cool completely.

1½ cups milk

1½ cups rolled oats

½ cup light brown sugar

½ cup (1 stick) unsalted butter

2 teaspoons iodized salt

2 packets (4½ teaspoons) active dry yeast

½ cup lukewarm water

2 large eggs, beaten

4½–5½ cups all-purpose flour

WORLD'S BEST CORNBREAD

Makes 8 servings

1. Preheat oven to 400°F. Lightly oil a 9-inch square or round pan or a cast-iron skillet. Put pan into the hot oven and heat 5 minutes.

2. Meanwhile, sift cornmeal, flour, baking powder, salt, and baking soda into a mixing bowl. Stir in buttermilk, egg, and drippings and pour batter into hot skillet.

3. Bake until top is golden brown, about 20–25 minutes. Serve warm.

1½ cups white cornmeal

3 tablespoons all-purpose flour

1½ teaspoons baking powder

1 teaspoon salt

¼ teaspoon baking soda

1½ cups buttermilk

1 large egg

2 tablespoons bacon drippings or melted butter

OLD FASHIONED COCKTAIL

Makes 1 drink

In an old fashioned glass, add sugar to water. Swirl until sugar is dissolved. Add crushed ice to fill glass. Pour in bourbon, cherries, and cherry juice. Squeeze lemon peel over mixture, drop lemon peel in, and stir in bitters. Garnish with orange slice.

1 teaspoon sugar

3 teaspoons water

Crushed ice

1 jigger good bourbon (Fonville's standard was Tom Moore)

2 cherries

1 teaspoon cherry juice

1 twist lemon peel

1 drop good bitters

Slice of orange for garnish

BACARDI RUM COCKTAIL

Makes 1 drink

Shake all ingredients together well. Strain and serve in a stemmed cocktail glass.

1 cup finely chopped ice

1 jigger white Bacardi rum

Juice of ½ lime

1 teaspoon grenadine

Bibliography and Photograph Collections

Cado, J. F. "Interview: Fonville Winans." *Gris Gris,* n.d. www
.fonvillewinans.com, accessed July 30, 2016.

De Caro, Frank. *Folklife in Louisiana Photography: Images of Tra-
dition.* Baton Rouge: Louisiana State University Press, 1990.

Forkner, Ben, and Theodore Fonville Winans. *Cajun: Louisiane
Années 30.* Paris: Marval Publishing, 1991.

Goldsmith, Sarah Sue. "Fonville Winans." *Baton Rouge Maga-
zine,* September 1987.

Junior League of Baton Rouge. *River Road Recipes.* Baton Rouge,
1959.

Kennedy, Diana. *Essential Cuisines of Mexico.* New York: Clark-
son Potter, 2009.

Laney, Ruth. "Cruise of the *Pintail.*" *Country Roads,* November
2011.

———. "Fonville's LSU." *LSU Magazine,* September 1987.

McKenna, Kristine. "Southern Exposures." *Los Angeles Times,*
December 2, 1990.

Miller, Robin. "Photographer Fonville Winans Captured History,
Hard Times." *Baton Rouge Advocate,* July 12, 2014.

Price, Anne. "Fonville: Reception, Exhibit to Honor Famed Pho-
tographer." *Baton Rouge Advocate Sunday Magazine,* March 11,
1990.

Swanson, Betsy. *Historic Jefferson Parish: From Shore to Shore.*
Gretna, LA: Pelican Publishing, 2003.

Tassin, Myron. *We Are Acadians/Nous Sommes Acadiens.* Gretna,
LA: Pelican Publishing, 1976.

Vetter, Cyril E. *Fonville Winans' Louisiana: Politics, People, Places.*
1995; updated ed., Baton Rouge: Louisiana State University
Press, 2016.

Winans, Fonville. *Cruise of the Pintail: A Journal.* Edited by
Robert L. Winans. Baton Rouge: Louisiana State University
Press, 2011.

———. Letters. www.bobwinans.homestead.com/Fonville-s-
Letters.html (accessed August 9, 2016).

Wonk, Dalt. "Fonville's Louisiana." *Louisiana Life,* July/August
1991.

COLLECTIONS OF FONVILLE WINANS' PHOTOGRAPHS

Fonville Winans website: www.fonvillewinans.com

Fonville Winans Photograph Collection, Special Collections,
Hill Memorial Library, Louisiana State University, Baton
Rouge.

T. Fonville Winans Collection, Louisiana State Museum His-
torical Center, New Orleans.

Index of Recipes